PRIDE
PRIDE
PRIDE
PRIDE
PRIDE
PRIDE

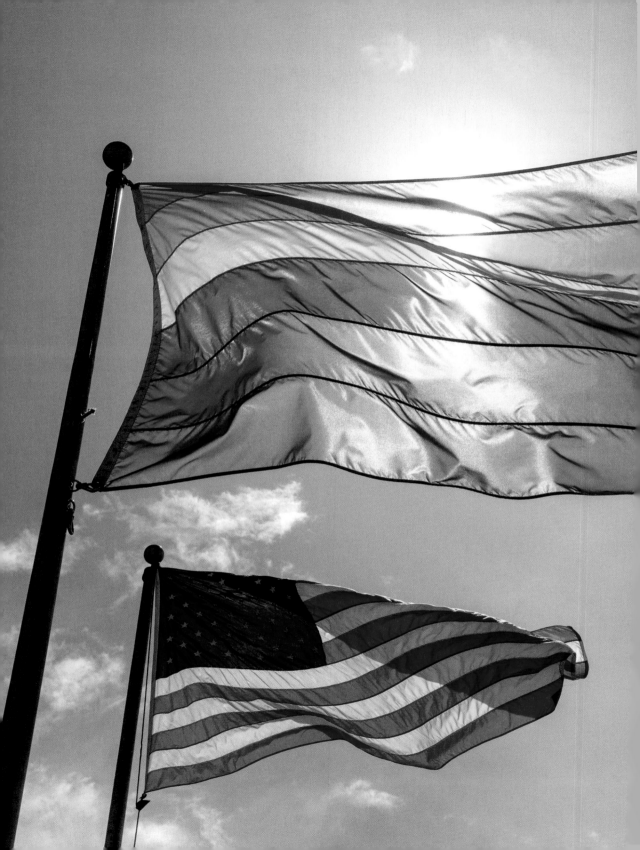

PRIDE
PRIDE
PRIDE
PRIDE
PRIDE
PRIDE

FIFTY YEARS OF PARADES AND PROTESTS
FROM THE PHOTO ARCHIVES OF The New York Times

ABRAMS IMAGE, NEW YORK

4 POLICEMEN HURT IN 'VILLAGE' RAID

Melee Near Sheridan Square Follows Action at Bar

Hundreds of young men went on a rampage in Greenwich Village shortly after 3 A.M. yesterday after a force of plainclothes men raided a bar that the police said was wellknown for its homosexual clientele. Thirteen persons were arrested and four policemen injured.

The young men threw bricks, bottles, garbage, pennies and a parking meter at the policemen, who had a search warrant authorizing them in investigate reports that liquor was sold illegally at the bar, the Stonewall Inn, 53 Christopher Street, just off Sheridan Square.

Deputy Inspector Seymour Pine said that a large crowd formed in the square after being evicted from the bar. Police reinforcements were sent to the area to hold off the crowd.

Plainclothes men and detectives confiscated cases of liquor from the bar, which Inspector Pine said was operating without a liquor license.

The police estimated that 200 young men had been expelled from the bar. The crowd grew to close to 400 during the melee, which lasted about 45 minutes, they said.

Arrested in the melee, was Dave Van Ronk, 33 years old, of 15 Sheridan Square, a wellknown folk singer. He was accused of having thrown a heavy object at a patrolman and later paroled in his own recognizance.

The raid was one of three held on Village bars in the last two weeks, Inspector Pine said.

Charges against the 13 who were arrested ranged from harassment and resisting arrest to disorderly conduct. A patrolman suffered a broken wrist, the police said.

Throngs of young men congregated outside the inn last night, reading aloud condemnations of the police.

A sign on the door said, "This is a private club. Members only." Only soft drinks were being served.

June 29, 1969

Introduction

BY ADAM NAGOURNEY

The Stonewall Inn on Christopher Street in New York City is just another bar—just another gay bar—with the *thump-thump-thump* of dance music, and people, men mostly, clustered around the bar, glancing at their phones, checking out the crowd, or trying to get a bartender's attention. Some are dancing and others are slipping out to the street for a smoke, no matter how cold it is.

But this bar in Greenwich Village has been more than that for half a century—it is a shrine. Walk by any day or night, particularly on Pride weekend in June, and the sidewalk is clumped with people posing for photographs next to the neon "Stonewall Inn" sign in the window, or in front of its New York State historical landmark plaque. Madonna showed up there one New Year's Eve. It has become the symbol of the modern gay rights movement because of something that happened there fifty years ago in June.

The Stonewall of that era was far different than it is today. It was a dive, with overpriced, watered-down drinks and ties to the mob, and a target for busts and shakedowns by the police. What happened on the night of June 28, 1969, has been mythologized and, yes, exaggerated over the years. In the late 1990s I cowrote a book on the movement with Dudley Clendinen, and it seemed like every New York gay and lesbian old-timer we spoke to claimed to have been there that night. But the fact is that the police did raid the place, and patrons, including the drag queens who were an integral part of the Stonewall clientele, fought back.

Within days, a group of activists—many already beginning to be radicalized by the churn of the late 1960s: the anti–Vietnam War demonstrations, the civil rights struggle, and the feminist movement—gathered in a loft to form the Gay Liberation Front. And yes, a movement was born—or at least a neat moment presented itself to define the next chapter of a civil rights struggle that had been lumbering along, mostly out of sight, in the form of organizations like the Daughters of Bilitis and the Mattachine Society. Within the next two years, pride marches were drawing thousands of attendees—and onlookers, including newspaper reporters and television crews—from Manhattan to Los Angeles. Those marches continue to this day.

Standing in front of the Stonewall Inn now, it's almost impossible to comprehend the sweep of change, progress, and tragedy of the past fifty years. "We've lived to see a revolution in our own time," Arthur Evans, who sprang to activism after the uprising, helping to create New York's Gay Activists Alliance, told me in his kitchen in San Francisco several years ago. "If things had been this way in 1969, I never would have become a noisy street activist. Instead, I would be a quiet professor leading an unobtrusive life in a small university."

And what a revolution it has been. The notion that the United States Supreme Court might one day affirm the constitutional right of same-sex marriage would have seemed unthinkable to those early pioneers, if they had thought about it at all; most did not. Gay people have moved from the shadows to positions of stature and influence across American life: television hosts and Hollywood movie stars; news anchors and city council presidents; governors and corporate executives.

When Jerry Brown, the former governor of California, appeared before a gay audience in Washington, D.C., when he ran for president in 1979—with reporters and camera crews gathered in the back—it was a moment in history. Now, it is hard to imagine a Democratic candidate for president winning the party nomination without a total embrace of gay rights. That may not yet be the case for most Republicans, but even a casual perusal of polling data—on the views of same-sex marriage and gay rights among younger Americans—leaves little doubt that Republican candidates will move to the

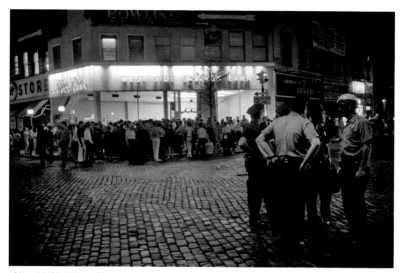
New York's West Village on July 2, 1969, several days after the Stonewall riots began

same ground soon enough, if only in the interest of political survival. The AIDS epidemic—for all the unthinkable destruction, death, and heartbreak it spread across the nation—produced a movement that was more sophisticated in the ways of government, medicine, and public advocacy. Recall the era-defining manifesto of ACT UP, the AIDS organization: "Silence = Death." Before Stonewall, many of the older activists were chided for being too polite and passive. Now the AIDS movement, and the gay rights movement, had become loud, demanding, insistent, and very public.

From the beginning, this has been a movement of fits and starts, of triumphs and disappointments. And to pronounce the gay rights movement a success—a battle won and done—would be a vast overstatement, as the election of 2016 made clear. The advances have taken place mostly in urban areas and on the coasts; pockets of anti-gay sentiments exist in many corners of the country. Two women might walk hand in hand along Sunset Boulevard in Hollywood, the U Street corridor in Washington, D.C., North Halstead Street in Chicago, Hell's Kitchen in New York, or pretty much any place in San Francisco. But the same cannot be said of many medium-size and small towns in America.

And in this history of fits and starts, the election of Donald Trump as president counts as the former, as his policies have addressed and arguably encouraged animus among many of his supporters toward LGBTQ Americans.

Yet this is a dramatically different world than it was for the activists there in the uncertain months after Stonewall, as gay rights groups emerged in, to name just a few places, Chicago, Boston, Minneapolis, Los Angeles, San Francisco, and college communities like Lawrence, Kansas. Many of those men and women are gone now, taken by AIDS or old age. Looking back, the modesty of their demands is striking: in short, the right to live openly and without harassment, protected from discrimination in hiring and finding a place to live, ensured that the police would protect them from being attacked on the street, and wanting to be accepted by families that had cast them out in an era when homosexuality was viewed as a disease or a sin. It must be noted that the early agenda also included a demand by many gay men to fight police crackdowns on men engaging in sexual activities in public places like parks, piers, and highway rest stops.

And there was one cause that decidedly was not on most of those early agendas. The idea of same-

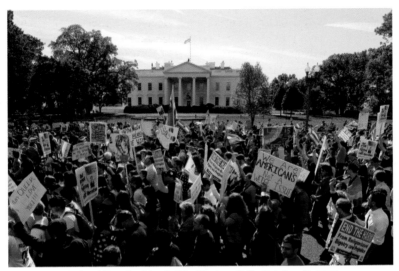

National Equality March, Washington, D.C., October 12, 2009

sex marriage was viewed with disdain by many of the early organizers who returned the animus they faced from society with a rejection of the norms society embraced to govern love and relationships.

Because of Stonewall, New York City is seen as the birthplace of the modern gay rights movement. But in fact, cities like San Francisco, Boston, and Los Angeles were as, if not more, important in laying the building blocks for the transformation we see today. The most elemental expressions of the movement in those early days were antidiscrimination laws passed by city councils and state legislatures.

But the New York City Council did not pass a gay rights bill until March 1986, by which time fifty cities and one state had already adopted gay rights ordinances. "God, I can't believe it, after all this time," Thomas B. Stoddard, executive director of the Lambda Legal Defense and Education Fund, told *The New York Times* after the vote.

Throughout the course of American history, struggles for civil rights have suffered the whiplash of inspiring victories followed by dispiriting defeats, and that has certainly been the case with the gay rights movement. Consider the years between 1977 and 1982. As that period began, seventeen states had repealed anti-sodomy laws and a fed-

eral gay rights bill was introduced in Congress by Representative Ed Koch, the New York Democrat who would go on to be mayor (and who throughout his life confronted questions, which he ultimately declined to answer, about whether he was gay). The movement, born on the street, was becoming more mainstream and patterned on established political campaigns. In Los Angeles, a group of middle-class women and men created the Municipal Elections Committee of Los Angeles, raising money to contribute to and gain influence with elected officials. In San Francisco, Harvey Milk was the first openly gay man elected to the Board of Supervisors. A senior adviser to President Jimmy Carter, Midge Costanza, organized a meeting of activists in the White House (Carter was at Camp David at the time). A voter initiative that would have banned gay teachers in California was defeated in 1978, after a riveting campaign in which Ronald Reagan, a Republican and former California governor, called for its defeat.

And it was during this same period that Anita Bryant, the singer and face of the Florida orange juice industry, led a successful campaign to convince voters in Dade County to reject a gay rights amendment that played to the fear that gays were a threat to children. In the wake of that vote, Wichita,

Kansas; St. Paul, Minnesota; and Eugene, Oregon, proceeded to repeal their own gay rights ordinances. Milk was assassinated at San Francisco City Hall, along with Mayor George Moscone, less than eleven months after he took office. As the new decade arrived, the first symptoms of AIDS could be seen on the streets of the Castro District in San Francisco.

It is interesting to consider how this movement might have evolved were it not for the epidemic. The gay rights campaign became the AIDS movement as gay men and lesbians rallied together to fight government and the media—including, it must be said, *The New York Times*, which was slow and timid in its early coverage of gay issues and AIDS. The paper devoted just two scant, unbylined nine-paragraph stories to the Stonewall uprising, and first reported on what would be known as the AIDS epidemic with a relatively brief story on page 20 on July 3, 1981. The first front-page story did not appear for another two years. *The Times*'s coverage of the epidemic lagged for years, even in the face of pressure from activists who complained in a barrage of letters and meetings.

The Times would not even use the word "gay" from 1975 until 1987, when a memorandum went out from a senior editor detailing a major change in the paper's culture. "Starting immediately, we will accept the word gay as an adjective meaning homosexual," it read. And for years, the paper's newsroom was widely considered to be a hostile place for gay men and lesbians, an atmosphere that finally began to dissipate in 1992 when Arthur Sulzberger Jr. took over as publisher of the paper from his father.

During the 1980s, lesbians and gay men became caregivers, experts in health policy, and lobbyists in the halls of Congress. It was a terrifying moment because of the threat not only to life, but to liberty as well, as opponents described AIDS as a punishment and invoked quarantines. "The poor homosexuals," wrote Patrick Buchanan, the conservative columnist. "They have declared war upon nature, and now nature is exacting an awful retribution."

Yet it has become clear that the AIDS movement helped advance the gay rights movement. From the earliest days, activists argued that coming out was the surest way to change public attitudes about homosexuality. AIDS accelerated this process; the disease led to people discovering that their children, siblings, coworkers, and even matinee idols—like Rock Hudson—were gay.

By 1992, when Bill Clinton first ran for president, AIDS was a mainstream political issue. "If I could, I would wave my arm for those of you that are HIV positive and make it go away tomorrow," he told an audience of mostly gay supporters, some of them in tears, at the Palace Theater in Los Angeles. "I would do it, so help me God, I would." Clinton would get elected and promote an openly gay man with AIDS, Bob Hattoy, to speak at the Democratic convention and work in his White House. But—fits and starts again—Clinton would fumble a campaign promise to allow gays in the military. He instituted the clumsy "Don't Ask, Don't Tell" policy that President Barack Obama would abolish nearly twenty years later. He also signed the Defense of Marriage Act, which permitted states to refuse to recognize same-sex marriages in other states. Looking back, it was not merely a modern-day low point for the movement, but arguably *the* modern-day low point. By 2013, the Supreme Court declared the act unconstitutional; two years later, the court ruled that the Constitution guarantees a right to same-sex marriage.

And where do we go from here? The battle has slowly moved from the courts and legislatures to the broad public culture. The prevalence of gay public figures, plot lines in television and movies, singers, politicians, actors, and business leaders— the chief executive officer of Apple, no less—has done as much to integrate the movement into public life as any single law. There will long be places in the country where this is not true, where young gay and transgender people are struggling with discrimination and rejection. But there really is no turning back now.

PRIDE

TEXT BY DAVID KAUFMAN
PHOTO EDITING BY CECILIA BOHAN

Protest March by Homosexuals Sparks Disturbance in 'Village'

80% Success Claimed for Sex Therapy

17 in Gay Alliance Held After Protests At Lindsay Offices

'GAY GHETTOS' SEEN AS POLICE TARGETS

But Homosexuals' Charge of Harassment Is Denied

BAR GROUPS BACK HOMOSEXUAL BILL

Measure in Council 2 Years Would Protect Rights

3 Candidates Support Rights of Homosexuals

500 HOMOSEXUALS STAGE A PROTEST

More Homosexuals Aided To Become Heterosexual

Homosexual Civil-Rights Group Is Announced by Ex-City Aide

100 at Police Headquarters Complain of Abuses

Hogan's Home Is Picketed By Homosexual Protesters

COUNCIL DEFEATS HOMOSEXUAL BILL BY 22-TO-19 VOTE

Supporters Shouting 'Bigot' Denounce Action—Sit-In Held at St. Patrick's

The Changing View of Homosexuality

What It Means To Be a Homosexual

"The whole thing began with an event that has been compared to the Boston Tea Party: on June 28, 1969, police raided a gay bar in the West Village, the Stonewall Inn. 'Instead of submitting to the cops' abuse,' reports a friend who was there, 'the sissies fought back' ... On the anniversary last summer 5,000-15,000 gay people marched up Sixth Avenue to Central Park for a 'gay-in'"

HOMOSEXUAL BILL ARGUED IN COUNCIL

Hearing on Discrimination Erupts Into a Debate

Christopher Street: From Farm to Gay Center

5 Gay Candidates Are in State Contests

HOMOSEXUALS GET POLICE PROMISES

Precinct Chief Says Action Will Be Taken to Lessen 'Friction' in Chelsea

Psychiatrists Review Stand on Homosexuals

HOMOSEXUAL RUNS FOR CITY COUNCIL

Court, Overruling State, Gives Gay Alliance Right to Incorporate

Maye Is Held as Harasser In Gay Alliance Outbreak

Judge Supports 'Consensual Sodomy'

500 Homosexuals March to the U.N. In a Rights Protest

ARSON DESTROYS GAY ACTIVIST SITE

Wooster St. Headquarters Reported Burglarized

Homosexual Teacher Fights to Survive

THERAPY SCORED BY HOMOSEXUALS

'Aversion Cure' Is Protested at Psychiatrists' Meeting

Psychiatrists, in a Shift, Declare Homosexuality No Mental Illness

Homosexuals in 'Village' Fearful After Series of Similar Killings

Hackensack Marks First Gay Pride Day

Archdiocese Asks City Council To Defeat Bill on Homosexuals

2 DEATHS MOURNED BY SAN FRANCISCANS

25,000 Pay Tribute at City Hall to Slain Mayor and Supervisor

Homosexuals Gaining Recognition and Support on Campuses Throughout U.S.

Homosexuals In New York Find New Pride

Laws Aiding Homosexuals Face Rising Opposition Around Nation

Homosexuals Are Moving Toward Open Way of Life As Tolerance Rises Among the General Population

Thousands Backing Homosexuals March Uptown to Columbus Circle

Stunned Crowd Gathers Near Scene of 2 Slayings

Slain Mayor and Supervisor Are Mourned by 25,000 San Franciscans

75,000 March in Capital in Drive To Support Homosexual Rights

Bill on Homosexual Rights Advances in San Francisco

Homosexuals Press for Rights

California Homosexuals Prepare for Schools Battle Homosexual Foster Children Sent to Lesbian Homes

1970s

The first decade of the modern gay rights movement began improbably on June 28, 1969, with the Stonewall riots in New York City—an event described by some as "the Boston Tea Party of the 1970s." The riots—a rebellion, really, of mostly gay men and transgender women—were indeed revolutionary, unleashing decades, if not centuries, of frustration at being abused, ignored, and criminalized by science, religion, the family, and the state.

Of course, for many in the community, Stonewall did little to immediately change their daily lives. But for some, mostly in cities, predominantly along the coasts, the 1970s marked a transformational period of vibrancy, visibility, and liberation. Gay people literally came out of the shadows, as their lives—still often pitied, if not pathologized—received the first glances of mainstream affirmation in films, in theater, and on television. The barriers for these people in traditional family life also began to dismantle thanks to efforts by the group Parents and Friends of Lesbians and Gays (PFLAG) to support parents struggling to accept their children's sexuality.

A thriving culture of newspapers, magazines, and bookstores emerged as the community more fully embraced its newfound confidence, while gay-themed novels like Rita Mae Brown's *Rubyfruit Jungle* (1973), Andrew Holleran's *Dancer from the Dance*, and Armistead Maupin's *Tales of the City* (both 1978) offered honest, erotic, and celebratory accounts of gay lives. These works were worlds away from the bitterness and self-loathing that typified important LGBTQ writing during the previous decade. And their often frank accounts of sexuality—particularly in gay resort colonies like Fire Island—epitomized an era when sex was viewed as both a physical and a revolutionary act.

Just a year after Stonewall, in June 1970, the nation's first-ever Pride parade took place in Manhattan, and parades quickly spread nationwide. The marches were demonstrations of very real and very public bravery at a time when there were few legal protections from institutionalized homophobia—despite homosexuality being officially declassified as a psychiatric disorder by the American Psychiatric Association in 1973. In Florida, for instance, the singer and political activist Anita Bryant successfully led a campaign in 1977 to repeal an ordinance prohibiting discrimination on the basis of sexual orientation; just a year earlier, the transgender tennis player Renee Richards was barred from competing in the women's United States Open because she had been born a man. In the same period, Maryland became the first state to enact a formal ban on same-sex marriage—an effort that would eventually spread to much of the nation.

This need for true equal rights prompted maverick gay activists like Harvey Milk to run for political office on stridently LGBTQ platforms. Milk, a onetime closeted Wall Street researcher, became one of the nation's first openly gay elected officials when he won a seat on the San Francisco Board of Supervisors in 1978 (Kathy Kozachenko was the actual first, in 1974—just a year after the founding of Lambda Legal, America's first legal association focusing on gay rights).

After less than a year in office, Milk was assassinated along with San Francisco mayor George Moscone, an act of anti-gay violence that, while prompting widespread riots and protest, also inspired the artist George Baker to design the now iconic Rainbow Flag. Less than a year later, community anger forcefully coalesced around the first-ever March on Washington for Lesbian and Gay Rights, which drew an estimated 75,000 to 125,000 people to the nation's capital and capped a decade of promise, protest, and newly (and truly) found pride.

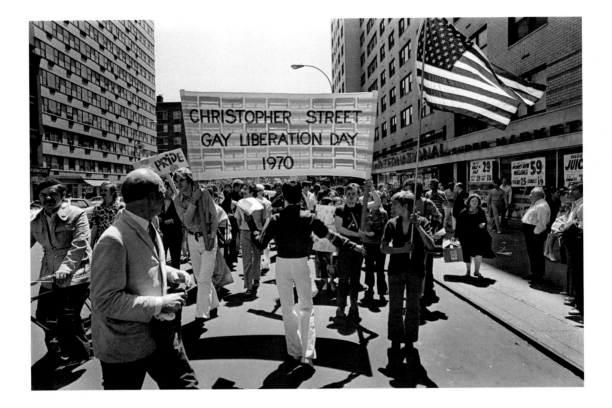

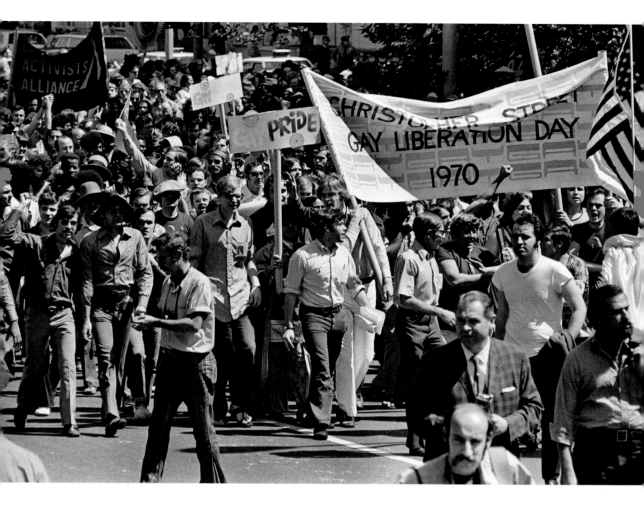

OPPOSITE & ABOVE
The first Pride March begins in Sheridan Square and follows 6th Avenue to the Sheep Meadow in Central Park, June 28, 1970. An estimated five to ten thousand people attended.

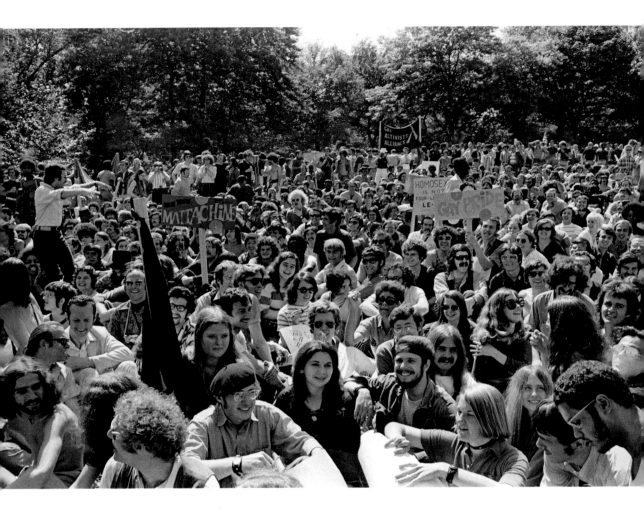

ABOVE & OPPOSITE
Marchers arrive at the Sheep Meadow in Central Park, June 28, 1970.

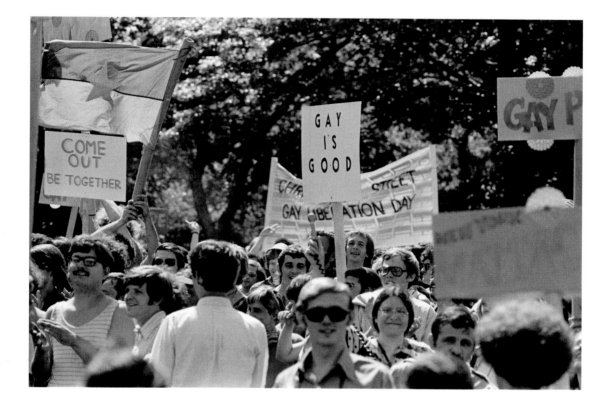

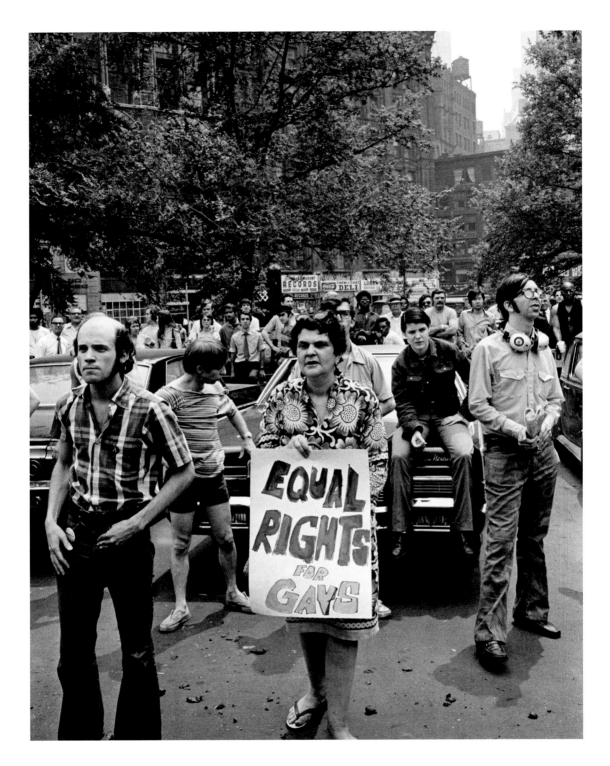

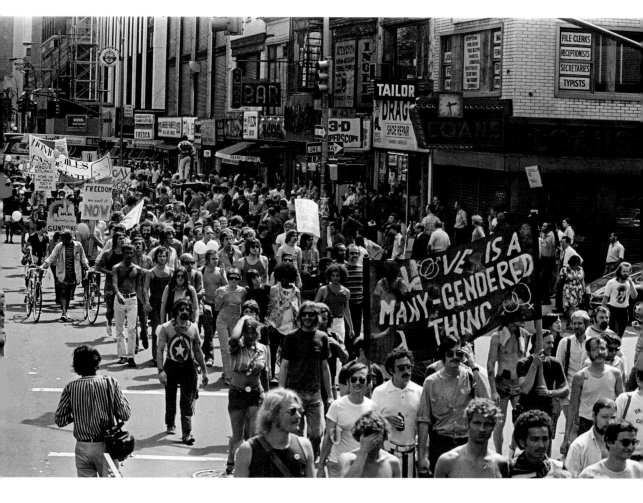

OPPOSITE & ABOVE
New York, June 27, 1971

New York, June 25, 1971

More Homosexuals Aided To Become Heterosexual

By JANE E. BRODY

"You are a sad and pathetic man," says Harold in Mart Crowley's play "The Boys in the Band." "You're a homosexual and you don't want to be. But there is nothing you can do to change it."

The widely held view that once a homosexual, always a homosexual, expressed in Mr. Crowley's drama, is being challenged by specialists around the country.

Therapists, using a variety of psychological approaches, have found that the young homosexual who is strongly motivated to change his sexual orientation has an excellent chance of success.

Furthermore, the therapists report that they have helped between 25 and 50 per cent of all their homosexual patients—regardless of age or original motivation—to make a heterosexual adjustment.

While the vast majority of homosexuals are not interested in psychiatric treatment and while most of those who do enter therapy do not want to become heterosexual, the therapists say that growing numbers of dissatisfied male homosexuals are seeking to change their sexual orientation, or at least make a better adjustment to it.

Biologically Normal

"The minute the word gets around that we are treating homosexuality with some success, we are literally besieged with requests for help," remarked one New York psychiatrist who has written widely on the subject.

Dr. William Masters and Mrs. Virginia Johnson, the St. Louis specialists in sex research and therapy whose findings in their work with homosexuals are still unpublished, report that they are receiving an increasing number of referrals of homosexual patients as word gets around in professional circles that they are involved in such research.

Approaches to treatment range from the traditional psychoanalytic method to directed psychotherapy, group therapy, behavior therapy and any combination of these. Chemical treatment has not worked since studies have shown that homosexuals are biologically normal males.

The doctors say that their techniques would apply equally to male and female homosexuals. But they note that Lesbians rarely seek treatment and, when they do, they are usually not interested in changing their sexual orientation.

Male homosexuals who want to become heterosexuals usually enter therapy with a problem directly related to their homosexuality—such as break-up in a love affair, disenchantment with the homosexual life style, fear of exposure or loss of employment, fear of growing old and undesirable or desire for a family.

Doctors who treat homosexuality believe that many who might want and benefit from treatment never seek it because of the deep pessimism about prospects for change that prevails in both the public and the professional mind.

The first turn away from this pessimism came with the publication eight years ago of a study by a team of psychoanalysts who reported that 27 per cent of 106 homosexual patients who had undergone analysis had shifted to exclusive heterosexuality.

The team, headed by Dr. Irving Bieber of the New York Medical College, called them "the most optimistic and promising results thus far reported."

The analysts, who view the main goal of therapy as ridding the homosexual of his fears of heterosexual activity, found that a shift to heterosexuality was most likely to occur if the total number of therapy hours exceeded 350—usually three years of more. Among those who underwent the therapy, nearly half achieved a complete heterosexual adjustment.

Habit Reconditioning

More recently, a New York Hospital psychiatrist, Lawrence J. Hatterer reported that, by combining the psychoanalytic method, in which he was trained, with some of the new habit reconditioning techniques of behavior therapy, he "can achieve in 50 sessions what it often takes regular psychoanalysis 350 sessions to do."

In a recently published book, "Changing Homosexuality in the Male," Dr. Hatterer documents his work over the last 15 years with more than 200 homosexual patients, a third of whom made a stable heterosexual adjustment.

Like the analysts, Dr. Hatterer tries to help his patients understand the origins of their homosexual behavior by exploring their family relationships and childhood experiences. At the same time, he tries to change the homosexual habit by asking his patients to identify and avoid those aspects of their life that trigger homosexual episodes, replacing them with heterosexual stimuli and relationships.

He might, for example, tell a patient to stop frequenting "gay" bars and go to "straight" ones instead and to substitute Playboy magazine and images of women for homosexual pornography and images of men.

Dr. Hatterer also uses capsulized tape recordings of relevant therapy sessions, which the patient listens to at home when he feels inclined to revert to the sexual activity he is trying to avoid.

One 30-year-old patient made a complete heterosexual adjustment within three months of treatment, the doctor reported. The man, who had never before had any heterosexual experience, entered therapy on the verge of suicide, having just broken up with the man he had been living with for two years.

"After just nine 45-minute sessions and 27 listenings to the tapes, the man was engaged to be married and having successful sexual intercourse with his fiancée several times a week," Dr. Hatterer said.

Dr. Hatterer, Dr. Bieber and others who have treated many homosexuals cite the following characteristics of patients as favorable to a heterosexual adjustment:

¶Strong motivation to become heterosexual.

¶Late introduction to homosexuality (late in adolescence or in adulthood).

¶Therapy beginning before the age of 35.

¶Some heterosexual interest or experience in the past.

¶A liking for women at least on a social level.

¶A work and living pattern not dominated by constant homosexual contacts.

Yet, Dr. Hatterer says, some patients with few or none of these characteristics have greatly benefited from therapy. A critical aspect of treatment, he maintains, is to convey to the patient that some form of help for his problem is possible.

Dr. Samuel B. Hadden, a Philadelphia psychiatrist who 15 years ago helped pioneer the group-therapy approach to redirecting homosexuals, deplores the "hopeless attitude" that he says "prevails in the minds of many psychiatrists."

Dr. Hadden feels he has reason to be hopeful. Working with all-male homosexual groups, he has found that "about one-third of those who persist in treatment [usually for several years] reach an effective heterosexual adjustment" and another third become better adjusted to their homosexuality.

The group approach, he says, gives patients a feeling of acceptance and hastens catharsis, since group members often have shared similar life experiences and reactions.

Each group member, eager for success, supports and reinforces the successes of every other member and, in turn, each successful member provides living proof to the others that sexual reorientation can be achieved.

Group therapy, like psychoanalysis, is a long-term proposition and many doctors believe that, if the many thousands of homosexuals who might benefit from treatment are ever going to get it, a faster way will have to be found.

At Temple University's Behavior Therapy Institute, Dr. Joseph Wolpe and his colleagues are attempting to treat homosexuals solely by reconditioning them through behavioral techniques.

Three-Sided Attack

Their three-sided attack works on the homosexual's fear of physical contact with females, his attraction to males and his general interpersonal fears. For example, to remove their anxieties about women, patients are placed in a state of deep relaxation and then told to conjure up images of women. To erase their sexual interest in men, patients are also subjected to such "aversive" stresses as mild electric shocks when shown pictures of naked men.

Since this combined behavioral approach is relatively new, Dr. Wolpe says he does not yet have enough cases to collate results or evaluate their long-term effectiveness. However, his "impression" is that "about 75 per cent" of patients become heterosexually oriented after about six months of therapy.

A number of therapists believe that some homosexuals are able to become heterosexuals without professional help—through will power, deep religious experience or the adoption of a new philosophical system.

But for the many homosexuals who want to change their life style and cannot do so on their own, treatment can be costly, time-consuming and difficult to find.

A National Institute of Mental Health study group on homosexuality recently called for an "expansion of efforts to develop new therapies and to improve the efficiency of current therapeutic procedures."

"While it cannot be assumed that a large portion of homosexuals will go into treatment," the study group said, "we hope and expect that, as treatment methods improve and expand, more and more persons will seek treatment voluntarily."

Noting that "another 5,000 psychiatrists would be needed to help all the homosexuals who might want it," Dr. Hatterer suggests the establishment of "sexual mental health clinics," staffed by paraprofessionals. And as the ranks of former homosexuals grow, he envisions the development of a Homosexuals Anonymous, a self-help approach that could do for homosexuals what Alcoholics Anonymous has done for many alcoholics.

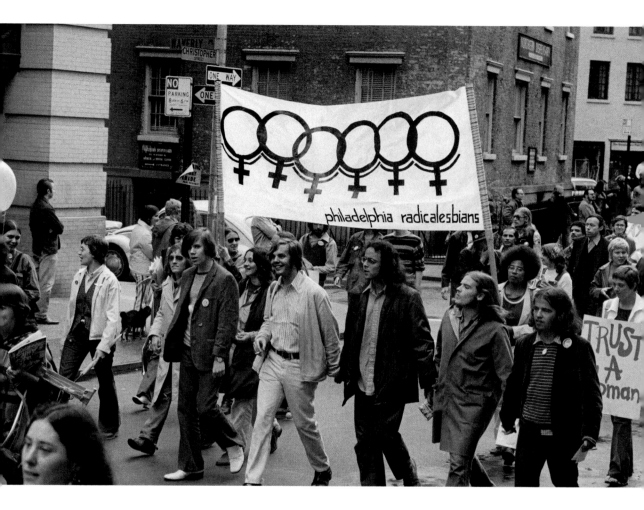

New York, June 25, 1972

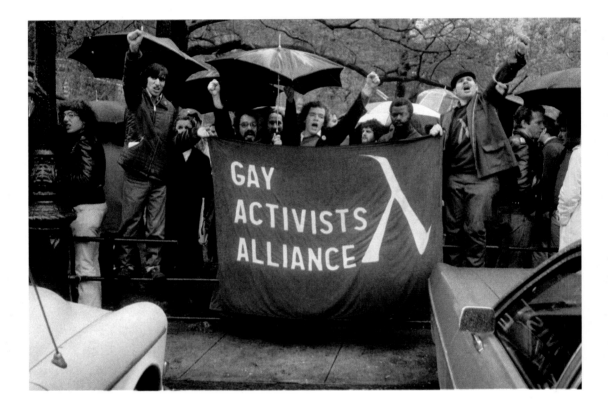

ABOVE
Members of the Gay Activists Alliance gather at New York's City Hall, April 27, 1973.

OPPOSITE & FOLLOWING
Drag queens from the East Village's 82 Club, New York, June 24, 1973

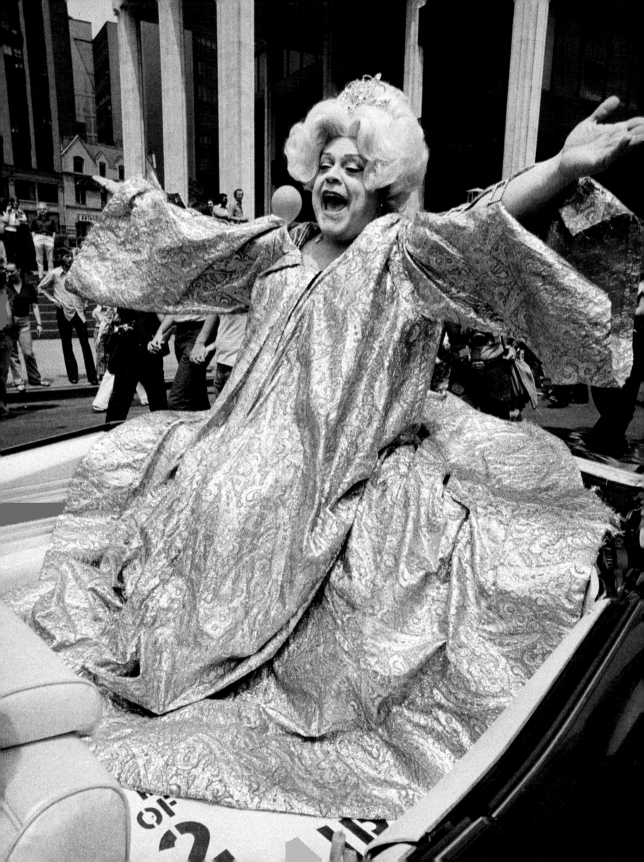

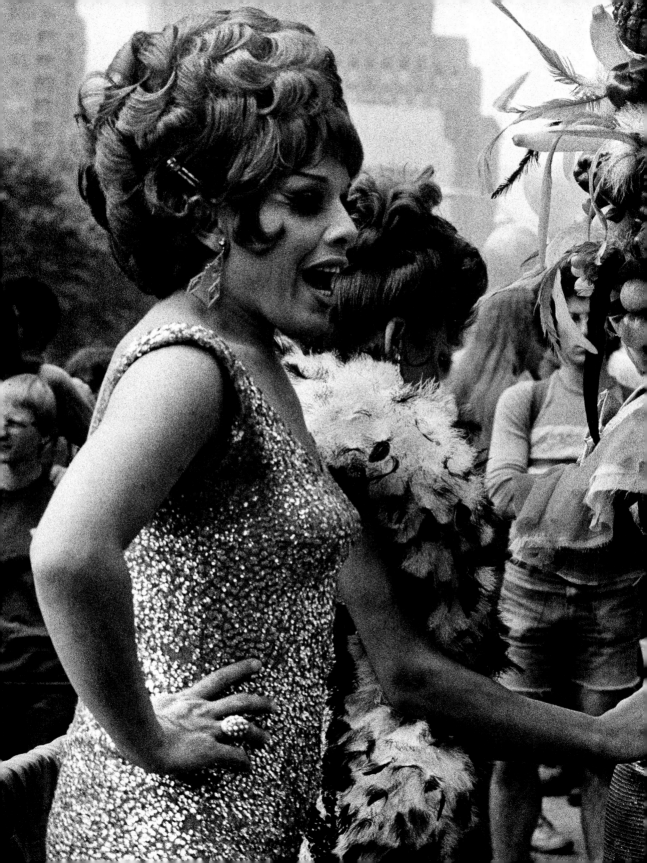

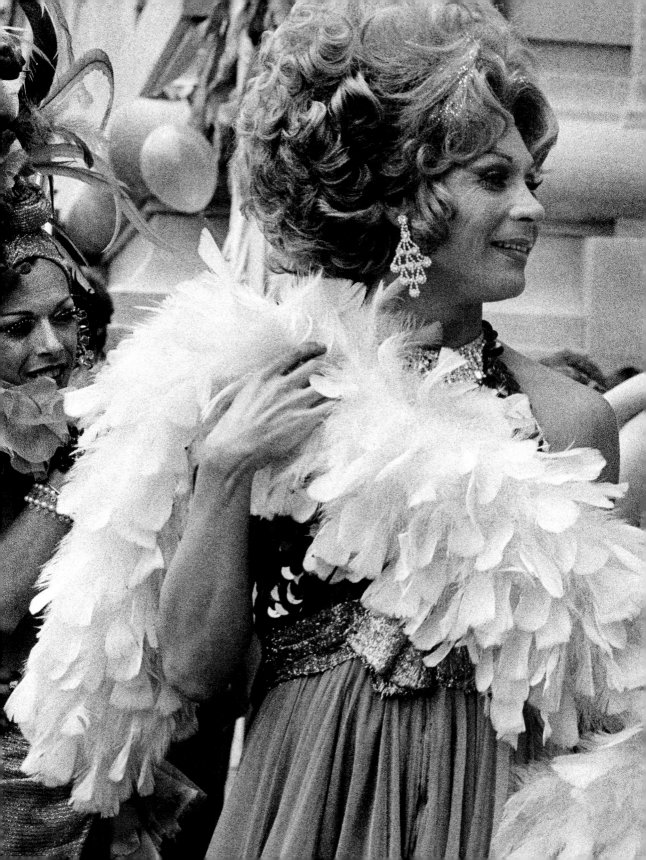

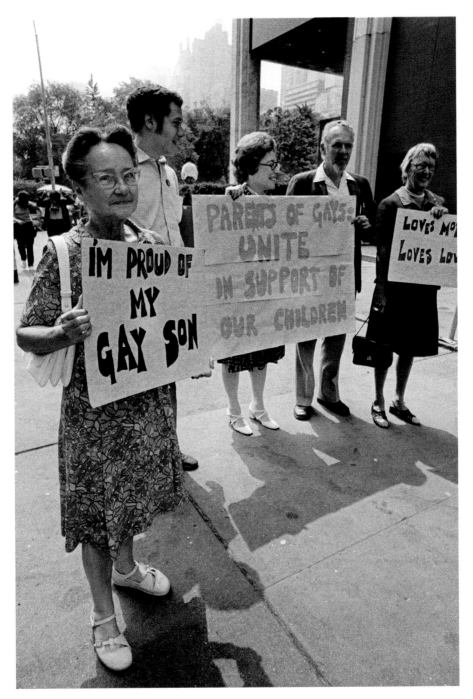

New York, June 24, 1973

Psychiatrists Review Stand on Homosexuals

By BOYCE RENSBERGER

A committee of the American Psychiatric Association yesterday began deliberating whether homosexuality should be considered a form of mental illness and whether it ought to be stricken from the association's official catalog of mental disorders.

Gay organizations have contended that psychiatry's continued recognition of homosexuality as a mental disorder lends support to efforts to discriminate against homosexuals in business and government.

In a closed meeting at Columbia University's Psychiatric Institute the association's eight-member Committee on Nomenclature, which recommends revisions in the catalog, heard members of the Gay Activists Alliance present the findings of nearly a score of medical studies showing that many homosexuals are as well adjusted mentally as most heterosexuals.

Although the "Diagnostic & Statistical Manual [of] Mental Disorders" still classifies homosexuality as a "sexual deviation" along with fetishism, sadism and masochism, a growing number of individual psychiatrists are voicing a contrary opinion.

One of the most prominent is Dr. Judd Marmor, vice president of the A.P.A. and professor of psychiatry at the University of Southern California.

"Homosexuality in itself," Dr. Marmor said, "merely represents a variant sexual preference which our society disapproves of but which does not constitute a mental illness."

Dr. Marmor, who is also president elect of the prestigious Group for the Advancement of Psychiatry, said he supports the movement to eliminate homosexuality as a diagnostic category.

'Term Misused'

A new edition of the manual is not due to be published until 1978. In the meantime the organization of homosexuals is seeking a statement from the A.P.A. disavowing the implications of the old classification.

Dr. Henry Brill, director of Pilgrim State Hospital and Chairman of the Nomenclature Committee, said after the meeting that his group hoped to draw up a statement in time to be considered by the A.P.A. at its annual meeting in May in Honolulu.

"There's no doubt this label [homosexuality] has been used in a discriminatory way," Dr. Brill said. "We were all agreed on that."

Dr. Brill said the committee also agreed that whether a person prefers to have sexual relations with a member of the same or of the opposite sex was, in itself, not an indicator of a mental disorder.

"This term has been misused by the public at large," Dr. Brill said. "The public assumes that all homosexuals are dangerous or sex fiends or untrustworthy or some other part of a stereotype. This, of course, isn't so. We know of many successful, well adjusted people in various professions who are homosexual."

Dr. Brill added, however, that some members of the committee felt that in some cases homosexuality was the central feature of a psychiatric problem.

"What are we going to do about the homosexual who comes to us and says he's miserable, that he doesn't like the homosexual way of life and that he wants to change?" Dr. Brill asked. "Very often these people have very clear psychiatric problems."

Statement to Be Drafted

Dr. Brill said the statement his committee expected to draft would express the points he summarized.

In its memorandum to the committee the Gay Activists Alliance contended that "the 'illness' model of homosexuality is unwarranted" and that, "on the contrary, there is a significant body of research data which supports the contention that a sizable number of homosexual persons are sufficiently well adjusted as to be indistinguishable from a control group of heterosexual peers."

Among the various excerpts from psychiatric reports supporting the homosexual position was one from Freud in which he responded to a question as to whether a homosexual candidate should be accepted for training as an analyst.

"We cannot," Freud wrote in a letter, "exclude such persons without other sufficient reasons, as we cannot agree with their legal prosecution. We feel that a decision in such cases should depend on a thorough examination of the other qualities of the candidate."

The delegation that presented the homosexuals' case before the committee comprised Charles Silverstein and Bernice Goodman, directors of the Institute for Human Identity; Ray Prada, a psychologist; Jean O'Leary, chairwoman of the Lesbian Liberation Committee of the Gay Activists Alliance and Ronald Gold, G.A.A. News and Media Relations chairman.

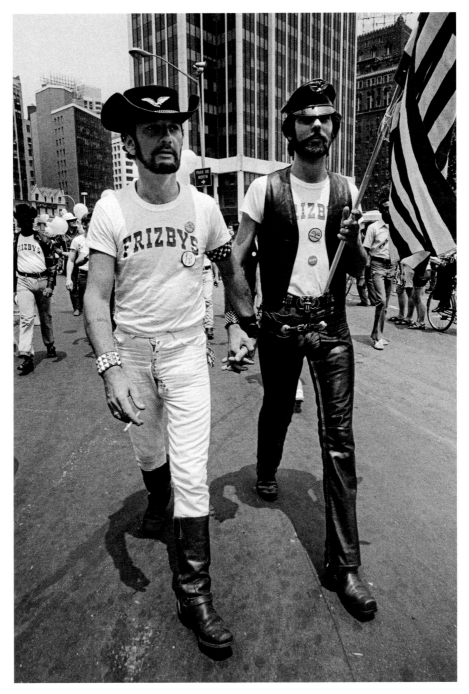

ABOVE & OPPOSITE New York, June 24, 1973

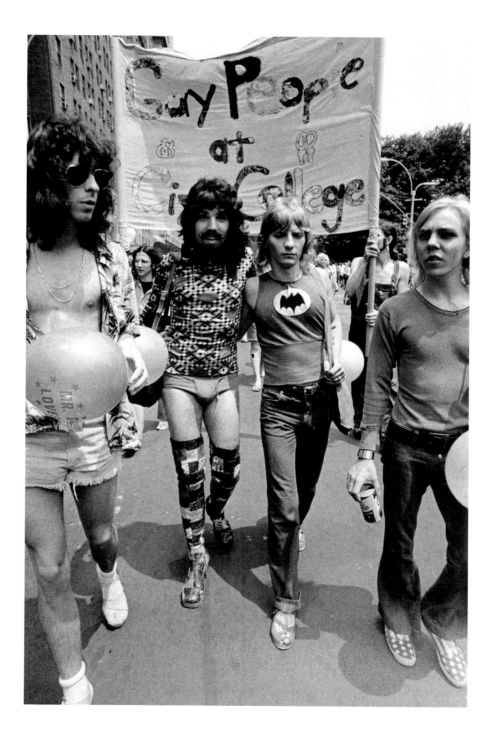

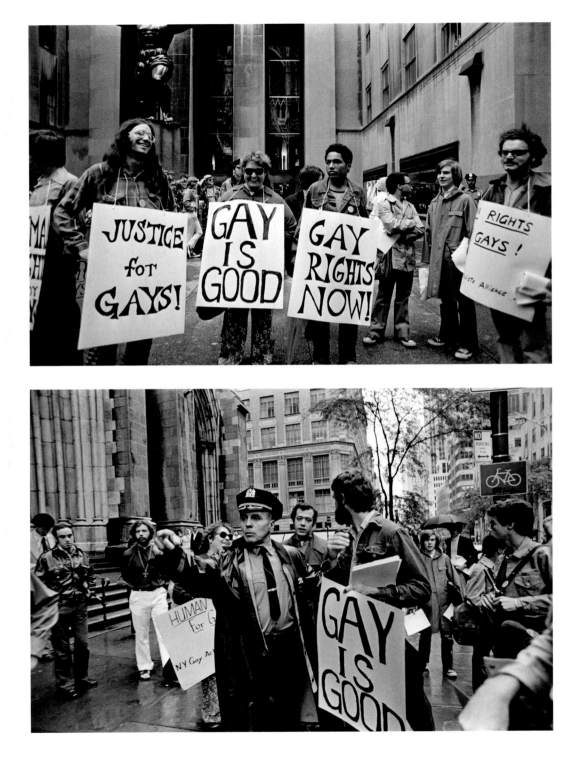

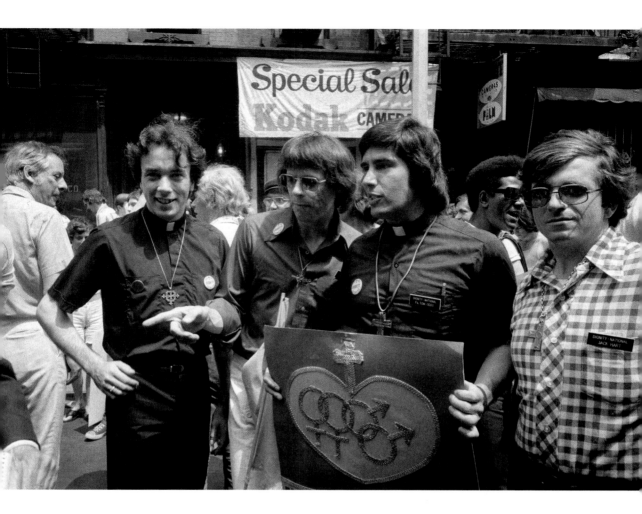

OPPOSITE
Members of the Gay Activists Alliance picketing across from St. Patrick's Cathedral,
New York, June 23, 1974

ABOVE
Reverend Tom Oddo, national secretary of Dignity, an organization of homosexual
Roman Catholics, holding one of the group's symbols, June 30, 1974

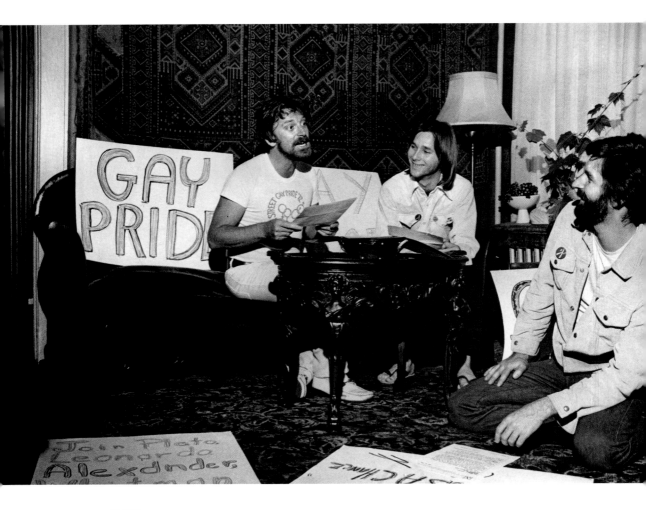

ABOVE
Leaders of the Gay Activists Alliance in New Jersey plan for a candlelight march in Hackensack, June 1974. Pictured from left to right are John Gish Jr., Bob Joli, and John Hanna.

OPPOSITE
New York, June 30, 1974

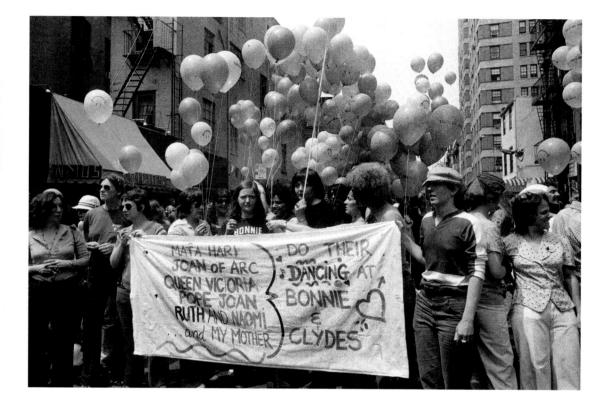

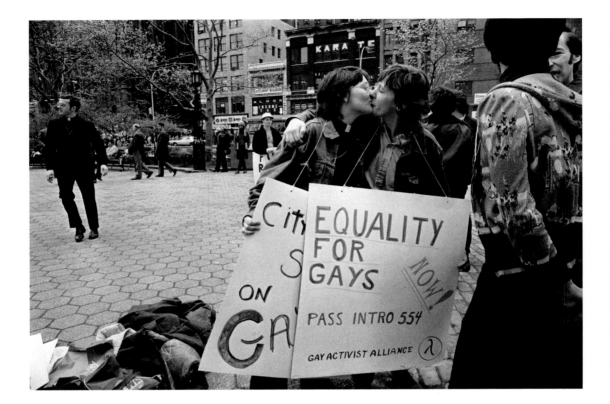

ABOVE
Supporters of a bill to provide protection to homosexuals in housing, employment, and other areas gather in front of New York's City Hall, May 5, 1975.

OPPOSITE
Outside New York's City Hall on May 23, 1974, where lesbians and women's liberation movement activists gathered in support of a gay rights bill before the City Council. Despite the actions, and after bitter debate, the bill was defeated. It would have guaranteed civil rights for homosexuals.

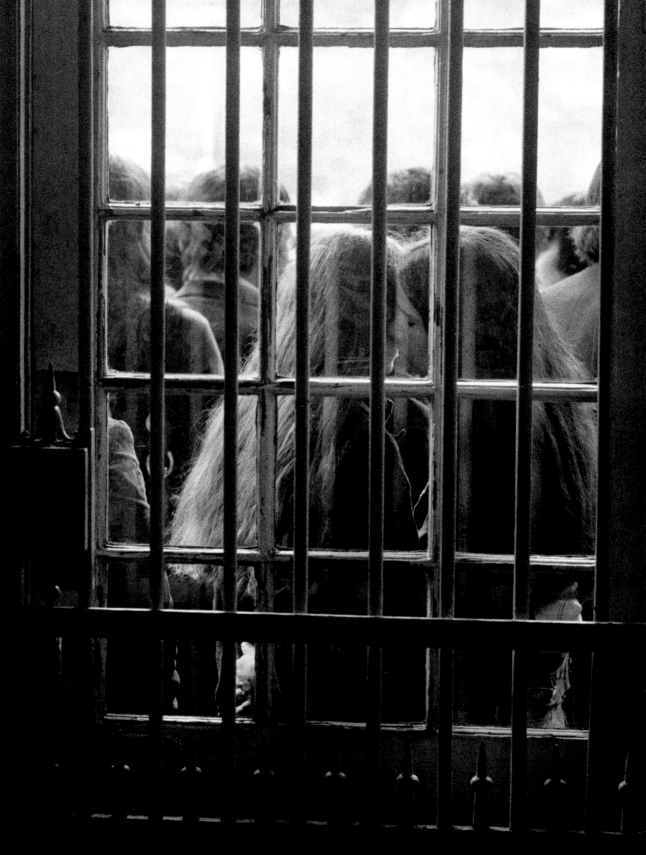

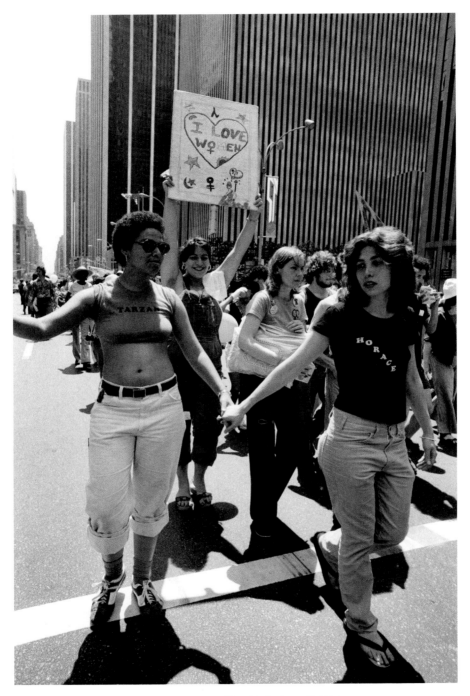

ABOVE & OPPOSITE New York, June 27, 1976

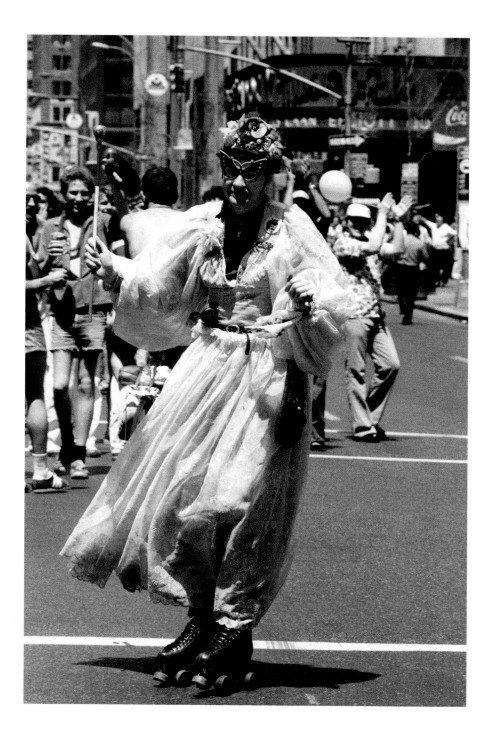

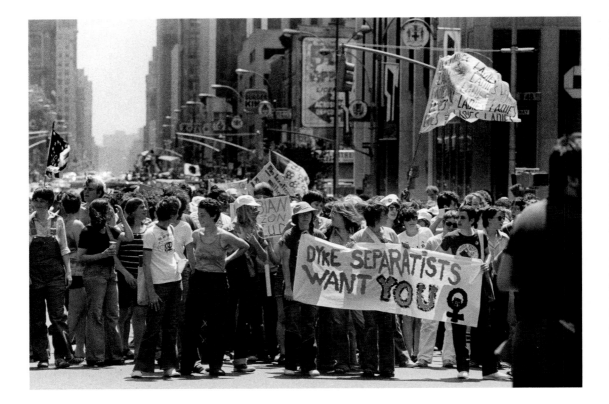

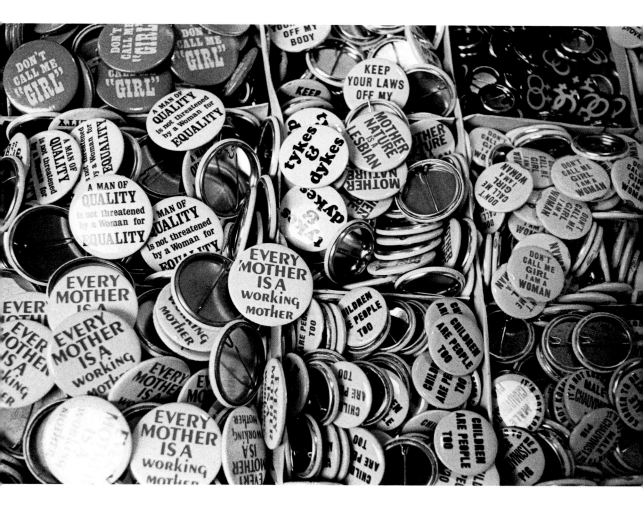

OPPOSITE
New York, June 27, 1976

ABOVE
Buttons on display at the fourth annual Conference of the Gay Academic Union held
at the Ferris-Booth Hall at Columbia University, New York, November 26, 1976

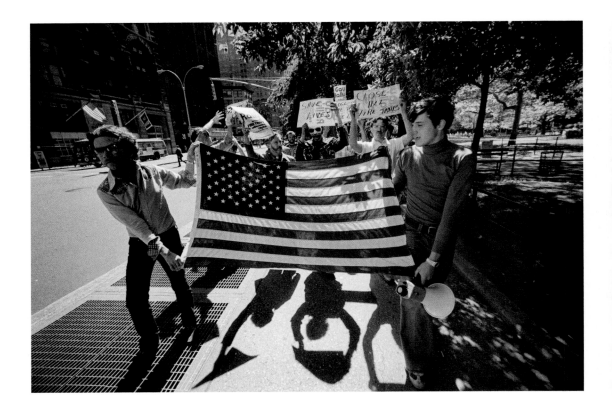

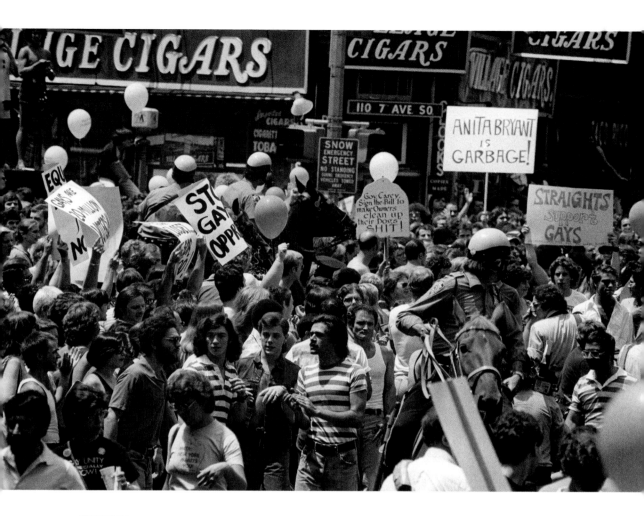

OPPOSITE
A demonstration at City Hall demanding the closing of fire traps in response to the
deadly fire at Everard Baths, one of the city's gay bathhouses, New York, May 31, 1977

ABOVE & FOLLOWING
New York, June 26, 1977

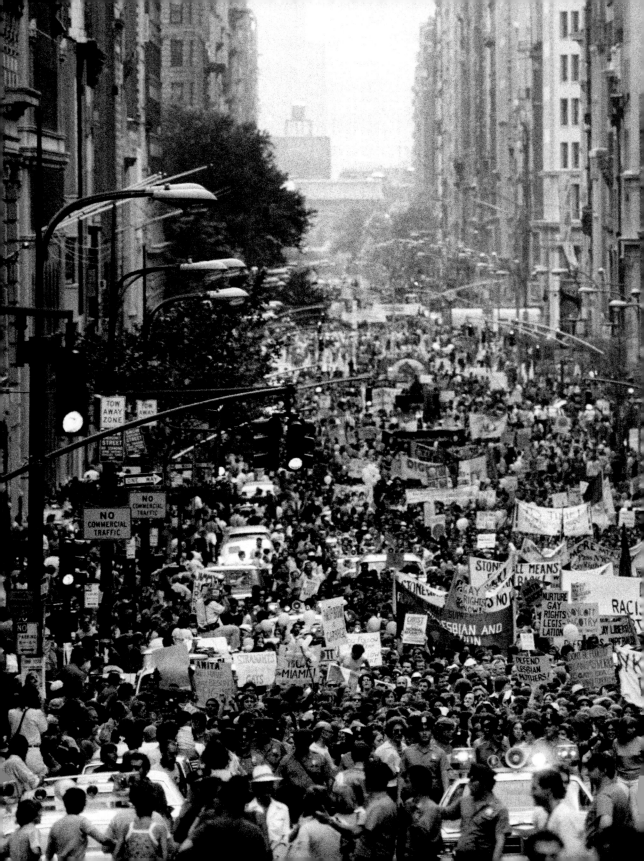

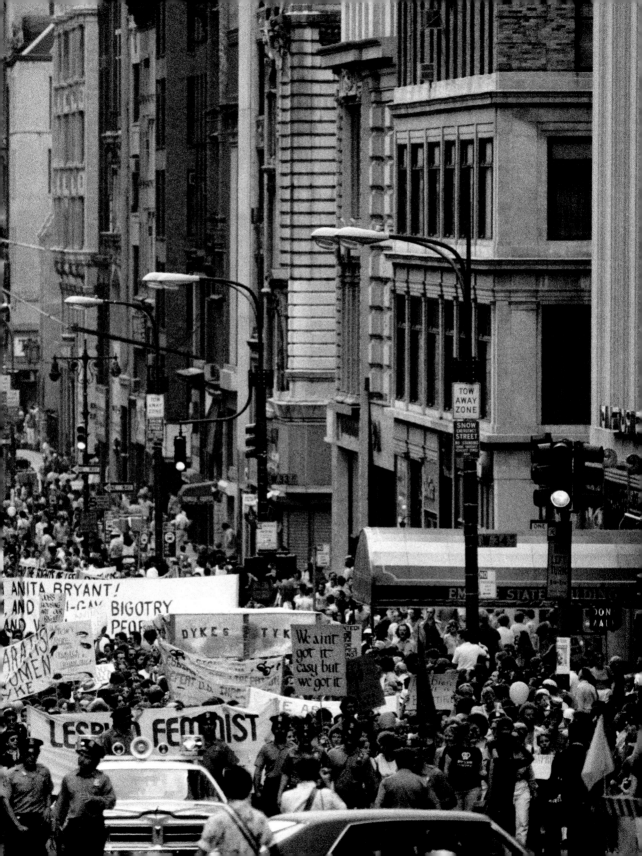

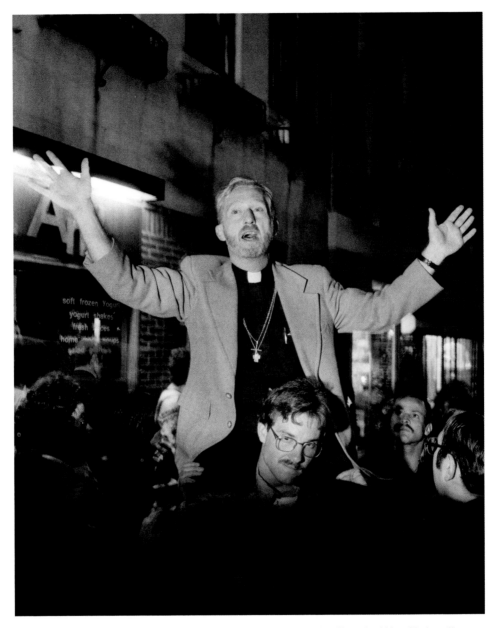

Reverend Gil Lincoln, pastor of the Metropolitan Community Church of New York, calls for a demonstration by members of the gay community for equal rights, June 8, 1977.

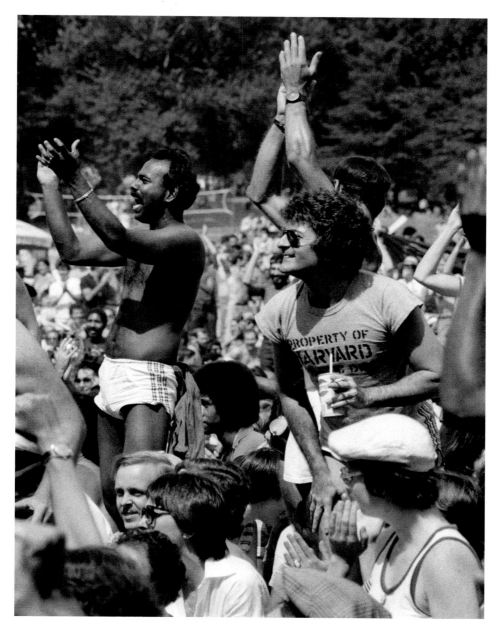

New York, June 25, 1978

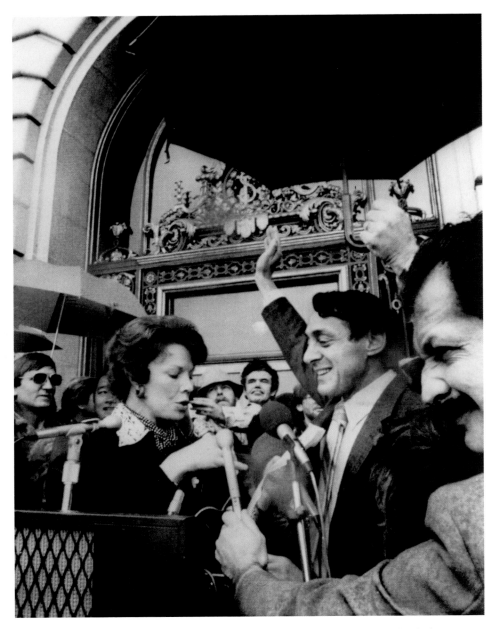

Harvey Milk (right) takes the oath of office from Judge Ollie Marie-Victoire during swearing-in ceremonies for the San Francisco Board of Supervisors, January 1, 1978.

Stunned Crowd Gathers Near Scene of 2 Slayings

By LACEY FOSBURGH
Special to The New York Times

SAN FRANCISCO, Nov. 27 — The day was clear and fresh, with just a touch of fall in the air. In the first moments after 11 A.M. here yesterday, there were mostly pigeons and sea gulls in attendance outside City Hall.

The Mayor's limousine was there. One policeman was on duty, as usual, directing traffic. But the broad park, with its massive fountains and manicured trees, surrounded on all sides by massive, stone government buildings, was almost empty. It was still too early for sandwiches or a lunchtime stroll.

Suddenly, inside City Hall, the sound of gunshots was heard. Some came from the Mayor's office, which overlooks the park from the second floor. Others came from the chambers of the city supervisor on the other side, across the broad, open lobby that occupies the entire center of the four-story building.

One body was found, then the other, and, as word spread, people began to flow out of the hundreds of little offices inside City Hall. On the street, first one, then two, then soon 25 police cars pulled up. And within minutes, there were as many as 1,000 people standing in almost total silence on the street at the edge of the park where before there had been virtually no one.

Pandemonium Inside the Hall

If it was quiet outside, inside City Hall there was pandemonium. In the enormous lobby downstairs, where thick columns reach up toward the upper floors, people were packed elbow to elbow, some trying to find out what had happened, some just trying to leave.

At the same time, the police had closed off all exits to the building, apparently thinking that the killer might still be on the premises. At the main door, only a trickle of people were permitted to leave. First they had to show the police their identification and leave their names and addresses.

At the top of the staircase outside the Board of Supervisors' room, Dianne Feinstein, the president of the board who was soon to be the Acting Mayor, emerged. She was shaking, clutching the collar of her camel-colored suit and made the formal announcement.

"It is my duty . . ." she began.

People began crying and shrieking. In a city still stunned by the bizarre events brought on by its own People's Temple last week, a new wave of reaction to death and the awful set in.

'What's Happening to Us?'

"This is terrible. What's happening to us?" said 22-year-old Heather Cogswell as she stood on the street. Beside her, two municipal workers were lowering all the flags in the park to half-staff.

"First it's the People's Temple crisis and then it's this."

"I feel frightened," her friend Holly Pierce said. "I feel frightened, as if something awful's going on all around me. There's no sense, there's mesmerization, irrationality, sickness, craziness and it's all at random."

The two women had been at work across the street at the public library when an official suddenly called out, "Library's closed."

"Why?" someone called out.

"The Mayor got shot," the official replied.

Darrell Dillon, an official with the United States Civil Service Commission, heard about the killing when a staff worker for Representative Philip Burton ran in from across the corridor with the news. Mr. Dillon then left for a walk.

"I had to," he said. "I had to come over and see what was happening here. You have to, I guess, to try to understand. I just feel bewildered. First it's one thing, then another. I don't understand."

Richard Flatto operates a delivery truck and he was part of the crowd that stood silently and almost as if on duty outside City Hall.

"I can't believe it," he said in a whisper. "It's too strange."

"But you know," he added, "in light of what happened at the People's Temple, something like this is almost banal by comparison."

A Vase of Chrysanthemums

In front of him, on the broad steps, was a large green vase holding a dozen yellow chrysanthemums. It had been delivered by several homosexual men who said it was in honor of Supervisor Harvey Milk, a leader of the homosexual community here and one of the victims. And now the vase stood there, separated from the crowd by about 10 feet, with people staring at it.

By now, City Hall was almost empty except for a small number of people still at work, literally hundreds of police officers and members of the press and a number of city officials. Ordinarily, security inside the building is lax and the guards on duty often allow people to pass without searching their bags or even making them walk through the metal detector.

Now, however, everyone was searched thoroughly.

Upstairs on the second floor, the police, carrying heavy metal equipment boxes, streamed in and out of the two offices where the killings had occurred. Mrs. Feinstein went back and forth, and even Gina Moscone, the wife of the slain Mayor, was brought in briefly by the police and local politicians, who included Assemblyman Willie Brown and Supervisor John Molinari. Both men stopped to talk about how stunned and grieved they were.

Guards at All Offices

There were guards on duty outside all the offices and by 1 o'clock, the special extra edition of The San Francisco Examiner had arrived. People everywhere, both inside and out, were carrying it. It had two broad black headlines, with the words "Extra. Extra. Extra." and "Mayor, Milk, Slain."

The afternoon began to get under way. People arrived at the second floor carrying cartons of sandwiches and soft drinks for the police and city officials who were closeted away inside, out of sight. And down on the street the crowd remained.

They stood with transistor radios and newspapers, men, women and even children. By late in the afternoon, the empty circle of space around the green vase had grown even larger. In the center there was no longer just one stand of yellow flowers. There were bunches of red roses and yellow roses, a single daisy, a copy of The Examiner, a pot of ivy, and a straggly bunch of plucked grass.

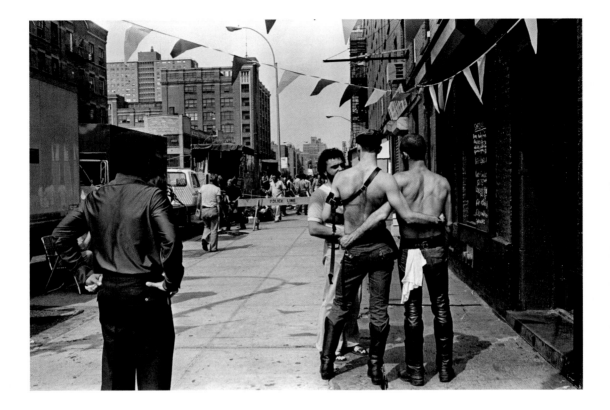

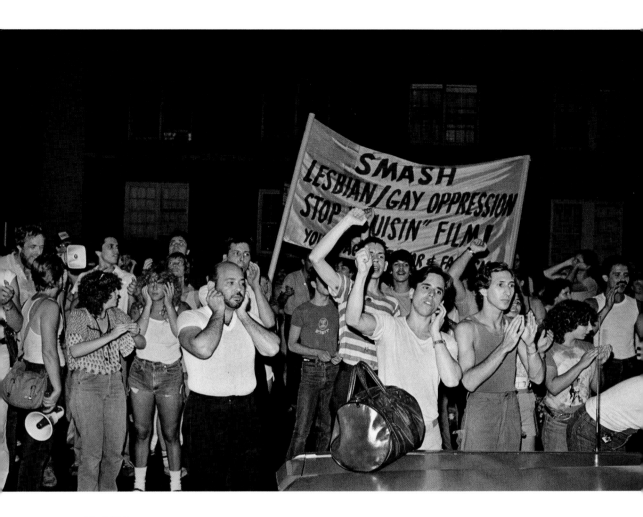

OPPOSITE
Cast members on set of the movie *Cruising*, New York, July 25, 1979

ABOVE
Gay and lesbian organizations demonstrate in Greenwich Village against the filming of *Cruising*. Protestors chant and blow whistles in front of Mayor Ed Koch's apartment, August 1, 1979.

FOLLOWING
National March on Washington for Lesbian and Gay Rights, October 14, 1979

75,000 March in Capital in Drive To Support Homosexual Rights

By JO THOMAS
Special to The New York Times

WASHINGTON, Oct. 14 — An enthusiastic crowd of at least 75,000 people from around the country paraded through the capital today in a homosexual rights march and gathered afterward on the grounds of the Washington Monument to marvel at their own numbers and to urge passage of legislation to protect the rights of homosexuals.

"Almost 30 years ago I thought I was the only gay person in the world," said the keynote speaker, Betty Santoro, of New York, as she looked out over a sea of banners that proclaimed "Alaska," "Wyoming," "Gay Mormons United."

"There are still gay people who feel alone and isolated," she said. "We are here today because we refuse, we refuse to allow this kind of suffering to continue. Our message is today they need not be alone, not ever again. Our very presence here is living proof we are, indeed, everywhere."

Most of the marchers were young, although all age groups were represented. Most were white, and it appeared that men slightly outnumbered women. Many of the marchers were parents and there much talk about family.

'Sharing' and 'Flaunting'

"When a heterosexual person shows a picture of his family, it's called sharing," Robin Tyler, a lesbian feminist comedian told the crowd. "When we show a picture of our lover, it's called flaunting. We want to share."

"We are family," said Howard Wallace, a homosexual activist and candidate for city office in San Francisco. "A new day is coming. It will come so much sooner if we cast out the great authoritarian father figures housed in our minds; if we shed our self-hatred and shame; if we stop assuming that the President, the governor, the mayor, the official, knows better than we."

Estimates of the number of people in the crowd varied. The United States Park Police first put the number at 75,000 but later said between 25,000 and 50,000 showed up. Eric Rofes, an organizer of the march, said he thought there were "more than 100,000."

Speaker after speaker cited an estimate that there were 20 million homosexuals in the United States, a sizable minority group.

The demonstrators and speakers called for legislation to amend the Civil Rights Act of 1964 to protect homosexuals against discrimination. They also have urged that President Carter sign an executive order banning discrimination in the military, civil service and among Government contractors.

While the demonstration was under way, a coalition of ministers met on Capitol Hill to organize a National Day of Prayer on Homosexuality to ask God "to deliver them from their lives of perversion," a spokesman for the group said.

The Rev. Richard Zone, executive director of the religious group, Christian Voice, said that the coalition had asked 40,000 ministers to urge their congregations to petition the President to resist efforts to give homosexuals special consideration under the law.

"God didn't create Adam and Steve, but Adam and Eve," said the Rev. Jerry Falwell, a television evangelist from Lynchburg, Va. He called homosexuality "an outright assault on the family."

October 15, 1979

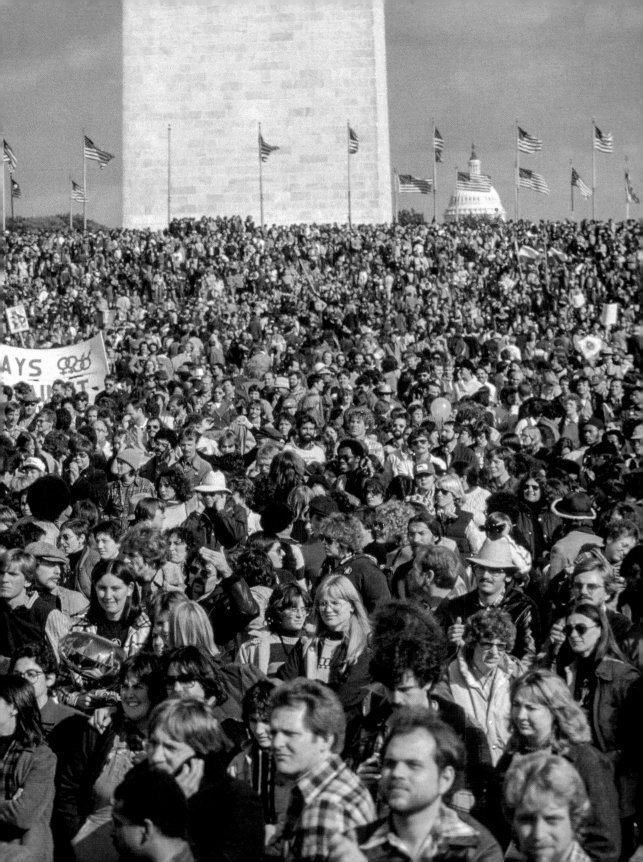

'If We Gay Men and Lesbians' Stand Up

Navy Plans to Discharge 8 Accused As Lesbians

Homosexual Activists March on Fifth Avenue

Bill on Homosexual Rights Sparks Emotional Debates

A Panel Kills Bill That Aids Homosexuals

Rights for Homosexuals Denounced by Preachers

Former Transit Officer Held As Slayer of Two in Village

Council Members Vote 6-3 Against Measure

Homosexual Wins Suit on Date for Senior Prom

New Homosexual Disorder Worries Health Officials

Some of the infectious agents are entirely new to expert doctors

AIDS Spreads Pain and Fear Among Ill and Healthy Alike

'I've seen some people die in utter loneliness,' abandoned by friends.

Nursing Home Plans to Admit Victim of AIDS

'The Enormous Horror Of All This Hit Me'

Health Chief Calls AIDS Battle 'No. 1 Priority'

Homosexuals Confront 200 at Stanford Assail Attack
A Changing Way of Life On 'Gay Liberation' Artwork

Throughout the Country, Homosexuals Increasingly Flex Political Muscle

A Protest Erupts Outside Hearing On an AIDS Bil.

Homosexuals Call for Assurances On Confidentiality of AIDS Tests

Vatican Reproaches Homosexuals With a Pointed Allusion to AIDS

Screening of Blood for AIDS Raises Civil Liberties Issues

Homosexual Couples Find a Quiet Pride

Fear Is Prompting Bias Homosexuals Charge

Liberals Split as Homosexual Seeks Council Seat in Manhattan

Tens of Thousands March in 16th Annual Parade by Homosexuals

13th Street Group Assists Elderly Homosexuals

Groups to Sue Over State Rules on 'High Risk' Sex

AIDS PANEL'S CHIEF URGES BAN ON BIAS AGAINST INFECTED

AIDS Said to Increase Bias Against Homosexuals

Gay Rights Law Firm Sues Over AIDS Drugs

Homosexual Rights Bill Is Passed By City Council in 21-to-14 Vote

Treating AIDS Deaths With Dignity

To Neighbors of Shunned Family, AIDS Fear Outweighs Sympathy

SHARP CLASH WITH POLIC

Measure, Approved by Unexpectedly Big Margin, Blocks Discrimination in Housing and Jobs

U.S. APPROVES DRUG TO PROLONG LIVES OF AIDS PATIENTS

Violence Against Homosexuals Rising, Groups Seeking Wider Protection Say

Homosexual Parade Is Held 'In Face of Death' With AIDS

Hundreds Protest Supreme Court Sodomy Ruling

Lesbian Partners Find The Means to Be Parents

AIDS Fear Spawns Ethics Debate As Some Doctors Withhold Care

CURE STILL NOT ACHIEVED

200,000 March in Capital to Seek Gay Rights and Money for AIDS

2 Men Beaten By 6 Youths Yelling 'Fags'

AIDS Insurance Coverage Is Increasingly Hard to Get

Distribution Will Be Limited Because of Short Supply and Fear of Side Effect

Study Finds Most Health Insurers Screen Applicants for AIDS Virus

Lesbian Struggles to Serve in Army

Queens Judge Bars City Plan For Sheltering AIDS Victims

Amid AIDS, Gay Movement Grows but Shifts

RIGHTS BILL ON AIDS IS TO BE OPPOSED BY ADMINISTRATION

Greater Acceptance of Homosexuals Is Only a Pleasant Myth

Small Steps Toward Acceptance Renew Debate on Gay Marriage

San Francisco Votes Legislation Recognizing Unmarried Partners

U.S. Announces Grants for Trials of AIDS Drugs

Top Aide Says Responsibility to Prevent Discrimination Lies With the States

Homosexuals See 2 Decades Of Gains, but Fear Setbacks

New York Court Defines Family To Include Homosexual Couples

111 Held in St. Patrick's AIDS Protest

Decision Applies to Regulations for Rent Contro.

GAY SOLDIER WINS SUIT AGAINST ARMY

In the cathedral, a scream: 'We will not be silent.'

Attacks on U.S. Homosexuals Held Alarmingly Widespread

For AIDS Inmates, Prison in a Prison

Death and the Next Struggle: to Survive Gay Life

1980s

The 1980s will always be remembered as the decade that "should have been." More than ten years post-Stonewall, the Reagan era—which celebrated both conspicuous consumption and old-fashioned conventionality—might have been expected to allow for more high-profile LGBTQ cultural figures, a new wave of elected officials, larger protests and marches, and further integration into their families, schools, and religious communities.

Instead, the decade will be forever marked by the arrival of AIDS (Acquired Immunodeficiency Syndrome), cases of which were first reported in medical journals in young—and seemingly healthy—gay men in New York and California in the summer of 1981. Just over a year later, the Centers for Disease Control used the term "AIDS" for the first time and issued clear definitions for the disease's diagnosis. Chaos and confusion surrounded AIDS, fueled by uncertainty over its transmission and homophobia aimed at gay men, who had the majority of its early reported cases. By the time actor Rock Hudson died of AIDS in 1985, the disease was intrinsically linked with homosexuality—helping to erode decades of hard-won progress. A similar sentiment rang through the NAMES Project AIDS Memorial Quilt, a massive piece of community folk art that was created to celebrate the lives of people who died from the AIDS virus. Unfurled in public spaces nationwide, the quilt ultimately weighed in at fifty-four tons, the largest of its kind in history.

By 1987, more than 16,000 Americans had died of AIDS, with no cure or effective treatment in sight (though a test for exposure was approved for use in 1985). Education and activism, however, emerged as potent tools in the battle against the virus: In 1988, the federal government sent the brochure *Understanding AIDS* to every household in America. Its focus on sexual behavior rather than sexual identity was aimed at upending existing assumptions that only LGBTQs were susceptible to the disease.

Understanding AIDS arrived a year after the establishment of the group ACT UP (Aids Coalition to Unleash Power), launched primarily by LGBTQs fed up and furious with governmental inaction regarding the disease (President Reagan infamously failed to even utter the word "AIDS" until 1986). ACT UP members embarked on a series of guerilla-style protests. Fueled by anger—and its members' own HIV diagnoses—ACT UP even took over the Food and Drug Administration for a day in 1988 to demand faster approval of potentially life-saving medications (a demand that was ultimately successful).

With nearly 700,000 Americans living with HIV by 1989, groups like ACT UP helped shift the focus of the AIDS discussion from fear to treatment. ACT UP also offered its mostly LGBTQ membership the chance to forge an identity anchored in activism rather than illness at a time when HIV was still steeped in the specter of death for most of America. Perhaps most hearteningly, ACT UP's lack of formal hierarchy and consensus-driven power structure also provided for a level of coalition-building between gay men and lesbians rarely seen—or repeated.

Despite the shadow of AIDS, gay culture and politics continued to evolve in important and nuanced ways. In 1982, the first International Gay Games were held in San Francisco, bringing together 1,300 people to celebrate global athletic excellence. The same year, Wisconsin became the nation's first state to ban discrimination for sexual orientation. And then there was pop music—bands like Culture Club, Soft Sell, Bronski Beat, the Pet Shop Boys, and Frankie Goes to Hollywood cultivated a visible queer aesthetic. It was a sexual revolution that shocked music lovers worldwide and provided one of the few creative avenues for the community during this deeply dark era.

New York, June 26, 1983

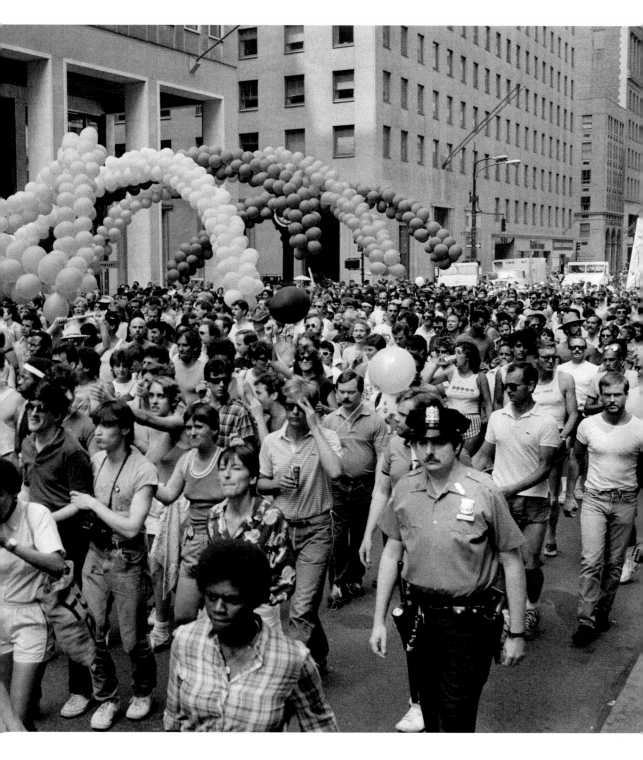

Homosexual Disorder Worries Health Officials

By LAWRENCE K. ALTMAN

A SERIOUS disorder of the immune system that has been known to doctors for less than a year — a disorder that appears to affect primarily male homosexuals — has now afflicted at least 335 people, of whom it has killed 136, officials of the Centers for Disease Control in Atlanta said yesterday. Federal health officials are concerned that tens of thousands more homosexual men may be silently affected and therefore vulnerable to potentially grave ailments.

Moreover, this immune-system breakdown, which has been implicated in a rare type of cancer, called Kaposi's sarcoma, and seems to invite in its wake a wide variety of serious infections and other disorders, has developed among some heterosexual women and bisexual and heterosexual men.

At a recent Congressional hearing, Dr. Bruce A. Chabner of the National Cancer Institute said that the growing problem was now "of concern to all Americans."

The cause of the disorder is unknown. Researchers call it A.I.D., for acquired immuno-deficiency disease, or GRID, for gay-related immunodeficiency. It has been reported in 20 states and seven countries. But the overwhelming majority of cases have been in New York City (158), elsewhere in New York State (10), New Jersey (14) and California (71).

Thirteen of those affected have been heterosexual women. Some male victims are believed to have been heterosexual, and to have been chiefly users of heroin and other drugs by injection into their veins. But most cases have occurred among homosexual men, in particular those who have had numerous sexual partners, often anonymous partners whose identity remains unknown.

According to both the Centers for Disease Control and the National Cancer Institute in Bethesda, Md., GRID has reached epidemic proportions and the current totals probably represent "just the tip of the iceberg." Preliminary results of immunological tests have led some Federal health officials to fear that tens of thousands of homosexual men may have the acquired immune dysfunction and be at risk for developing complications such as Kaposi's cancer, infections and other disorders at some future date.

GRID is "a matter of urgent public health and scientific importance," Dr. James W. Curran, a Federal epidemiologist who coordinates the Centers for Disease Control's task force on Kaposi's sarcoma and opportunistic infections, told the Congressional hearing. Opportunistic infections are those that rarely cause illness except in those whose immunological resistance has been lowered by drugs or disease.

More than human suffering is involved. Hospital costs have reached more than $64,000 per patient, and Dr. Curran said that if such costs are typical, "the first 300 cases account for an estimated $18 million in hospital expenses alone."

Experts currently think of GRID as a sort of immunological time bomb. Once it develops, it may stay silent for an unknown period, and then, at a later date, go on to produce Kaposi's sarcoma, an opportunistic infection, a so-called auto-immune disorder, or any combination of these.

Further, no one is certain that the immune disorder can be reversed. Many patients have survived a bout of pneumonia or other illness, only to succumb to another or to go on to develop Kaposi's sarcoma or some other fatal cancer.

'Natural' Immunity Suppressor

GRID resembles the failures of the immunological system that complicate the treatment of many chronic disorders with steroid and other drugs that suppress the immune system. The same problem occurs among recipients of transplanted kidneys and other organs who take the immunosuppressive drugs to help prevent rejection of the organ. With immunity suppressed, the body becomes vulnerable to a variety of problems, chiefly infections by organisms that otherwise rarely cause disease.

GRID, however, is the first naturally occurring outbreak of immune suppression to affect a community of free-living people, in contrast, for example, to an epidemic in a hospital. The degree of immunological suppres-

Some of the infectious agents are entirely new to expert doctors

sion is extraordinary, far greater than usually observed in patients treated with immunosuppressive drugs, according to articles in medical journals and interviews with experts.

Those experts are now reporting finding a wider range of disorders than were associated with GRID when it first came to public attention last summer. These include eye damage, lupus, I.T.P. (idiopathic thrombocytopenic purpura), certain types of anemia, and other cancers, including Burkitt's lymphoma and cancers of the tongue and anus.

Doctors are also seeing many cases of a generalized lymph gland swelling throughout the body, together with weight loss, fever and thrush, a fungal infection often found in the mouth and throat.

So far, epidemiologists have found no evidence that the condition is spread from person to person like influenza or measles. Therefore, they say, the general public need not fear an epidemic.

Many Causes Are Likely

Rather, Dr. Arthur S. Levine of the National Cancer Institute said, development of the syndrome seems to result from an accumulation of risk factors. Most experts say that if there is an infectious cause, it is not a single organism, but an organism acting together with another factor or factors, perhaps a drug.

Epidemiologists from the Centers for Disease Control have done studies among homosexual men with and without the immune disorder but matched in age, background and other characteristics. After testing for more than 130 potential risk factors, they found that the median number of lifetime male sexual partners for affected homosexual men was 1,160, compared to 524 for male homosexual men who did not have the syndrome. The study also found more use of sexual stimulants and illicit drugs among the GRID patients.

As further evidence against simple contagious spread, epidemiologists note that the syndrome has not spread to other family members, hospital workers or researchers on the disease.

Kaposi's sarcoma was first described in 1872 in Rumania. Until recently, it was rare in the United States, occurring chiefly in older people, usually of Italian or Jewish ancestry, and among patients receiving immunosuppressive therapy. It affected men much more commonly than women by about 15 to one. It usually developed slowly.

In recent decades, however, Kaposi's sarcoma has been found common in Africa, mainly among young people. In equatorial Africa, it accounts for 9 percent of all cancers, and in some areas it is 100 times more prevalent than in the United States. The cancer has not been linked to homosexuals in Africa, and the reasons for its high frequency there are unknown.

In its new form in this country, the course of Kaposi's sarcoma generally has been rapid and fatal. Only about 15 percent of patients treated with a combination of anticancer drugs experience any remission, as compared to the 90 percent complete response in Africa, according to Dr. Levine.

However, it is not just the cancer that is killing GRID patients. Many such patients develop infections with an often fatal parasitic illness called Pneumocystis carinii. Hitherto, that disease has been seen mainly as a complication of treatment of patients with leukemia and other cancers because their immune systems were depressed by chemotherapy.

Others succumb to cytomegalovirus infection or to a fungal infection called toxoplasmosis. By using sophisticated molecular biology tests in which the genetic messages of the various strains can be compared, scientists have found no evidence that the epidemic is due to a deadly new mutant strain.

But the list of infections diagnosed among GRID patients is long, and some of the organisms are so unusual that even the most experienced infectious disease experts have not treated a case in the past. The newest is cryptosporidiosis, a parasitic infection much more familiar to veterinarians than to physicians because it infects deer and other mammals.

Why Now and Not Before?

Given the fact that homosexuality is not new, the most puzzling question is why the outbreak is occurring now, and not sometime in the past.

Scientific investigations are wide ranging, although most are focused on viruses, other organisms, drugs, or a combination of such factors.

Because homosexuals affected by GRID have reported using nitrite drugs more frequently than homosexuals who have not, some studies have focused on this class of drugs, which have come into widespread street use since the 1960's.

But although epidemiological studies have not "totally exonerated nitrites, the scientific evidence to implicate them is quite shaky," according to Dr. Curran.

Some experts theorize that the immunological disorder may be triggered by the introduction of sperm or seminal fluid into the blood through sexual contact, though infection and drug reaction are still also candidates.

In studies on mice at the National Cancer Institute, Dr. Ursula Hurtenbach and Dr. Gene M. Shearer have reported that a single injection of mouse sperm into the veins of male mice produced a profound and long-lasting suppression of certain immune functions.

Dr. Lawrence D. Mass, a New York City physician, said that "gay people whose life style consists of anonymous sexual encounters are going to have to do some serious rethinking."

The urgent need to discover the cause of the immune system disorder and to prevent the problems it creates has been underscored by Dr. Linda Laubenstein of New York University Medical Center. Dr. Laubenstein, who said she has treated 62 such patients in the last year and who is a leading investigator of the syndrome, summarized it by saying: "This problem certainly is not going away."

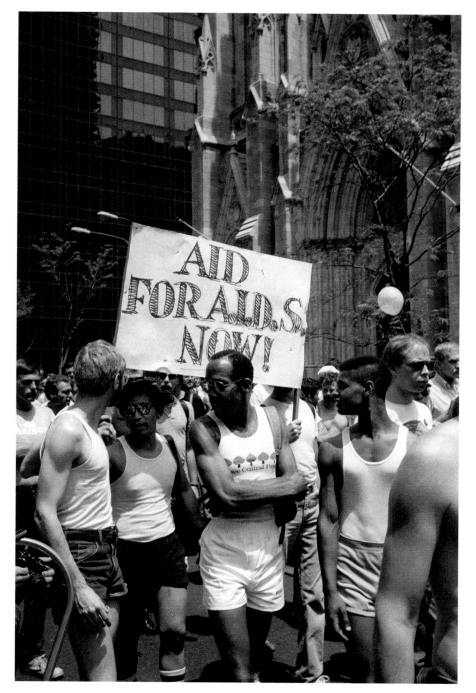

New York, June 26, 1983

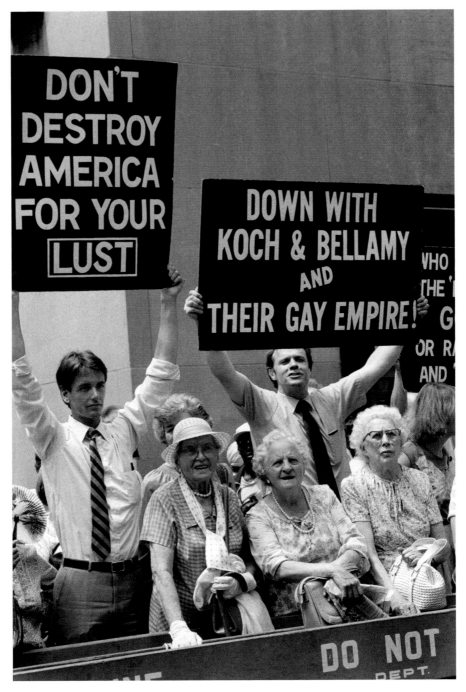

Demonstrators near St. Patrick's Cathedral, New York, June 26, 1983

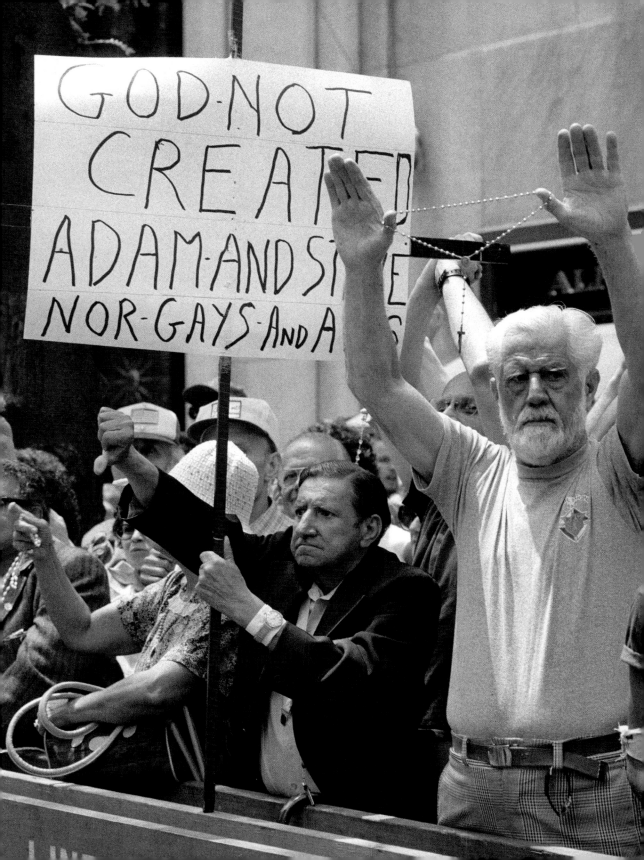

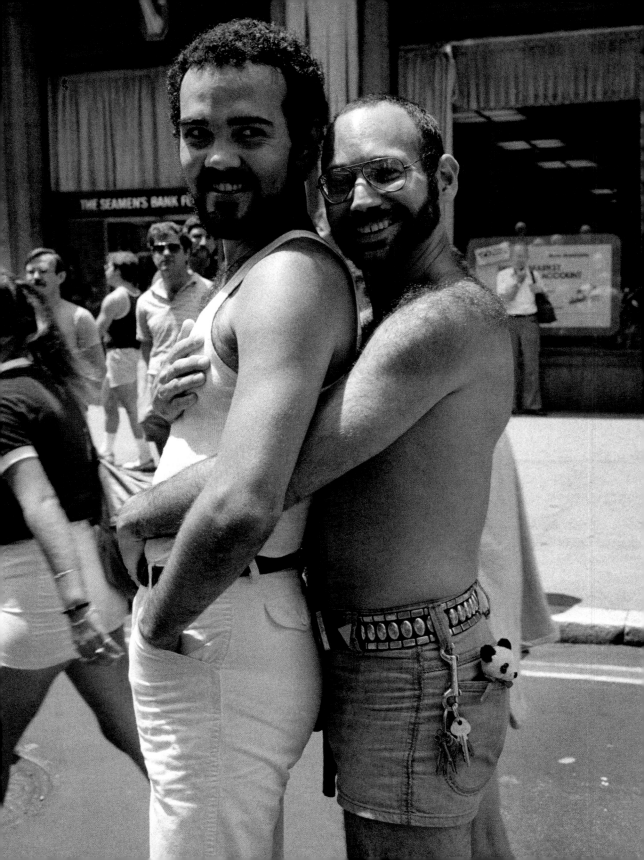

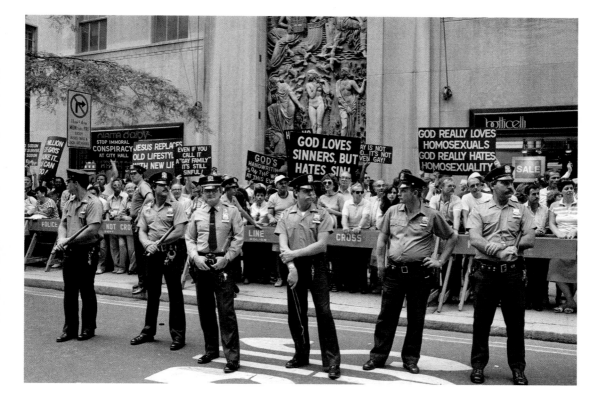

OPPOSITE & ABOVE
New York, June 26, 1983

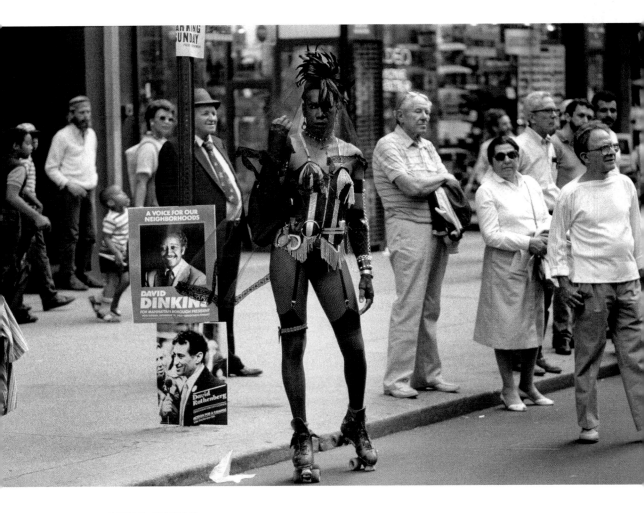

ABOVE & OPPOSITE
New York, June 30, 1985

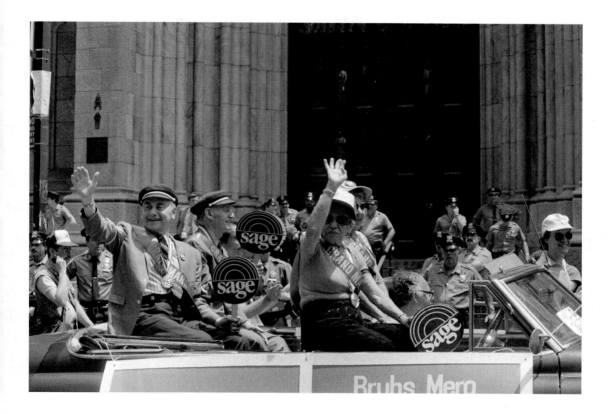

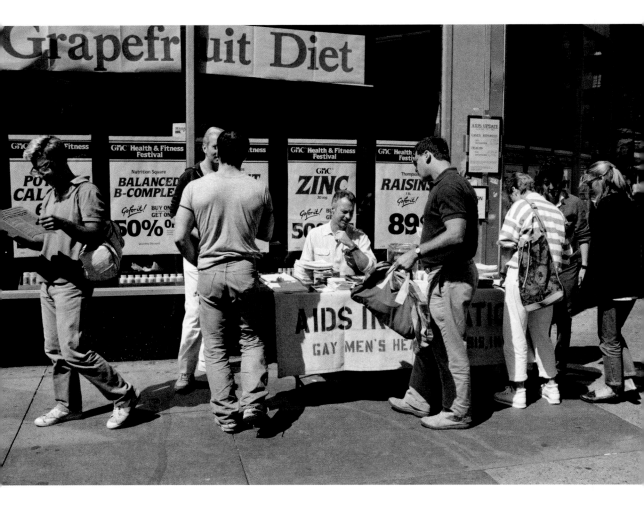

The Gay Men's Health Crisis information table outside a health food store on Sheridan Square, New York, September 14, 1985

Rock Hudson, Screen Idol, Dies at 59

By JOSEPH BERGER

Rock Hudson, the actor whose handsome looks and flair for comedy made him a romantic idol of the 1950's and 60's, died yesterday at his home in Los Angeles. He was 59 years old and had been suffering for more than a year from AIDS.

Mr. Hudson, whose search for medical treatment in recent months focused worldwide attention on the incurable disease, died peacefully at 9 A.M. in his sleep, according to his spokesman in Los Angeles, Dale Olson.

The actor was the first major public figure to acknowledge openly that he was suffering from acquired immune deficiency syndrome, a mysterious and usually fatal illness that primarily afflicts male homosexuals, intravenous drug users, and recipients of contaminated blood transfusions.

Mr. Hudson was in Paris in July and collapsed at the Ritz Hotel. He was taken to the American Hospital in Neuilly, a Paris suburb, where it was first said that he had liver cancer. Reports circulated, however, that he had AIDS and had gone to Paris for treatment, and a few days later, a spokesman confirmed them.

Acquaintances often described Mr. Hudson as being homosexual but the actor never publicly commented or acknowledged the reports.

An Outpouring of Concern

Mr. Hudson was flown back from Paris at the end of July to Los Angeles, where his acknowledgement of his illness prompted an outpouring of concern for him and for other victims of the disease.

For more than a decade, the name Rock Hudson was synonymous with masculine good looks. Blessed with a broad-shouldered, 6-foot-4 physique, dark, brooding eyes and a sonorous voice, Mr. Hudson was an enormously popular screen presence. In a career that included 62 movies, he twice was voted the nation's top box-office draw.

Yet he did not begin to win broad respect for his skills as an actor until he played an imperious Texas rancher in "Giant" (1956), a role that earned him an Academy Award nomination, and a series of romantic comedies in which he was paired with Doris Day.

In the first of those comedies, "Pillow Talk" (1959), Mr. Hudson began to poke fun at the hysteria his looks provoked. The catalyst for the plot is a telephone party line where Miss Day overhears Mr. Hudson pitching the same corny lines to a variety of cooing girls.

Critics voiced pleasant surprise at his deft performance. Then after "Lover Come Back" (1962), which featured Mr. Hudson as a rake who disguises his identity to trick Miss Day, and "Send Me No Flowers" (1964), where he plays a hypochondriac convinced he is dying, the critics deepened their respect for his comedic talent.

More recently, Mr. Hudson starred on television in two series, "McMillan & Wife" and "The Devlin Connection," and he had a recurring role on "Dynasty." The production of "The Devlin Connection" was interrupted in 1981 when Mr. Hudson underwent heart surgery and five heart bypasses.

Reportedly Reclusive as a Boy

Rock Hudson was named Roy Scherer Jr. when he was born in Winnetka, Ill., on Nov. 17, 1925. During the Depression, his father lost his job as an automobile mechanic and left the family. His mother, a telephone operator, remarried, and the actor, then 8 years old, took the surname of his stepfather, Wallace Fitzgerald. His mother's second marriage ended after nine years.

The reportedly rather reclusive boy took odd jobs to help support the family and tried out for school plays, but could not hold parts because he could not remember lines. That failing dogged him in his early years in Hollywood, where he took 38 repetitions to say correctly the line: "Pretty soon you're going to have to get a bigger blackboard."

In 1944, he joined the Navy and served in the Philippines as an airplane mechanic. After his discharge in 1946, he worked as a piano mover, then moved to Los Angeles to live with his father, who had remarried.

After doing poorly as a vacuum cleaner salesman in his father's appliance store, he took a job as a truck driver. Desirous of lining up work as an actor, he bought a tan gabardine suit and started parking his truck outside a film studio's gates, waiting to be discovered.

Name Changed by Agent

Henry Willson, a talent scout for Selznik Studio, liked photographs the actor had sent him and took him under his wing in 1947. One of the first things he did was change the actor's name from Roy Fitzgerald to Rock Hudson. Years later, the actor confided to an interviewer that he hated the name.

The director Raoul Walsh put Mr. Hudson under contract and gave him acting lessons, but a year later sold Mr. Hudson's contract to Universal-International Pictures. The studio paid Mr. Hudson $125 a week and gave him small roles in 28 pictures.

His career did not really take off until the film "Magnificent Obsession" (1954), where he appeared opposite Jane Wyman as a playboy who causes Miss Wyman's blindness and then becomes a surgeon to cure her.

That role was followed by a few lackluster films, but "Giant," the story of how the growth of oil in Texas unhinged the feudalistic culture of the ranch barons, catapulted him into the ranks of the top stars. The 3-hour-17-minute film, based on a novel by Edna Ferber, was directed by George Stevens and also starred Elizabeth Taylor and James Dean.

Other Films Cited

To take advantage of Mr. Hudson's popularity, the studio released an earlier film called "Something of Value" (1957), in which Mr. Hudson played a white settler in a Kenya torn by the Mau Mau uprisings. He went on to play Lieut. Frederick Henry in "A Farewell to Arms" (1958), based on Ernest Hemingway's novel of World War I.

His other films included "Written on the Wind" (1956), "Twilight for the Gods" (1959), "Come September" (1961), "The Spiral Road" (1962) "Ice Station Zebra" (1968), and "Darlin' Lili" (1969)

In 1955, he married Phyllis Gates, who had been the secretary of his agent, Mr. Willson. The marriage ended in divorce three years later.

On Sept. 19 many well-known entertainers joined in a special performance to help raise money to find a cure for AIDS, and although Mr. Hudson, who bought $10,000 worth of tickets, was reported too ill to attend, he did send a telegram. It said in part:

"I am not happy that I am sick. I am not happy that I have AIDS. But if that is helping others, I can at least know that my own misfortune has had some positive worth."

There are no known immediate survivors.

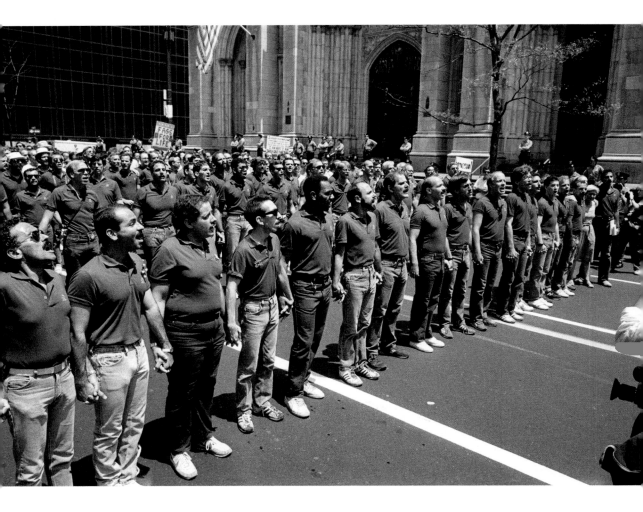

ABOVE
Members of the Gay Men's Chorus sing "America the Beautiful"
in front of St. Patrick's Cathedral, New York, June 30, 1985.

OPPOSITE
New York, November 15, 1985

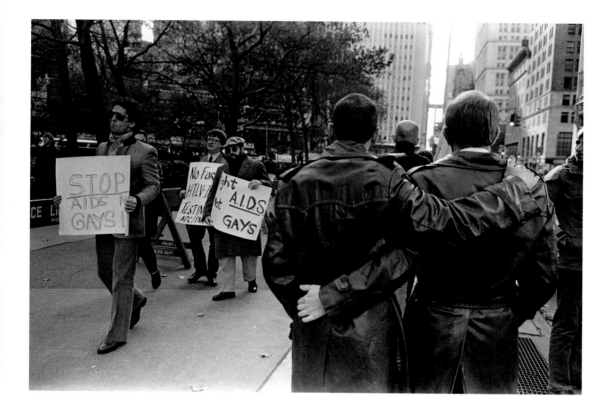

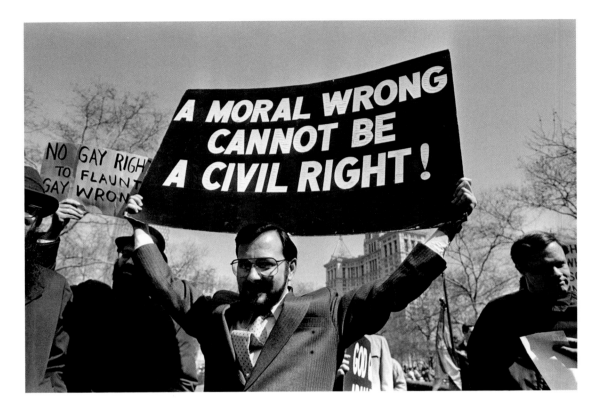

ABOVE
Noach Dear demonstrates against the gay rights bill, Intro 2, March 18, 1986.

OPPOSITE
Celebrating the passage of Intro 2, Sheridan Square, New York, March 21, 1986

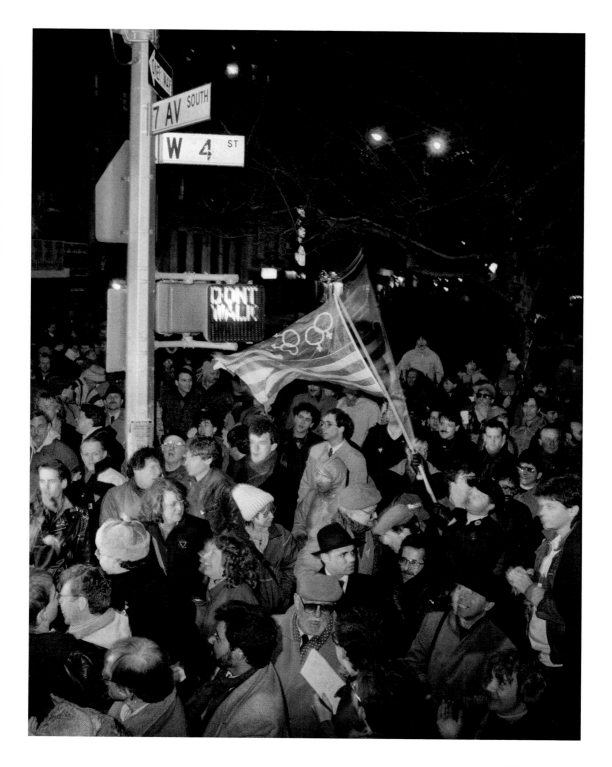

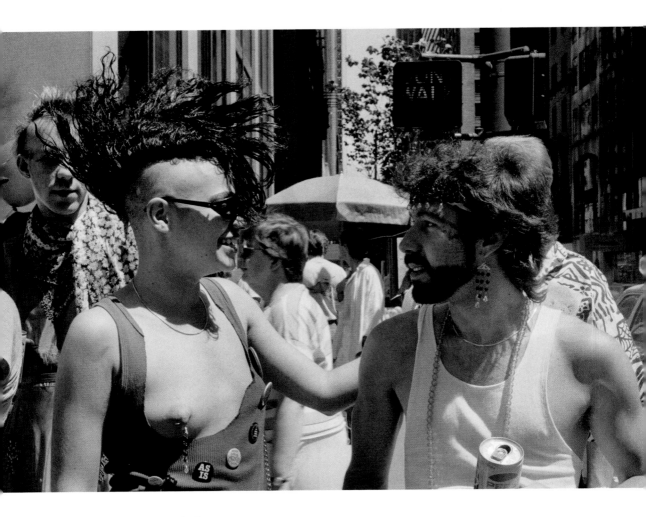

ABOVE & OPPOSITE
New York, June 29, 1986

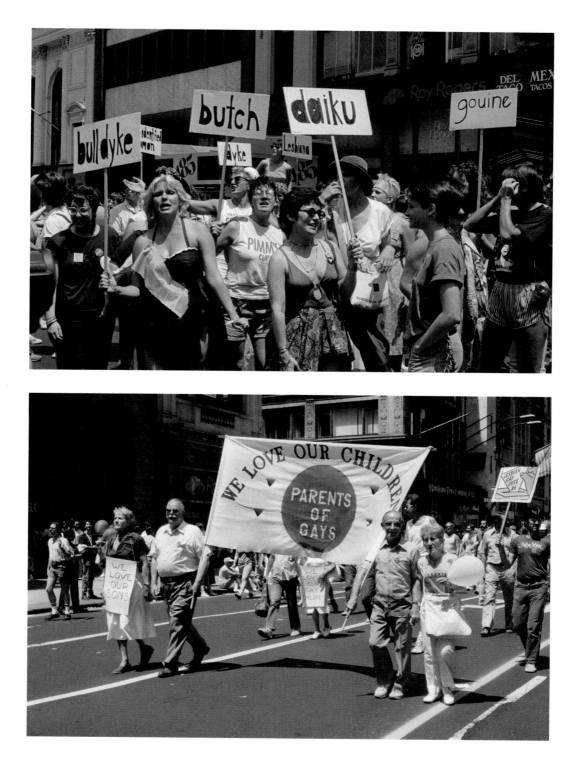

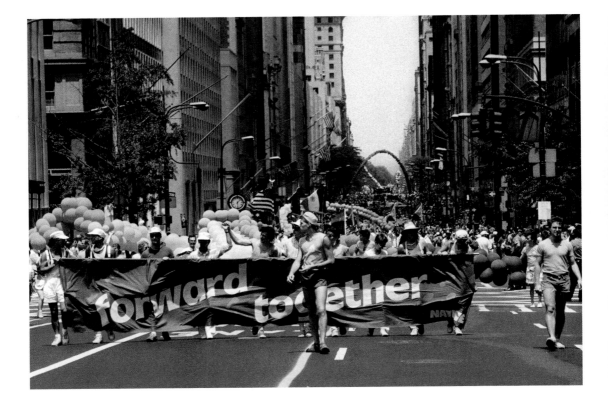

ABOVE & OPPOSITE
New York, June 29, 1986

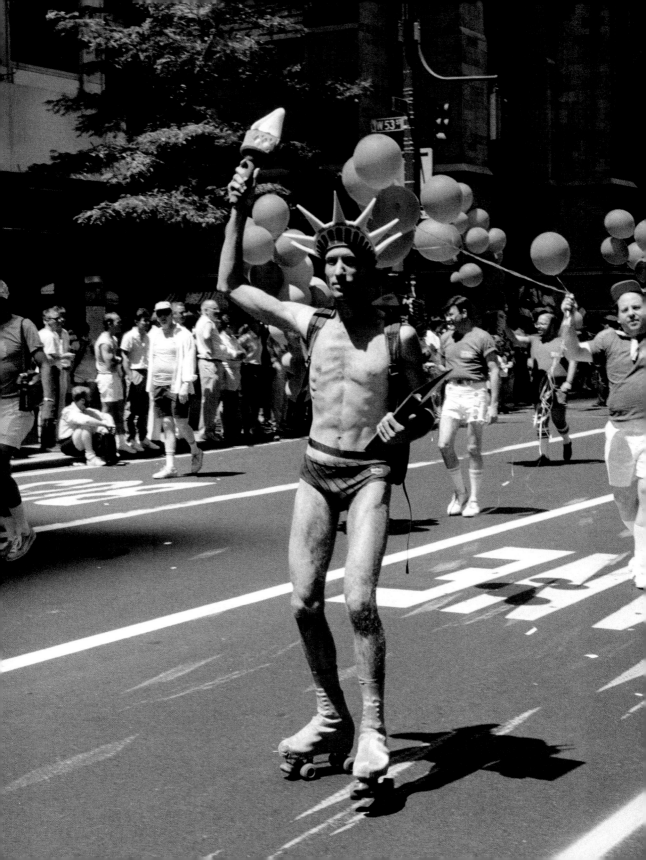

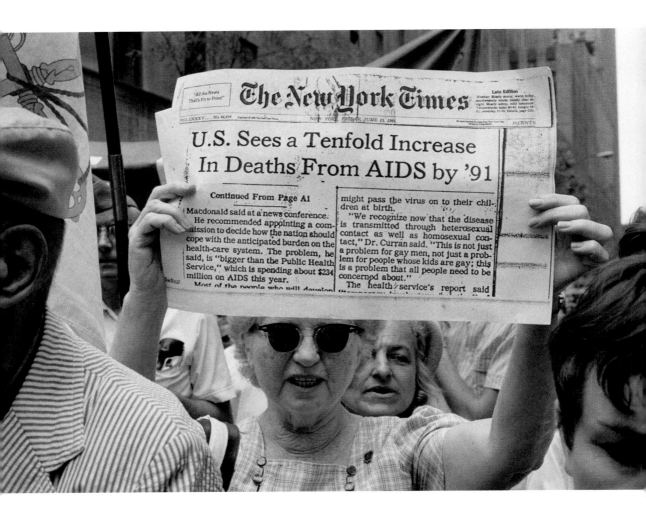

ABOVE & OPPOSITE
New York, June 29, 1986

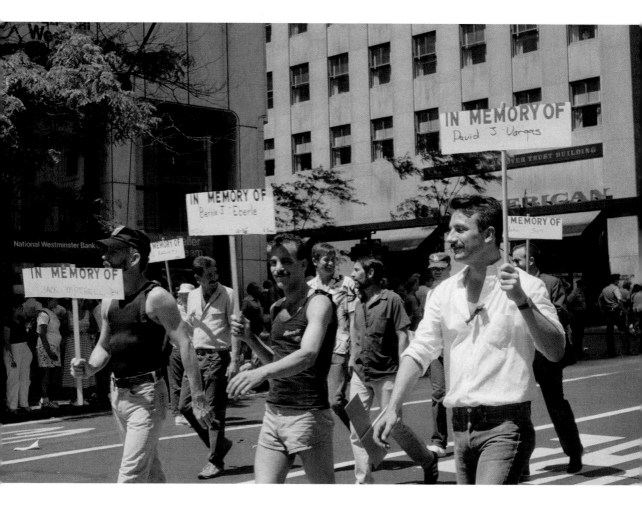

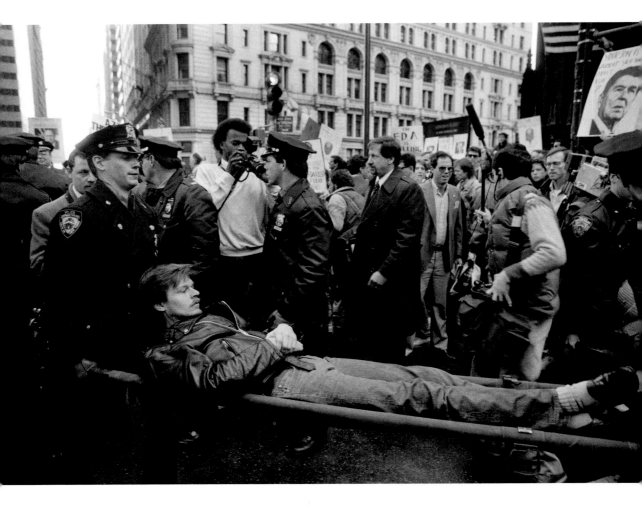

ABOVE & OPPOSITE
Demonstration at Trinity Church to pressure the FDA to release
drugs that might help AIDS victims, New York, March 24, 1987

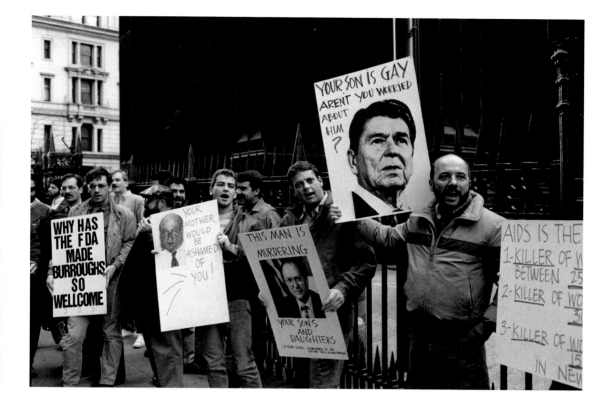

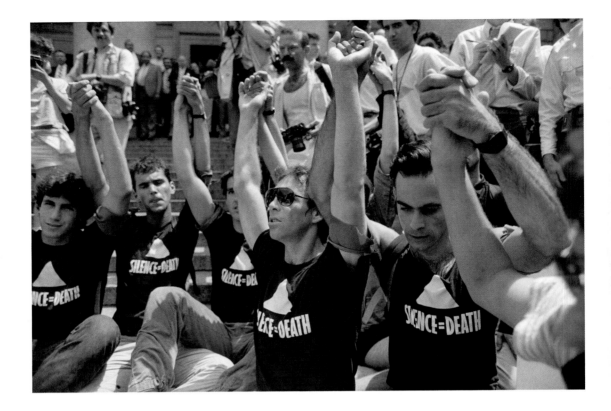

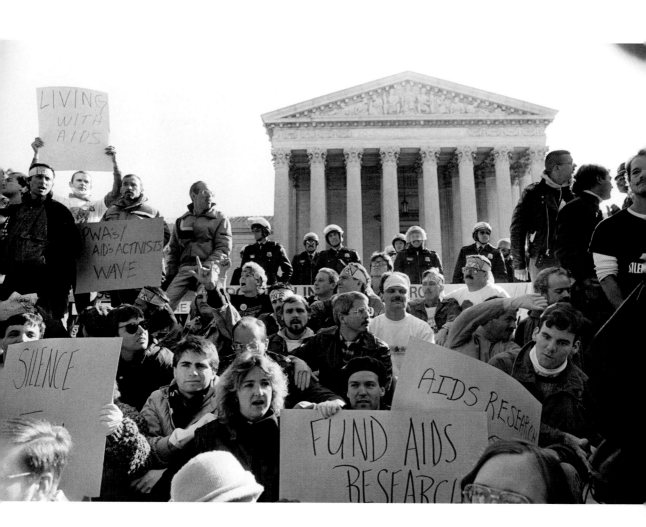

OPPOSITE
Protesters hold hands in a moment of silence before being arrested,
Foley Square, New York, June 30, 1987.

ABOVE & FOLLOWING
Demonstrators participating in Gay Day stand outside of the
U.S. Supreme Court in Washington, D.C., October 13, 1987.

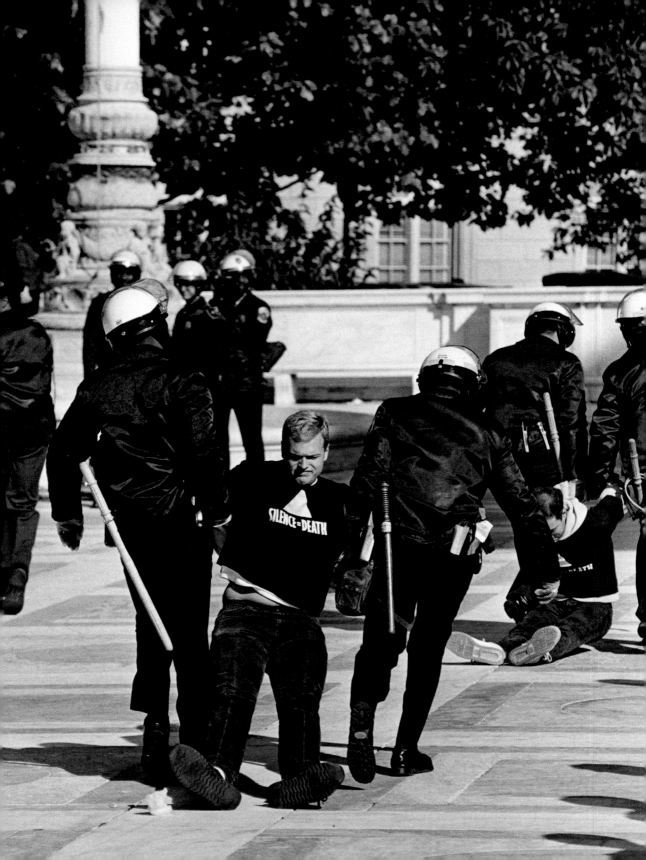

F.D.A. Pressed to Approve More AIDS Drugs

By WARREN E. LEARY

ASHINGTON, Oct. 10 — Advocates for AIDS patients, dissatisfied with the progress of developing and approving new treatments for the disease, are continuing to put pressure on the Food and Drug Administration through meetings with Government officials and demonstrations.

Groups concerned about AIDS are planning to stage a demonstration on Tuesday at F.D.A. headquarters in nearby Rockville, Md., to shut down the agency for a day in what they called a nonviolent act of civil disobedience. While agency officials said the F.D.A. would remain open, organizers said several thousand people were expected to protest and hundreds planned to be arrested to dramatize their concerns.

The protest is sponsored by more than 50 groups from around the nation. Advocates complain that the agency has failed to make available more experimental drugs to people infected with the virus that causes acquired immune deficiency syndrome.

The Commissioner of Food and Drugs, Dr. Frank E. Young, who previously promised to meet with demonstrators but changed his plans to attend a meeting out of the country, instead met with leaders of several groups last week.

"The commissioner summed up by saying he felt meetings like this were healthy and that he learned a few things," said Don McLearn, an F.D.A. spokesman who attended the gathering at which AIDS advocates listed demands.

While the agency says it is moving as fast as possible on testing and approving AIDS treatments, advocates say the pace still is too slow and bureaucratic as thousands face death from the disease. Only one drug, AZT or azidothymidine, has so far been approved to treat AIDS, and critics say it is so toxic that almost half the patients cannot take it for long periods.

"This was the beginning of a series of meetings," said Sue Hyde of the National Gay and Lesbian Task Force, who attended. "Young and the other F.D.A. people seem willing to discuss issues, but I'm not sure how much good it will do. There was a lot of hot air in the room but no balloons went up."

The meeting was part of a recent F.D.A. effort to reach out to its critics, who frequently condemn the agency for what they see as a lack of urgency and compassion in making new treatments available.

In July, Dr. Young surprised critics by appearing before a largely hostile audience at the 10th National Lesbian and Gay Health Conference and AIDS Forum in Boston, and announcing that his agency would allow people to import small quantities of unapproved drugs for personal use, including ordering some drugs by mail.

Ms. Hyde said, "I think Young is a nice, sincere man who is more an academic than a career bureaucrat, and that he's unable to meet the basis of our requests: that the F.D.A. interact with drug companies to draw them more quickly into the process of making more drugs available."

A list of demands given Dr. Young include having the F.D.A. stop all placebo-controlled trials, in which a candidate drug is tested against a nontherapeutic dummy preparation; allow participants in AIDS drug trials simultaneously to take other drugs for treating complications of the disease; require that drug trials include representatives of all groups hard-hit by the disease, such as women, children and minority groups; give drugs conditional approval if they appear safe and at least theoretically effective, and seek the power to force companies to release their potential AIDS drugs and open their books in cases of suspected price gouging.

"Commissioner Young noted that some of the points they brought up, such as equitable patient distribution in trials, were things no one had mentioned before that he would look into," said Mr. McLearn, the F.D.A. spokesman. "He asked for some of these concerns in writing and promised to respond."

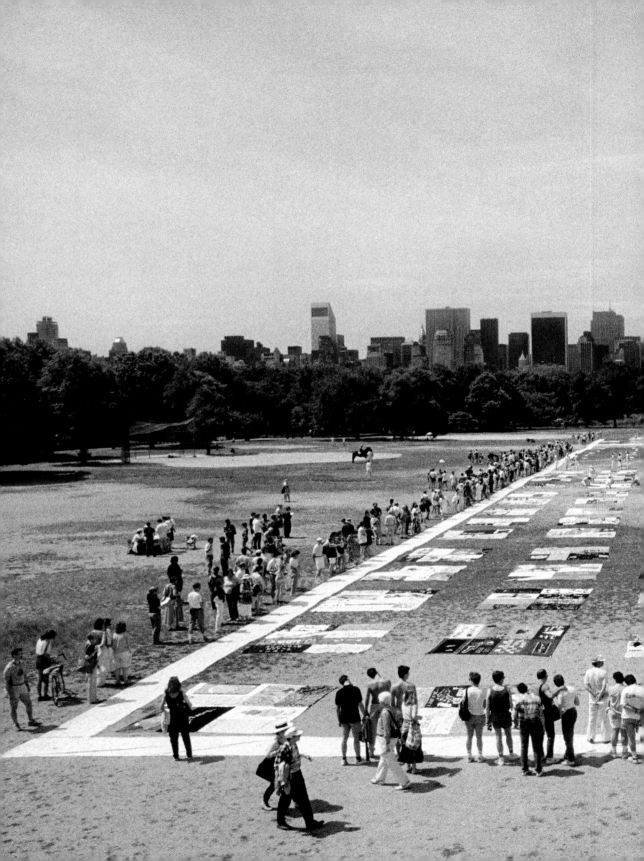

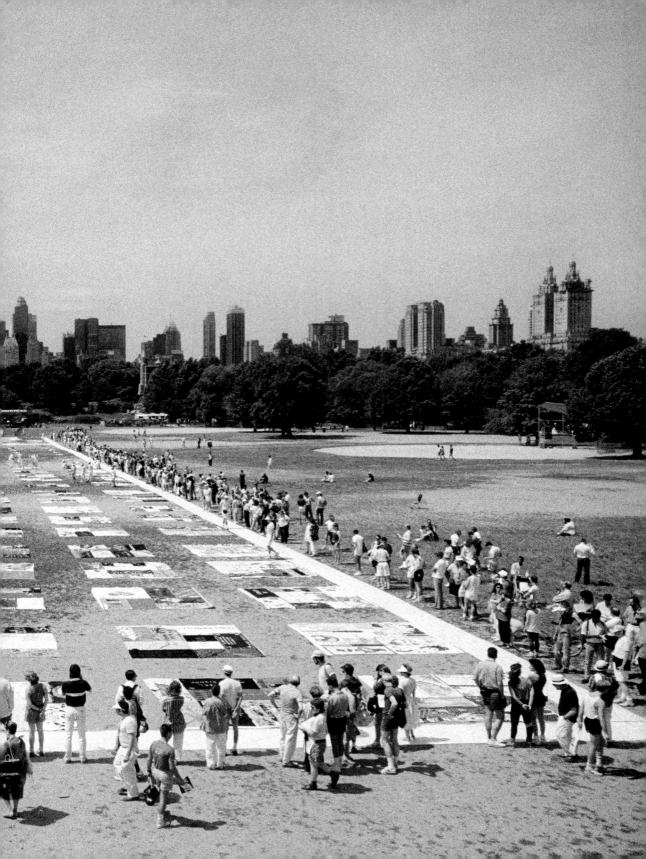

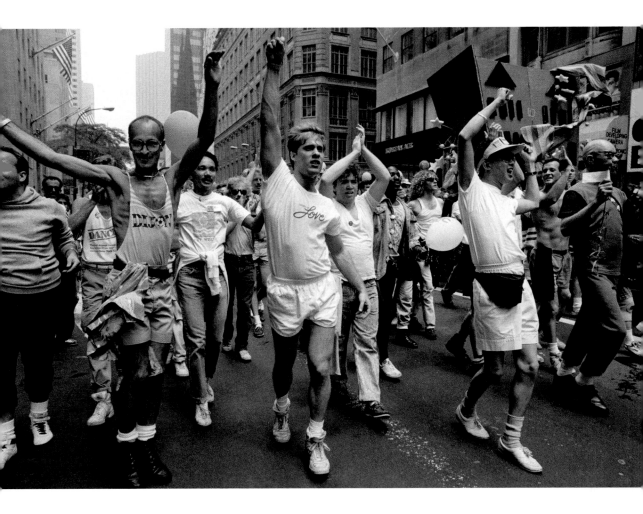

PREVIOUS
AIDS quilt on display in Central Park, June 25, 1988

ABOVE & OPPOSITE
New York, June 26, 1988

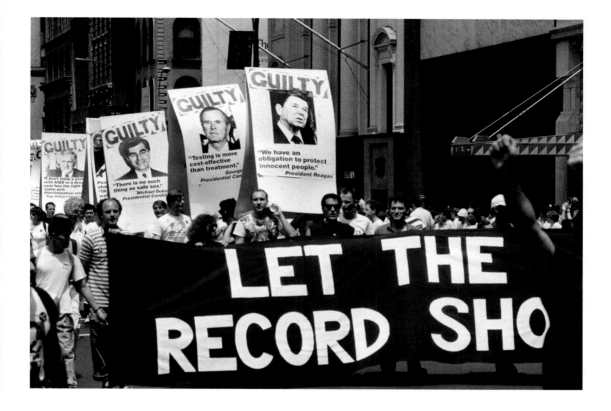

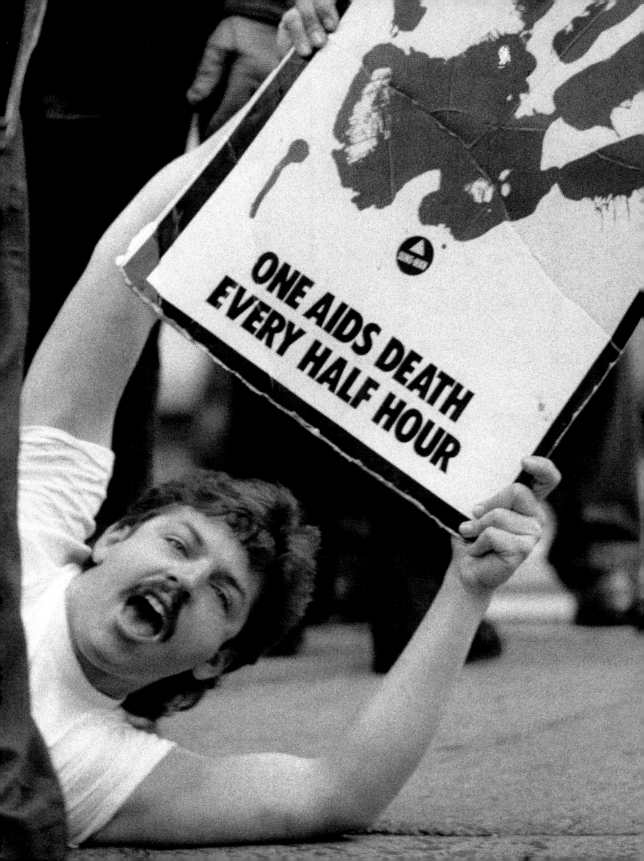

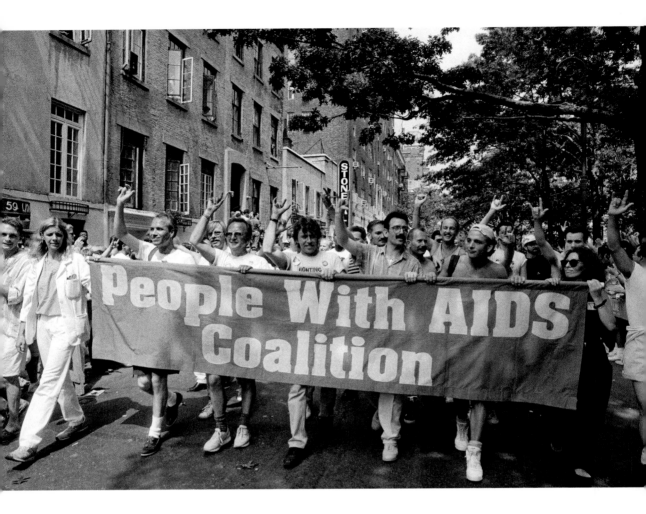

PREVIOUS
During New York's largest demonstration to date by thousands who say the city provides inadequate services and funds for people with AIDS, a protester lies down in front of City Hall, March 28, 1989. Approximately two hundred people were arrested.

ABOVE & OPPOSITE
New York, June 25, 1989

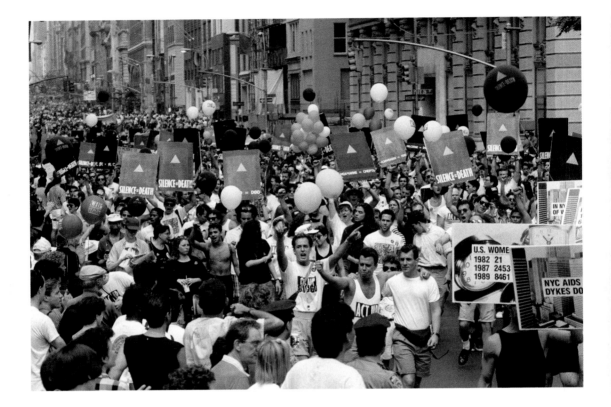

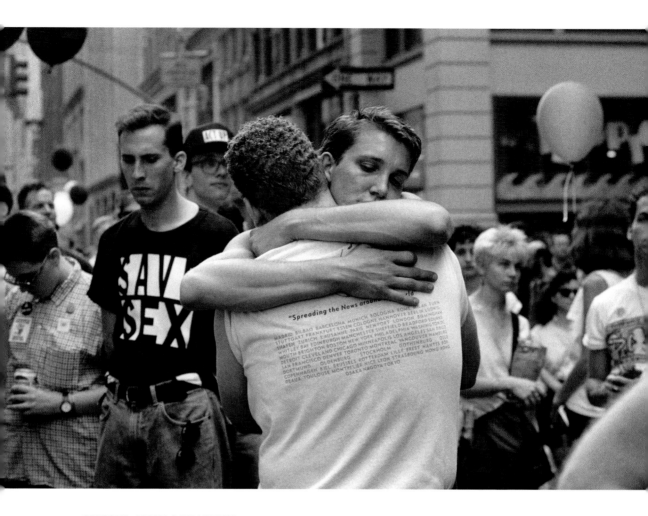

OPPOSITE, ABOVE, & FOLLOWING
New York, June 25, 1989

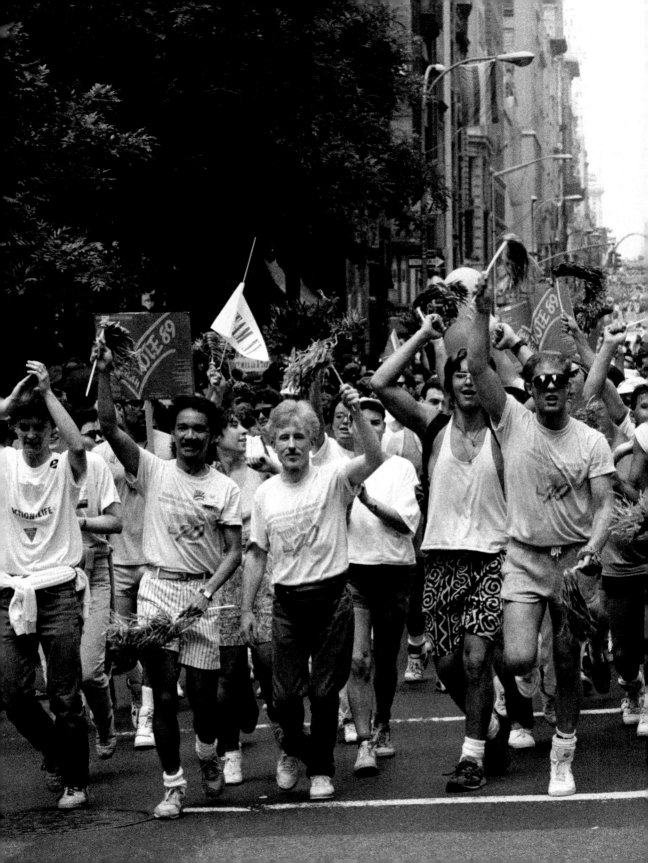

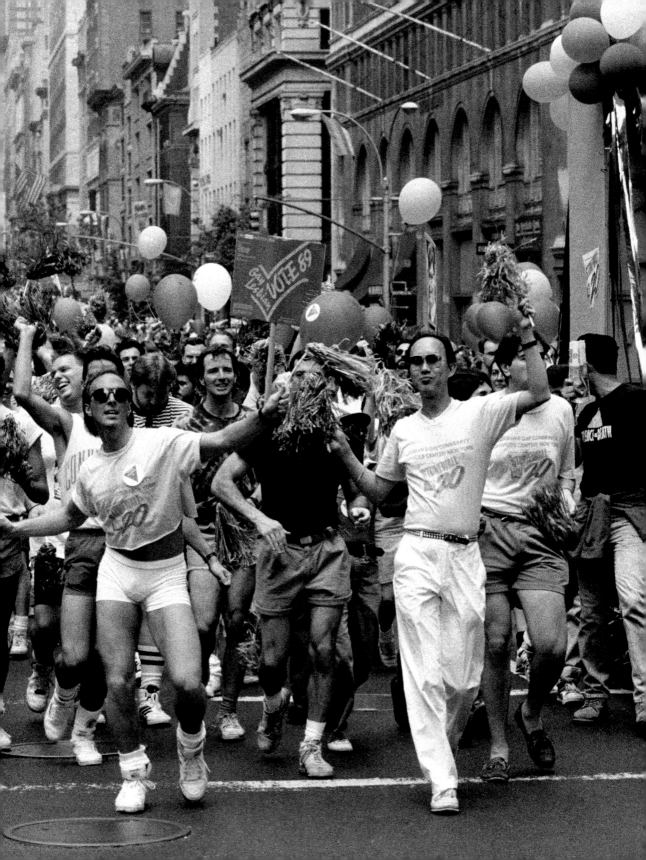

'So many people are dying. So many people are sick.'

AIDS Conference Is Told Danger Of Disease Is Spreading in U.S.

President Signs Law for Study Of Hate Crimes

U.S. Panel Backs Sale of Experimental AIDS Drug

AIDS WAR SHUNNED BY MANY DOCTORS

'AIDS is a test of community. It's a test of how we respond to this terrible thing.'

The Spread Of AIDS: A Mystery Unravels

Gay and non-gay adolescents need to know that 'being gay is all right.'

Cut Down as They Grow Up: AIDS Stalks Gay Teen-Agers

Patients Are Said to Miss Out on Life-Prolonging Drugs

Gay-Bashing, Villainy and the Oscars

Anti-Gay Attacks Increase And Some Fight Back

For decades, gay characters have been defined by sexuality alone. Now they're being portrayed as dangerous enemies.

Rude, Rash, Effective, Act-Up Shifts AIDS Policy

Gay Center Is Hub to Share and Care

Less Visible but Heavier Burdens As AIDS Attacks People Over 50

In teams of eight, the Pink Panthers patrol to protect their own.

TV Film About Gay Black Men Is Under Attack

Lesbians Clear Hurdles

First Openly Gay Legislator Brings a Full Agenda to Albany To Gain Posts of Power

Throngs Cheer at Gay and Lesbian March **10,000 Protesters Demand**

Anti-Gay Crimes Are Reported on Rise in 5 Cities **Help for People With AIDS**

Anti-Homosexual T-Shirts Prompt Suspension of Syracuse Fraternity

For Gay High-School Seniors, Nightmare Is Almost Over

Bronx Hospital Gives Gay Couples Spouse Benefits

W.H.O. Says 40 Million Will Be Infected With AIDS Virus by 2000

Clinton Administration Echoing Bush's White House on Gay Ban

PENTAGON SPELLS OUT RULES FOR OUSTING HOMOSEXUALS; RIGHTS GROUPS VOW A FIGHT

Openly Gay in Blue: Officers Tread Warily

SENATORS REJECT BOTH JOB-BIAS BAN AND GAY MARRIAGE

Ill Artists' Effort to Insure That Art Survives AIDS

Bitter Debate, Then a Vote for Rejecting Same-Sex Marriages

Couple Who Stirred Issue of Same-Sex Marriage Still Hopeful

CLOSE VOTE ON JOB BILL

26,000 Walk For Money To Combat AIDS Virus

'A critical opportunity, for the first time, to get ahead of the virus.'

HOUSE PASSES BAR TO U.S. SANCTION OF GAY MARRIAGE

HAWAII JUDGE ENDS GAY-MARRIAGE BAN

Close Margin on Employment Bill Is a Surprise — Same-Sex Unions Lose 85-14

Congressional Bills Withhold Sanction of Same-Sex Unions

BILL GAINS EASILY, 342-67

Each State Would Be Allowed to Ignore Same-Sex Unions Made Legal Elsewhere

Homophobia ¡Often Found In Schools, Data Show

President Would Sign Legislation Striking at Homosexual Marriages

Ellen and 'Ellen' Come Out

A Role Within a Role: A Girl Who Became a Boy

Gay Man Beaten and Left for Dead; 2 Are Charged

The Lesson of Matthew Shepard

Killing Shakes Complacency Of the Gay Rights Movement

Anti-Bias Effort Roils City Where Gay Man Died

Friends and Strangers Mourn Gay Student in Wyoming

96 Arrested During Rally Protesting Gay Man's Killing in Wyoming

1990s

The 1990s marked a period of deep reckoning for LGBTQ people across America. More than a decade into the AIDS crisis, hope began to emerge. New classes of antiviral drugs slowly came to market; Congress passed the Ryan White Act, which allocated $220.5 million in federal treatment funding; Bill Clinton established an Office of National AIDS Policy, and the FDA approved a series of rapid-result HIV tests. By the middle of the decade, over half a million AIDS cases had been reported nationwide, and fifty thousand Americans died from AIDS in 1995 alone. In the 1990s, the disease become the leading cause of death for Americans ages twenty-five to forty-four—a vast majority of them gay men. This was also when new HIV cases rose dramatically among African-Americans—including basketball legend Earvin "Magic" Johnson, who went public with his HIV diagnosis in 1991. More than two decades later, Johnson is still thriving, though African-Americans remain the hardest hit by the virus.

Beyond HIV, LGBTQ Americans also found themselves under surprising attack from Washington. President Clinton, despite progressive leanings, passed a pair of policies—Don't Ask/Don't Tell (DADT) in 1994 and the Defense of Marriage Act (DOMA) two years later—that codified anti-gay discrimination into law. The former made it impossible for LGBTQs to serve openly in the military while the latter denied same-sex couples the benefits of marriage by defining it as a union solely between a man and a woman. Nearly fourteen thousand troops had been dishonorably discharged by the time DADT was repealed in 2010.

Amid these profound losses, America's LGBTQ community still managed to cultivate a powerful culture of resistance and resilience. In 1990, Jenny Livingston's now seminal documentary *Paris Is Burning* chronicled the mostly African-American and Latino underground "ball" culture in New York City whose gender-fluid protagonists presaged the transgender rights and visibility movement that would follow more than two decades later. At the same time, ACT UP continued to advance the needs of people impacted by HIV and set a new standard for protest movements worldwide. Immortalized by the artist Keith Haring's now iconic graffiti-works, ACT UP cannily paired art with activism to successfully embed itself within '90s pop culture.

AIDS also inspired seminal theatrical works such as *Angels in America*, which won Tony Awards and a Pulitzer Prize in 1993, and the musical *Rent*, in 1994, a take on Puccini's *La Bohème* set against a backdrop of the Reagan-era AIDS crisis. In 1997, Ellen DeGeneres—along with her TV alter-ego—became the highest-profile "out" celebrity and television character, while films like *Philadelphia* and the reality TV show *The Real World: San Francisco* offered nuanced portraits of people living with HIV.

Finally, the 1990s marked major legislative milestones. Homosexual acts were finally decriminalized in Georgia and Maryland, and progressive states began legalizing same-sex adoption rights and workplace protections. In November 1995, the Hate Crimes Sentencing Enforcement Act went into effect, allowing heavier sentences for crimes with clear race, religion, or gender focus. The law also included sexual orientation as a basis for hate-fueled crimes. Most crucially, in 1996, Hawaii emerged as the first state to recognize same-sex marriage rights.

As the '90s drew to a close, the country was stunned by the brutal murder of Matthew Shepard. His death sparked protests nationwide, and served as a painful reminder to the LGBTQ community of its continued vulnerability. More than a decade later, anti-hate-crime legislation known as the Matthew Shepard Act was signed into law.

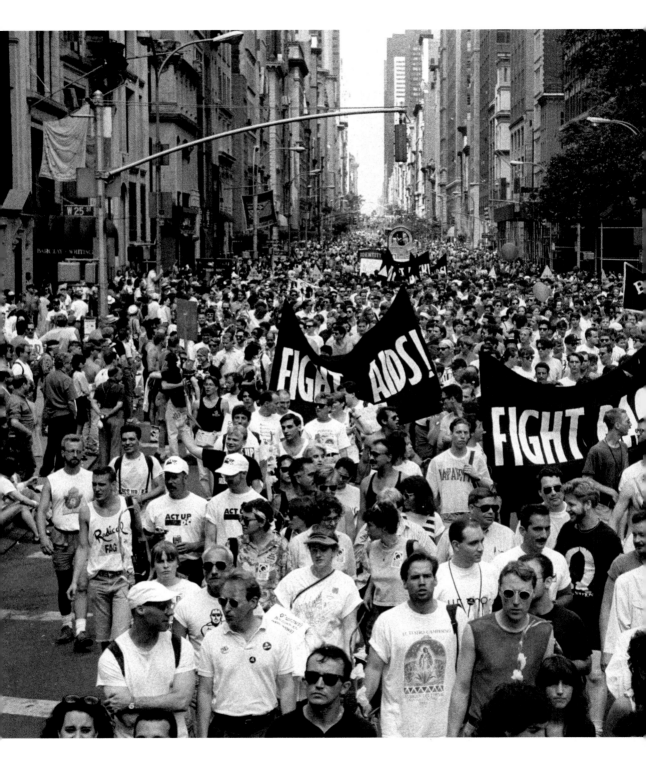

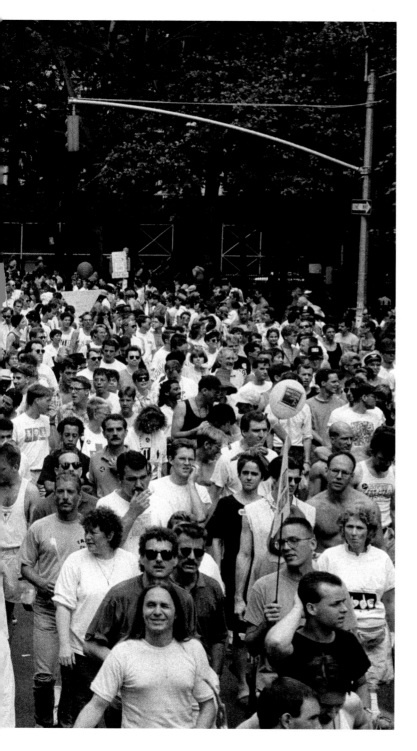

New York, June 24, 1990

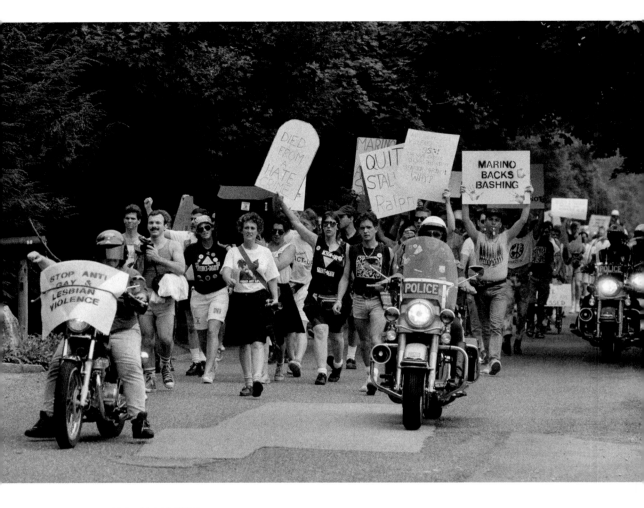

ABOVE & OPPOSITE
Demonstrators protest New York state senator Ralph Marino's refusal to support
a bill to provide protection for minorities, July 22, 1990.

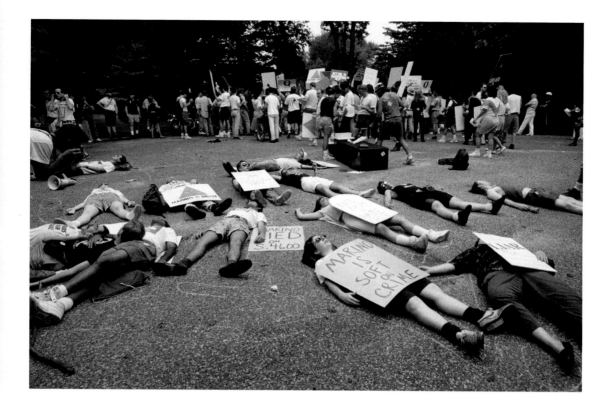

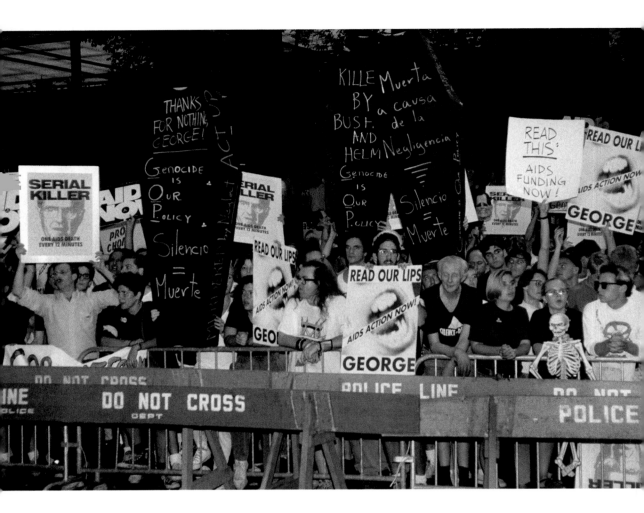

ABOVE
Demonstrators from ACT UP stand outside of the Waldorf-Astoria Grand Ballroom, while President George H. W. Bush addresses attendees at the New York State Republican Party dinner, July 24, 1990.

OPPOSITE
Members of a group called the Pink Panthers discuss their route while patrolling the West Village to try to stop attacks on gay people, New York, August 10, 1990.

FOLLOWING
ACT UP demonstrators hang a banner over the arrivals and departures board in the main room at Grand Central Terminal, New York, January 23, 1991.

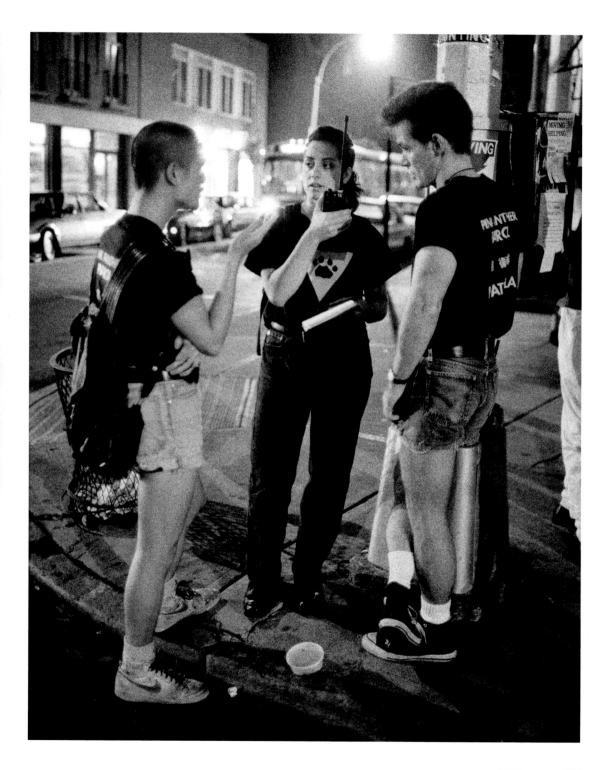

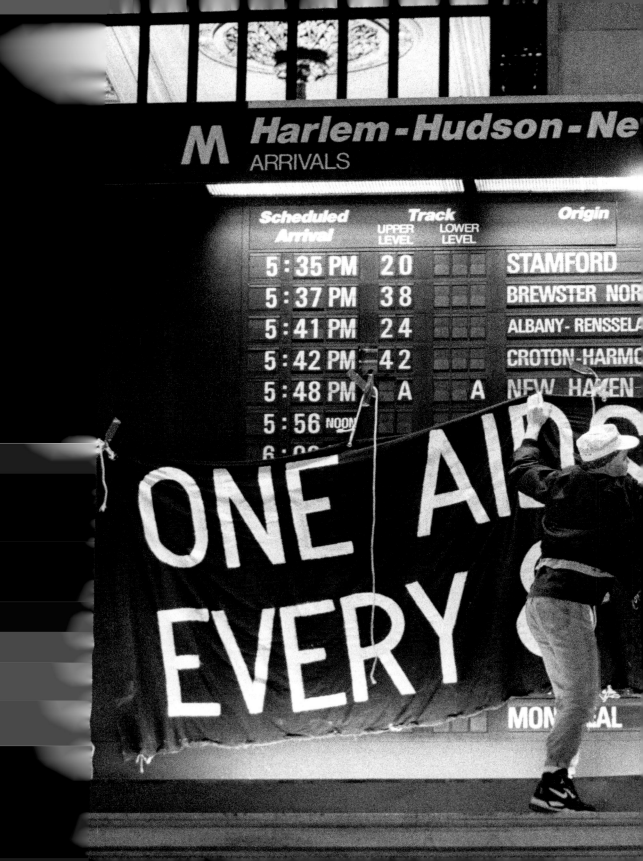

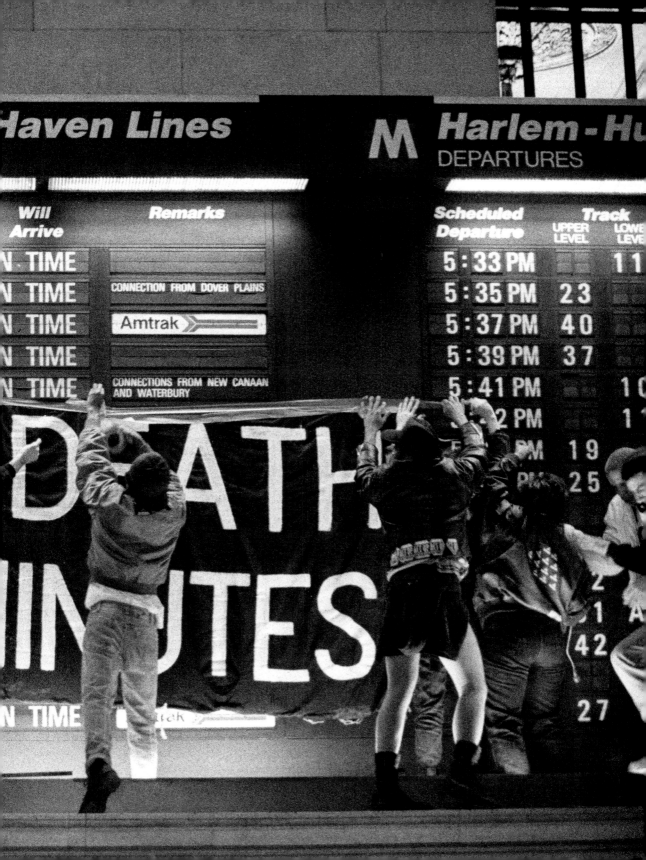

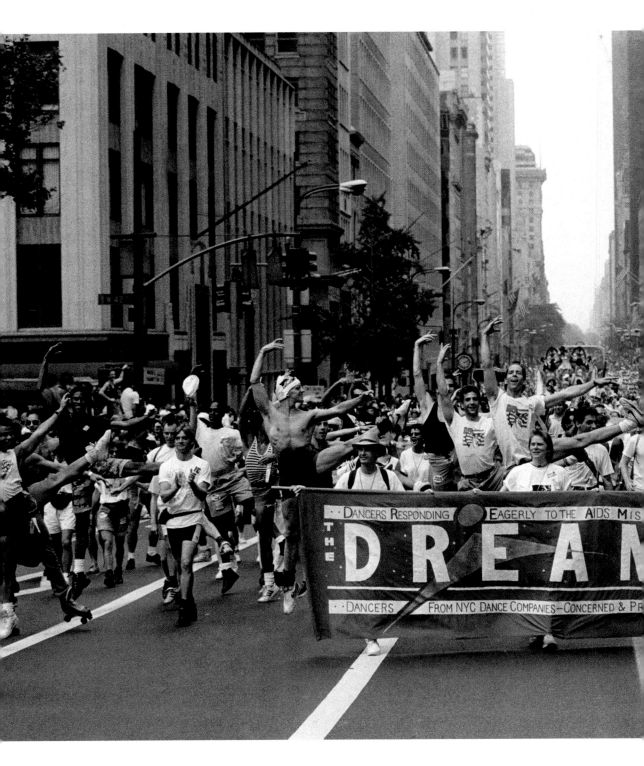

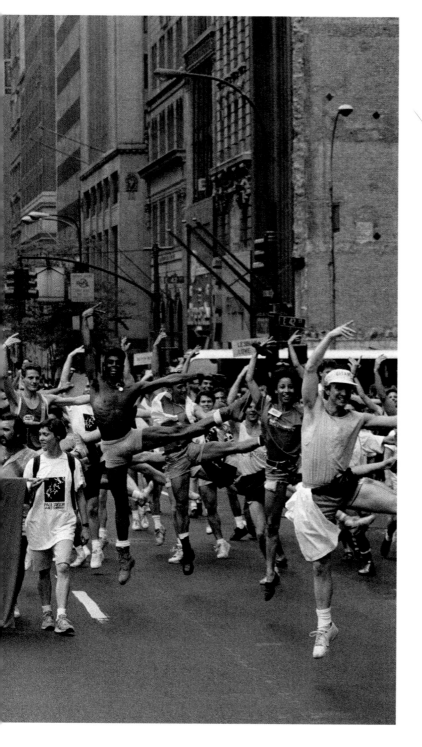

New York, June 30, 1991

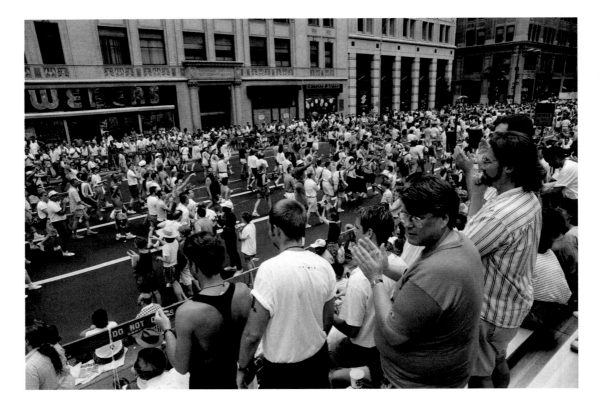

ABOVE
New York, June 30, 1991

OPPOSITE
Members of ACT UP stage a protest on Fifth Avenue, New York, June 30, 1991.

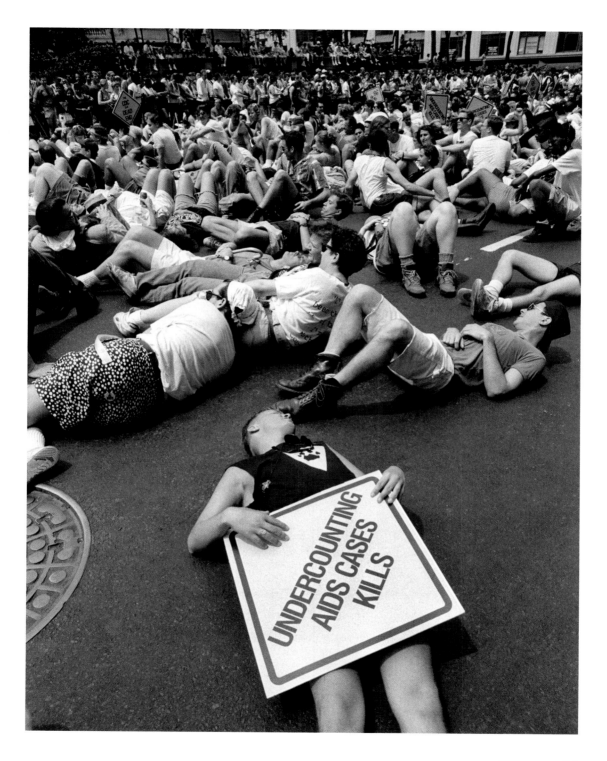

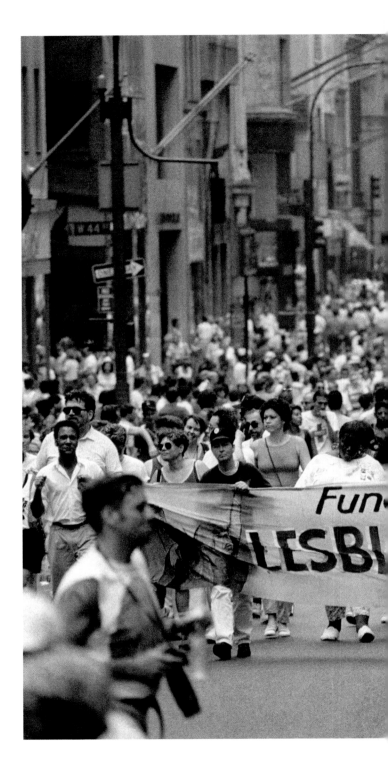

New York, June 30, 1991

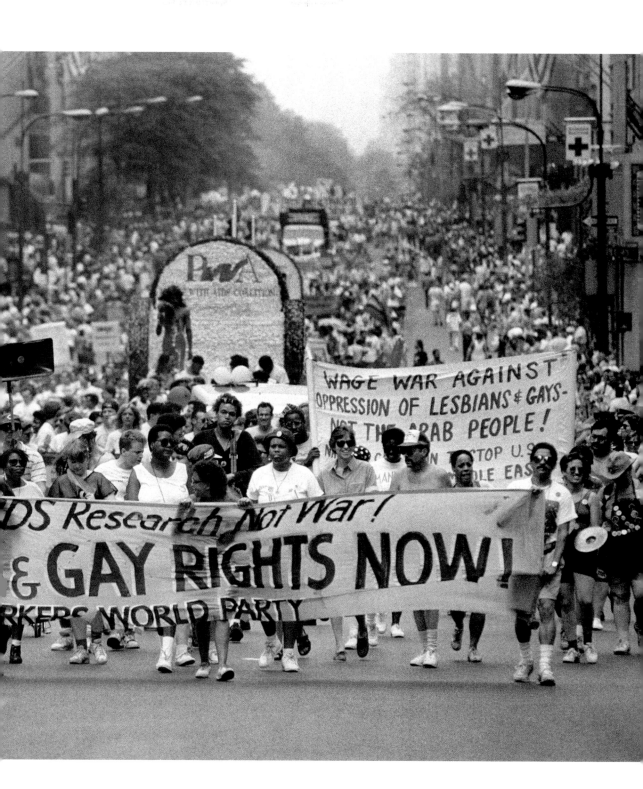

ABOVE
Demonstrators at a New York City Council meeting protest anti-gay comments
made by a council member, New York, April 28, 1992.

OPPOSITE
Sharon Kowalski, center, and Karen Thompson, right, serving as grand marshals of
the 1992 Pride March in New York, June 28, 1992. The pair won a landmark decision
in the Minnesota Court of Appeals reinforcing the right of adults to choose their
own guardians regardless of sexual orientation.

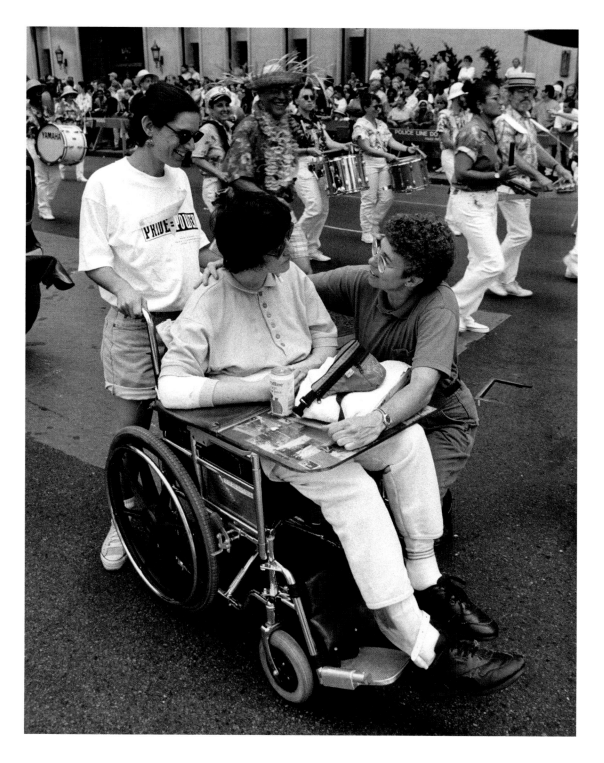

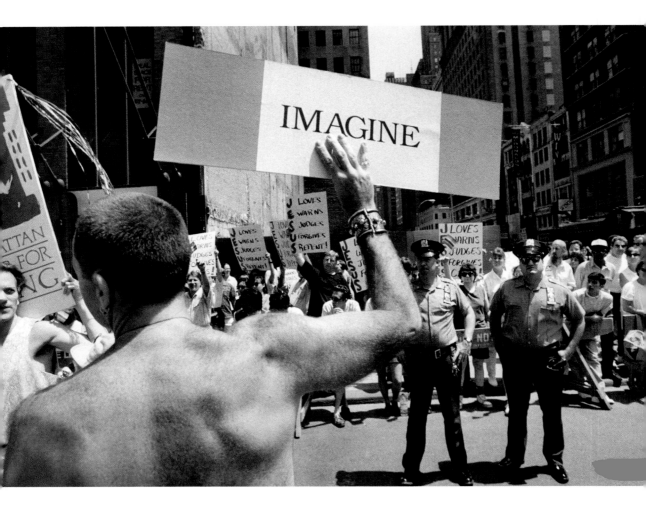

New York, June 28, 1992

A Play to Embrace All Possibilities in Art and Life

By FRANK RICH

"History is about to crack open," says Ethel Rosenberg, back from the dead, as she confronts a cadaverous Roy Cohn, soon to die of AIDS, in his East Side town house. "Something's going to give," says a Brooklyn housewife so addicted to Valium she thinks she is in Antarctica. The year is 1985. It is 15 years until the next millennium. And a young man drenched in death fevers in his Greenwich Village bedroom hears a persistent throbbing, a thunderous heartbeat, as if the heavens were about to give birth to a miracle so that he might be born again.

This is the astonishing theatrical landscape, intimate and epic, of Tony Kushner's "Angels in America," which made its much-awaited Broadway debut at the Walter Kerr Theater last night. This play has already been talked about so much that you may feel you have already seen it, but believe me, you haven't, even if you actually have. The new New York production is the third I've seen of "Millennium Approaches," as the first, self-contained, three-and-a-half-hour part of "Angels in America" is titled. (Part 2, "Perestroika," is to join it in repertory in the fall.) As directed with crystalline lucidity by George C. Wolfe and ignited by blood-churning performances by Ron Leibman and Stephen Spinella, this staging only adds to the impression that Mr. Kushner has written the most thrilling American play in years.

•

"Angels in America" is a work that never loses its wicked sense of humor or its wrenching grasp on such timeless dramatic matters as life, death and faith even as it ranges through territory as far-flung as the complex, plague-ridden nation Mr. Kushner wishes both to survey and to address. Subtitled "A Gay Fantasia on National Themes," the play is a political call to arms for the age of AIDS, but it is no polemic. Mr. Kushner's convictions about power and justice are matched by his conviction that the stage, and perhaps the stage alone, is a space large enough to accommodate everything from precise realism to surrealistic hallucination, from black comedy to religious revelation. In "Angels in America," a true American work in its insistence on embracing all possibilities in art and life, he makes the spectacular case that they can all be brought into fusion in one play.

At center stage, "Angels" is a domestic drama, telling the story of two very different but equally troubled young New York couples, one gay and one nominally heterosexual, who intersect by chance. But the story of these characters soon proves inseparable from the way Mr. Kushner tells it. His play opens with a funeral led by an Orthodox rabbi and reaches its culmination with what might be considered a Second Coming. In between, it travels to Salt Lake City in search of latter-day saints and spirals into

dreams and dreams-within-dreams where the languages spoken belong to the minority American cultures of drag and jazz. Hovering above it all is not only an Angel (Ellen McLaughlin) but also an Antichrist, Mr. Leibman's Roy Cohn, an unreconstructed right-wing warrior who believes that "life is full of horror" from which no one can escape.

•

While Cohn is a villain, a hypocritical closet case and a corrupt paragon of both red-baiting and Reagan-era greed, his dark view of life is not immediately dismissed by Mr. Kushner. The America of "Angels in America" is riddled with cruelty. When a young WASP esthete named Prior Walter (Mr. Spinella) reveals his first lesions of Kaposi's sarcoma to his lover of four years, a Jewish clerical worker named Louis Ironson (Joe Mantello), he finds himself deserted in a matter of weeks. Harper Pitt (Marcia Gay Harden), pill-popping housewife and devout Mormon, has recurrent nightmares that a man with a knife is out to kill her; she also has real reason to fear that the man is her husband, Joe (David Marshall Grant), an ambitious young lawyer with a dark secret and aspirations to rise high in Ed Meese's Justice Department.

But even as Mr. Kushner portrays an America of lies and cowardice to match Cohn's cynical view, he envisions another America of truth and beauty, the paradise imagined by both his Jewish and Mormon characters' ancestors as they made their crossing to the new land. "Angels in America" not only charts the split of its two central couples but it also implicitly sets its two gay men in a battle over their visions of the future. While the fatalistic, self-loathing Cohn ridicules gay men as political weaklings with "zero clout" doomed to defeat, the younger, equally ill Prior sees the reverse. "I am a gay man, and I am used to pressure," he says from his sick bed. "I am tough and strong." Possessed by scriptural visions he describes as "very Steven Spielberg" even when in abject pain, Prior is Mr. Kushner's prophet of hope in the midst of apocalypse.

•

Though Cohn and Prior never have a scene together, they are the larger-than-life poles between which all of "Angels in America" swings. And they could not be more magnetically portrayed than they are in this production. Mr. Leibman, red-faced and cackling, is a demon of Shakespearean grandeur, an alternately hilarious and terrifying mixture of chutzpah and megalomania, misguided brilliance and relentless cunning. He turns the mere act of punching telephone buttons into a grotesque manipulation of the levers of power, and he barks out the most outrageous

pronouncements ("I brought out something tender in him," he says of Joe McCarthy) with a shamelessness worthy of history's most indelible monsters.

Mr. Spinella is a boyish actor so emaciated that when he removes his clothes for a medical examination, some in the audience gasp. But he fluently conveys buoyant idealism and pungent drag-queen wit as well as the piercing, open-mouthed cries of fear and rage that arrive with the graphically dramatized collapse of his health. Mr. Spinella is also blessed with a superb acting partner in Mr. Mantello, who as his callow lover is a combustible amalgam of puppyish Jewish guilt and self-serving intellectual piety.

The entire cast, which includes Kathleen Chalfant and Jeffrey Wright in a variety of crisply observed comic cameos, is first rate. Ms. Harden's shattered, sleepwalking housewife is pure pathos, a figure of slurred thought, voice and emotions, while Mr. Grant fully conveys the internal warfare of her husband, torn between Mormon rectitude and uncontrollable sexual heat. When Mr. Wolfe gets both of the play's couples on stage simultaneously to enact their parallel, overlapping domestic crackups, "Angels in America" becomes a wounding fugue of misunderstanding and recrimination committed in the name of love.

•

But "Angels in America" is an ideal assignment for Mr. Wolfe because of its leaps beyond the bedroom into the fabulous realms of myth and American archetypes, which have preoccupied this director and playwright in such works as "The Colored Museum" and "Spunk." Working again with Robin Wagner, the designer who was an essential collaborator on "Jelly's Last Jam," Mr. Wolfe makes the action fly through the delicate, stylized heaven that serves as the evening's loose scenic environment, yet he also manages to make some of the loopier scenes, notably those involving a real-estate agent in Salt Lake City and a homeless woman in the South Bronx, sharper and far more pertinent than they have seemed before.

What has really affected "Angels in America" during the months of its odyssey to New York, however, is not so much its change of directors as Washington's change of Administrations. When first seen a year or so ago, the play seemed defined by its anger at the reigning political establishment, which tended to reward the Roy Cohns and ignore the Prior Walters. Mr. Kushner has not revised the text since — a crony of Cohn's still boasts of a Republican lock on the White House until the year 2000 — but the shift in Washington has had the subliminal effect of making "Angels in America" seem more focused on

Angels in America
Millennium Approaches

By Tony Kushner; directed by George C. Wolfe; sets by Robin Wagner; costumes by Toni-Leslie James; lighting by Jules Fisher; music by Anthony Davis; additional music by Michael Ward; sound by Scott Lehrer; production supervisors, Gene O'Donovan and Neil A. Mazzella; production stage manager, Perry Cline. Produced in association with the New York Shakespeare Festival. Associate producers, Dennis Grimaldi, Marilyn Hall, Ron Kastner, Hal Luftig/126 Second Avenue Corporation and Suki Sandler; executive producers, Benjamin Mordecai and Robert Cole. Presented by Jujamcyn Theaters and Mark Taper Forum/Gordon Davidson, with Margo Lion, Susan Quint Gallin, Jon B. Platt, the Baruch-Frankel-Viertel Group and Frederick Zollo, in association with Herb Alpert. At the Walter Kerr Theater, 219 West 48th Street, Manhattan.

Rabbi Chemelwitz, Henry, Hannah Pitt and Ethel Rosenberg.................Kathleen Chalfant
Roy Cohn and Prior 2.................Ron Leibman
Joe Pitt, Prior 1 and the Eskimo
.................David Marshall Grant
Harper Pitt and Martin Heller
.................Marcia Gay Harden
Mr. Lies and Belize.................Jeffrey Wright
Louis Ironson.................Joe Mantello
Prior Walter and Man in the Park
.................Stephen Spinella
Emily, Ella Chapter, the Woman in the South Bronx and the Angel.........Ellen McLaughlin

what happens next than on the past.

This is why any debate about what this play means or does not mean for Broadway seems, in the face of the work itself, completely beside the point. "Angels in America" speaks so powerfully because something far larger and more urgent than the future of the theater is at stake. It really is history that Mr. Kushner intends to crack open. He sends his haunting messenger, a spindly, abandoned gay man with a heroic spirit and a ravaged body, deep into the audience's heart to ask just who we are and just what, as the plague continues and the millennium approaches, we intend this country to become.

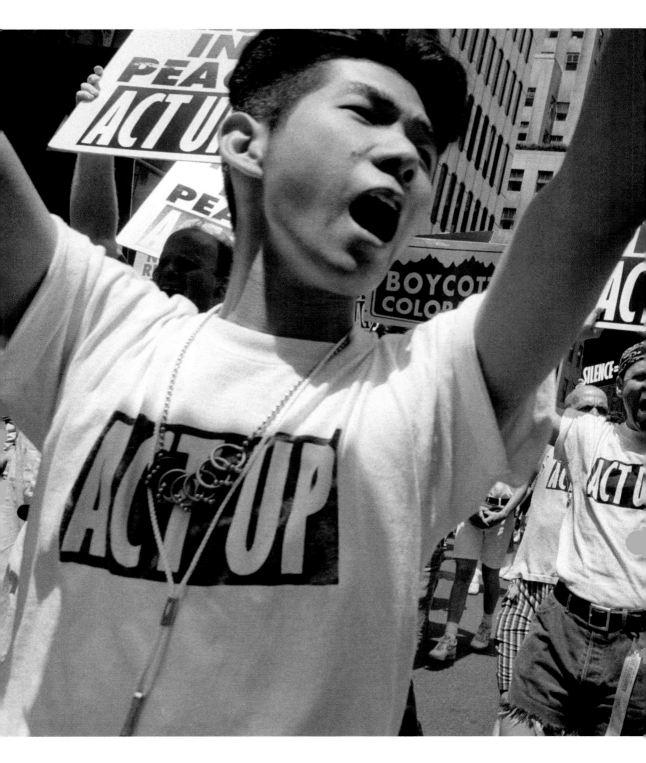

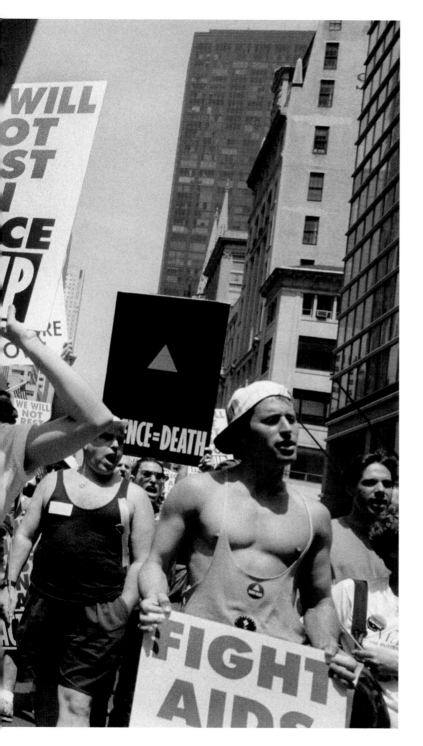

New York, June 27, 1993

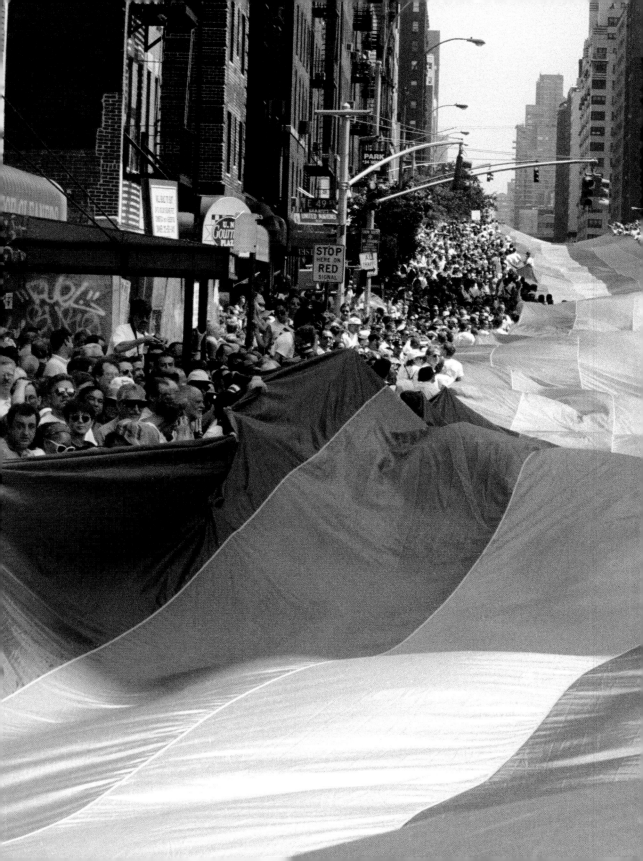

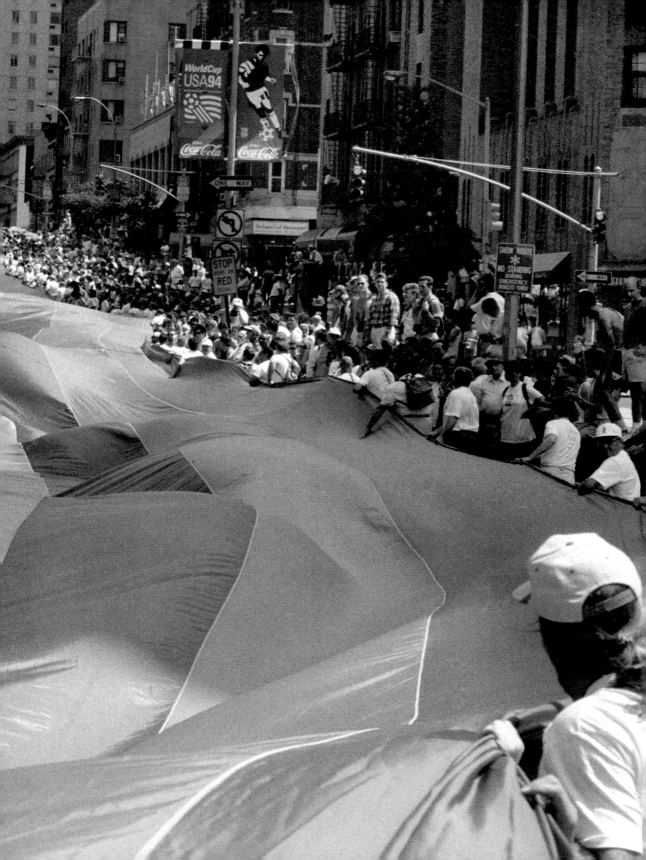

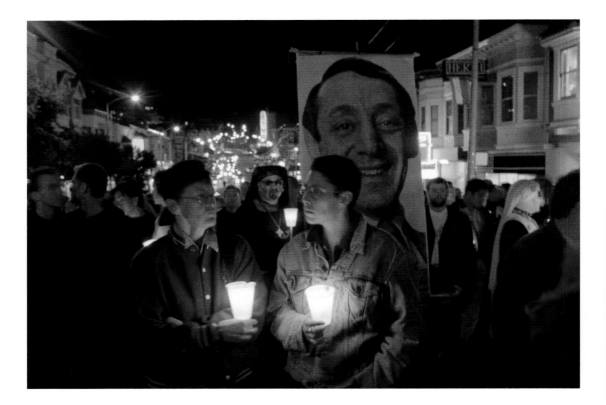

PREVIOUS
Part of the mile-long, 30-foot-wide, rainbow-colored flag symbolizing LGBTQ
unity leading the official march along First Avenue, New York, June 26, 1994

ABOVE
In front of #575 on Castro Street, people gather to pay homage to Harvey Milk
and George Moscone, who were gunned down at the spot eighteen years earlier,
San Francisco, November 27, 1996.

WHITE HOUSE ACTS TO PROTECT STAND ON GAY TROOP BAN

DECISION TO FIGHT RULING

Support for Old Policy Is Effort to Quiet Issues That Could Undermine New Rules

By ERIC SCHMITT
Special to The New York Times

WASHINGTON, Dec. 29 — The Clinton Administration has decided to fight a court ruling that threw out the old military policy under which service members could be dismissed for simply declaring their homosexuality. But the Administration has decided to appeal only on technical grounds, to avoid broad constitutional issues that could undermine its new policy on gay service members.

The decision to appeal is part of an Administration effort to bolster its position against any challenge to the new policy. The ruling, handed down in November by a three-judge panel of the United States Court of Appeals for the District of Columbia Circuit, involved a midshipman who was forced out of the United States Naval Academy at Annapolis and not commissioned as an officer because he said under questioning that he was homosexual.

Dealing With Old Policy

The court ruled that forcing him out violated the equal protection guarantee of the Constitution. The court was dealing with the old Defense Department ban on homosexuals, but its decision cast doubt on the Administration's slightly more liberal policy, which permits homosexuals to serve in the armed forces but only if they keep their sexual orientation a secret.

The ruling left the Administration in a difficult position. If it did not appeal, it would let stand a ruling that gay rights groups were prepared to use to fight the new policy. If it appealed, it was in danger of looking bad politically by going to court in favor of a Republican policy that President Clinton once vowed to abolish. The President has already come under fire from gay rights groups for abandoning that promise and keeping in place many of the old restrictions.

Some officials at the Justice Department had wanted to wait to go to court to defend the Administration's new policy, which it believes it will inevitably have to do, and not risk legal damage or expend time and resources defending the old policy.

Taking the Middle Ground

So it has chosen a middle ground, hoping to turn the debate from broad constitutional questions involving individual rights to narrower questions involving the separation of powers among the executive, judicial and legislative branches of government.

The appeal will be based on a narrow issue unrelated to the question of whether barring homosexuals is constitutional. The Administration will argue that under the principle of separation of powers, the appellate court panel exceeded its authority last month when it ordered the Navy to commission the midshipman, something the Justice Department will argue only the President can do with the consent of the Senate.

The Administration's decision is based on a fine political calculation. By doing it this way, the White House believes that it can satisfy its legal need to appeal the ruling, which it opposed, but without appearing to support the old policy on gay men and lesbians in the military.

"After working so diligently to define the new policy, we were reluctant to argue in favor of the old policy," a senior Administration official said.

The plan also settles a dispute between the Defense Department and the Justice Department over how to handle the case. Pentagon lawyers believed that since some of the elements of the old policy are embodied in the new policy, a successful challenge could end up undermining the new policy.

But many Justice Department officials were uncomfortable in defending a policy against which Mr. Clinton campaigned. Moreover, these officials said the old policy was moot, and that the Government should marshal its best legal arguments and financial resources to defend expected challenges to the more flexible new policy.

Last week the Pentagon issued new rules intended to put into practice a policy that allows gay men and lesbians to serve in the armed forces, but only if they do not engage in homosexual conduct and if they keep quiet about their sexual orientation. The new rules are to take effect on Feb. 5.

The court ruling in November did not expressly address the constitutionality of the new regulations, but it did bar the Pentagon from dismissing members of the military merely because they say they are homosexual.

The court ordered the Navy to commission the dismissed midshipman, Joseph C. Steffan, and to grant him his diploma. Mr. Steffan was forced to resign from the Naval Academy six weeks before his graduation in 1987 because he had acknowledged under questioning by a disciplinary board that he was homosexual.

The Administration is expected to file its appeal with the full United States Court of Appeals for the District of Columbia Circuit on Thursday.

The November opinion was by the Federal appeals court's three most liberal members: Chief Judge Abner J. Mikva and Judges Patricia M. Wald and Harry T. Edwards. The three, who were randomly selected, were appointed by President Jimmy Carter and are the only members of the full appellate court who are Democrats.

Taking up an old fight over the military's ban on homosexuals.

The full court is dominated by much more conservative judges appointed by Presidents Ronald Reagan and George Bush. Administration officials said today that they were betting that the full appellate court was more likely to side with the Government, particularly since the basis of the appeal would hinge on the separation-of-powers principle instead of the Fifth Amendment's equal-protection guarantee.

Lawyers for gay rights organizations expressed mild surprise at the Government's tactics, saying the commissioning had never been an issue, and vowed to fight the Administration's appeal.

"They're wrong on their legal position on the court's authority, and we're confident the court will deny this motion," said Evan Wolfson, one of Mr. Steffan's attorneys who is the senior lawyer for Lambda Legal Defense and Education Fund, a gay rights group. "We're disappointed by this petty effort to deny an outstanding midshipman his commission."

The case began in 1987, shortly before Mr. Steffan was to graduate as one of the 10 highest-ranking midshipmen in his class. Judged by his instructors as an "outstanding" midshipman who had "exhibited excellent leadership," Mr. Steffan has excelled in military performance. In his junior year he was selected as battalion commander and put in charge of one-sixth of the Academy's 4,500 midshipmen.

'F' for Military Performance

Mr. Steffan's troubles began after he told another midshipman and a chaplain at the Naval Academy about his sexual orientation, and an investigation was started. When Mr. Steffan acknowledged to a disciplinary board that he was homosexual, the panel changed the grade of his military performance from "A" to "F," and recommended that he be dismissed.

In the end, Mr. Steffan resigned and the Defense Department did not reinstate him. He is now a third-year law student at the University of Connecticut.

The Steffan case is also important because it has advanced to the furthest point of judicial review of five cases in Washington and California where district court judges have ruled the old ban unconstitutional.

The outcome of the Steffan case could serve to impair or strengthen the cumulative effect of the other cases, including one earlier this month in which a Government lawyer urged a Federal appeals court panel in San Francisco to reject a lower court order that barred bias against homosexuals in the armed services.

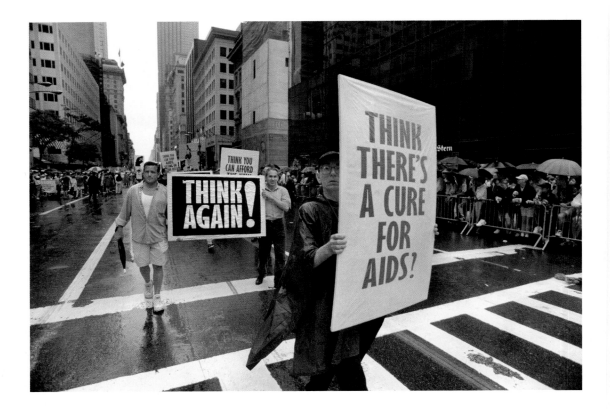

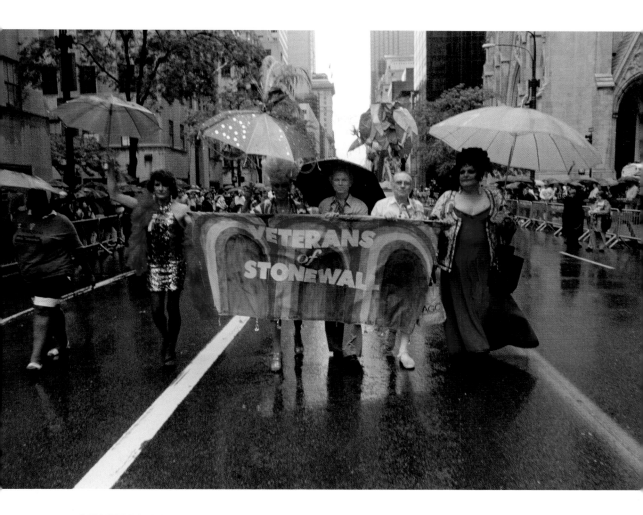

OPPOSITE & ABOVE
New York, June 30, 1996

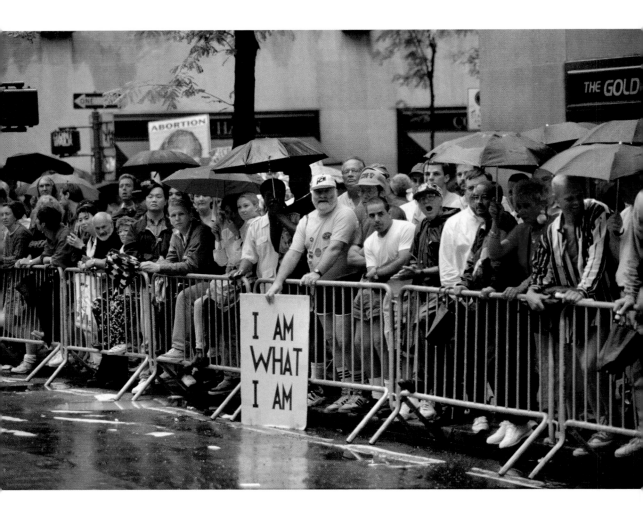

ABOVE & OPPOSITE
New York, June 30, 1996

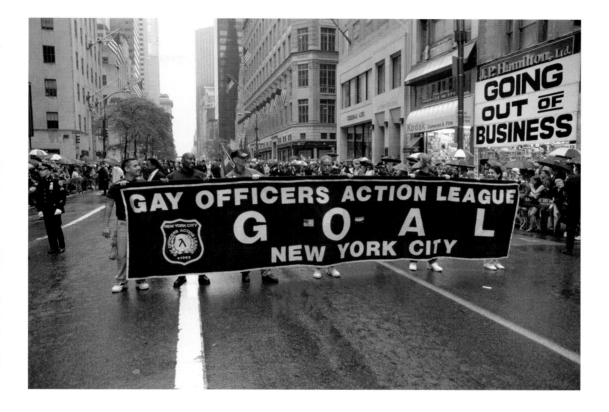

Congressional Bills Withhold Sanction of Same-Sex Unions

By DAVID W. DUNLAP

WASHINGTON, May 8 — State-by-state skirmishes over prospective marriage rights for lesbians and gay men escalated into a national battle today with the introduction in Congress of bills that would deny Federal recognition of same-sex marriages if they were ever legalized.

The bills, introduced by Senator Don Nickles, Republican of Oklahoma, and Representative Bob Barr, Republican of Georgia, would also absolve states of the obligation to recognize same-sex marriages performed in other states.

That gets to the heart of conservatives' concern that if Hawaii sanctions same-sex marriage in the next few years — which is considered a possibility because of a pending court case there — gay couples from around the nation will fly to the islands to be wed legally and then return to their home states to claim the benefits of civil marriage.

"If some state wishes to recognize same-sex marriage, they can do so," Mr. Nickles said today before introducing the measure, known as the Defense of Marriage Act. But he said the bill would insure that "the 49 other states don't have to and the Federal Government does not have to."

Mr. Barr emphasized that the bill "does not outlaw same-sex marriage." But by withholding Federal tax, welfare, pension, health, immigration and survivors' benefits, the bill would deny gay couples many of the civil advantages of marriage.

Critics of the legislation, including the American Civil Liberties Union, said Congress could not simply skirt Article 4 of the Constitution, which says that "full faith and credit shall be given in each state to the public acts, records and judicial proceedings of every other state."

One opponent, Representative Patricia Schroeder, Democrat of Colorado, said: "You can't amend the Constitution with a statute. Everybody knows that. This is just stirring the political waters and seeing what hate you can unleash."

But Mr. Barr said that Article 4 allowed Congress to prescribe "the effect" of the "full faith and credit" clause and that the article had never been interpreted as forcing one state to violate its own public policy in accommodating the laws of another.

"Clearly, Congress has the jurisdiction to do what we're doing," he said.

Mr. Barr said he expected that the bill would move "very quickly" through the Judiciary Committee to the House floor for a vote. He said he anticipated strong bipartisan support, noting that the bill had two Democratic co-sponsors, Representatives Ike Skelton and Harold L. Volkmer, both of Missouri.

President Clinton is "against same-sex marriage," his senior adviser, George Stephanopoulos, said today, but he could not say whether Mr. Clinton would sign the bill, since he had not seen it.

Even Mrs. Schroeder conceded that the bill's chances were "probably very good — it's right before an election." But Daniel Zingale of the Human Rights Campaign, a national lesbian and gay political group, said he was "cautiously optimistic" that members of Congress would stand up against "this kind of gay bashing," even if they opposed same-sex marriage.

For several months, conservative lawmakers around the nation have been introducing bills to foreclose recognition of same-sex marriages. Alaska, Arizona, Georgia, Idaho, Kansas, Oklahoma, South Dakota and Utah have passed such measures, according to the Lambda Legal Defense and Education Fund, a lesbian and gay organization. Legislation has been defeated, withdrawn or vetoed in 15 states and is pending in 8.

In New York, State Senator Serphin R. Maltese, Republican of Queens, introduced a bill on April 17 stating that "a marriage is absolutely void if contracted by two persons of the same sex, regardless of whether such marriage is recognized or solemnized in another jurisdiction." A companion bill in the Assembly was sponsored by Anthony S. Seminerio, Republican of Queens.

In a memorandum, Mr. Maltese said: "Heterosexual relationships traditionally have worked best for the raising of healthy children. In this sense, homosexual relationships are unnatural unions in our society."

But Assemblywoman Deborah J. Glick, a Manhattan Democrat who is a lesbian, said: "We're entitled to the same access to civic institutions. We have not seen Senator Maltese or Assemblyman Seminerio put forth a bill exempting gay men and lesbians in the state of New York from paying income taxes.

"Some people have been led to believe that their own marriage is somehow threatened if other people are allowed to marry," Ms. Glick said. "It's as if there's some finite pool of commitment and love in this world."

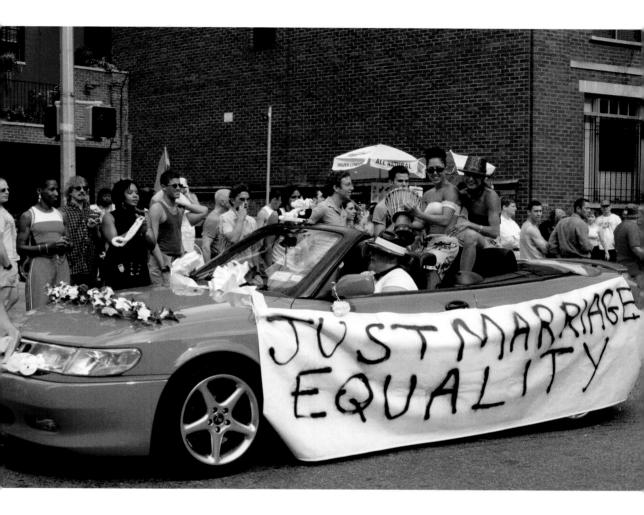

New York, June 28, 1997

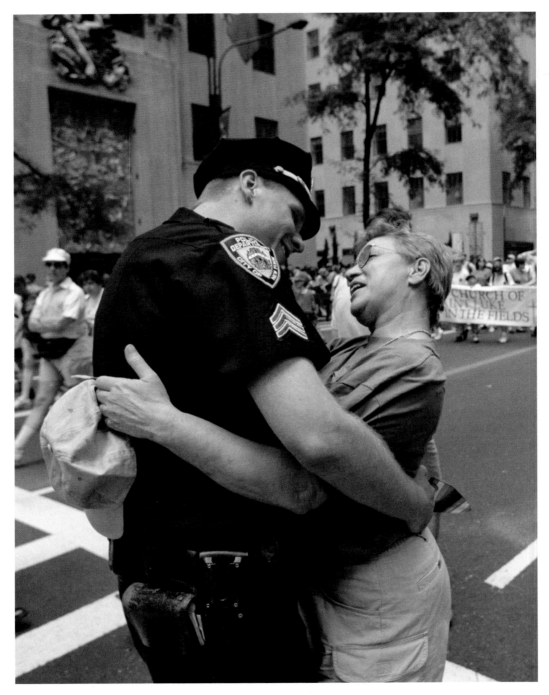

ABOVE & OPPOSITE New York, June 28, 1998

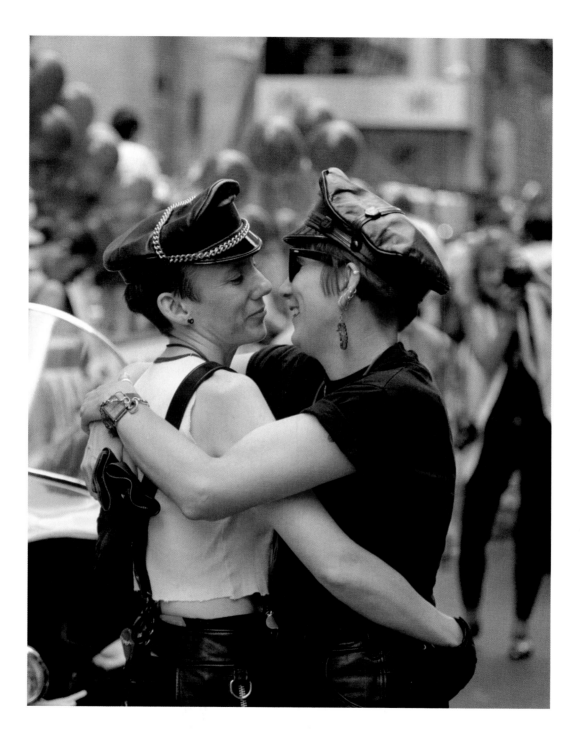

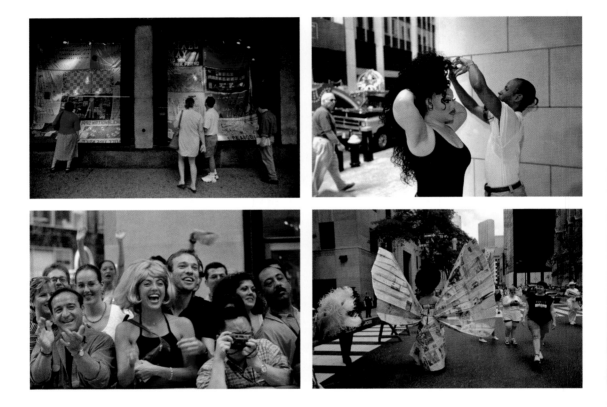

TOP LEFT
During Pride Week, passersby look at pieces of the AIDS Quilt displayed in the window of Saks Fifth Avenue, New York, June 23, 1998.

ABOVE & OPPOSITE
New York, June 28, 1998

FOLLOWING
Hundreds gather at a candlelight vigil for Matthew Shepard at the Cathedral Church of St. John the Divine, New York, October 20, 1998.

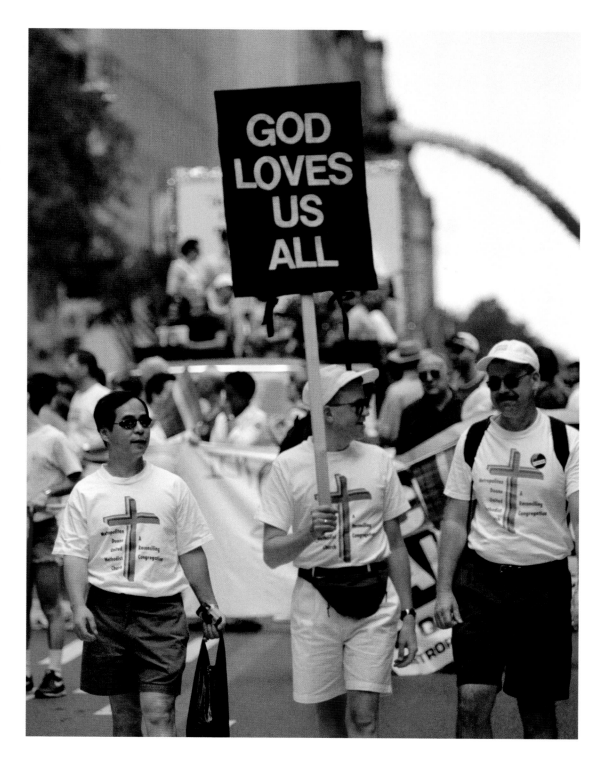

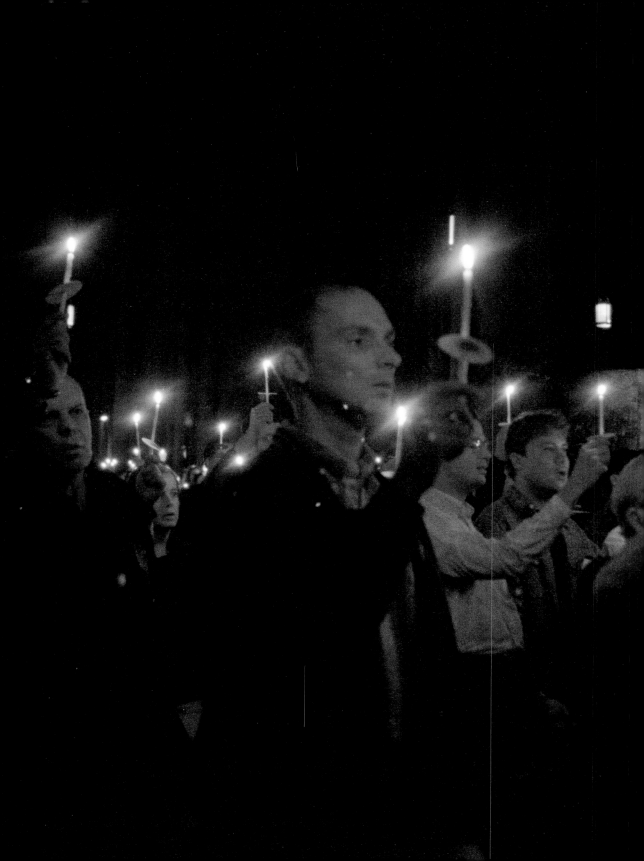

Gay Man Dies From Attack, Fanning Outrage and Debate

By JAMES BROOKE

FORT COLLINS, Colo., Oct. 12 — Matthew Shepard, the gay college student who was kidnapped, robbed and pistol-whipped, died here today, five days after he was rescued from a Wyoming ranch where he had been left tied to a fence for 18 hours in near-freezing temperatures.

His death, announced at the Poudre Valley Hospital here, fanned the outrage that followed word of the attack, spawning vigils, producing calls for Federal hate-crimes legislation from President Clinton and fueling debates over such laws in a host of Western states, including Wyoming, that have resisted them.

In places from Denver to the University of Maryland, people turned out to mourn the soft-spoken 21-year-old who became an overnight symbol of deadly violence against gay people after he was found dangling from the fence by a passerby.

Russell A. Henderson, 21, and Aaron J. McKinney, 22, were charged with attempted murder and are expected to face first-degree murder charges that could bring the death penalty. Their girlfriends, Chasity V. Pasley, 20, and Kristen L. Price, 18, were charged as accessories.

In Denver, mourners wrote messages on a graffiti wall as part of national Gay Awareness Week. In San Francisco, the giant rainbow flag that symbolizes the gay rights movement was lowered to half-staff in the Castro district.

"There is incredible symbolism about being tied to a fence," said Rebecca Isaacs, political director of the National Gay and Lesbian Task Force in Washington. "People have likened it to a scarecrow. But it sounded more like a crucifixion."

The Laramie police have said they believe robbery was the primary motive for the attack, which occurred outside a bar. But investigators also said Mr. Shepard's sexual orientation was a factor. They said the suspects lured Mr. Shepard from the bar by saying they, too, were gay, and one of the women said Mr. Shepard had embarrassed one of the men by making a pass at him, the investigators said.

Today, the Laramie police said that after leaving Mr. Shepard tied to the fence, the men returned to Laramie and picked a fight on a street corner with two Hispanic men, Emiliano Morales 3d, 19, and Jeremy Herrera, 18. Mr. McKinney and Mr. Morales suffered head injuries.

Gay leaders hope that Mr. Shepard's death will galvanize Congress and state legislatures to pass hate-crime legislation or broaden existing laws. Conservatives, particularly Christian conservatives, generally oppose such laws, saying they extend to minorities "special rights."

In the last two decades, 21 states and the District of Columbia have passed laws that increase penalties for crimes that are committed because of race, religion, color, national origin and sexual orientation.

Another 19 states, including Colorado, do not include sexual orientation in their hate-crime laws. Ten states, including Wyoming, have no hate-crime laws, or none based on specific categories.

In Washington, Mr. Clinton responded to news of Mr. Shepard's death by urging Congress to pass the Federal Hate Crimes Protection Act, which would make Federal offenses of crimes based on sex, disability and sexual orientation.

"Congress needs to pass our tough hate-crimes legislation," Mr. Clinton said. Current law covers only crimes based on race, color, religion or national origin.

Wyoming has been a holdout, rejecting three hate-crimes bills since 1994, most recently in February. But today, after the death of Mr. Shepard, who was a University of Wyoming freshman, Jim Geringer, the state's popular Governor, opened the door to legislation at a news conference. "I ask for a collective suggestion for anti-bias, anti-hate legislation that can be presented to the Wyoming Legislature for their consideration in January," he said.

The Governor met this morning with Dennis Shepard, Matthew's father, and said the father did not want the death to become "a media circus" and that "we should not use Matt to further an agenda."

Mr. Geringer said that Dennis Shepard also said: "Don't rush into just passing all kinds of new hate-crimes laws. Be very careful of any changes and be sure you're not taking away rights of others in the process to race to this."

Leaders of gay rights groups interviewed today said they would respect the family's privacy by not attending the burial in Casper, Wyo., on Saturday. But they added they hoped the death would have an impact.

"Matthew's death, I hope, will bring about a better and deeper understanding of hate-crime laws," said Elizabeth Birch, executive director of the Human Rights Campaign, a lesbian and gay rights group that has 250,000 members.

In 1996, 21 men and women were killed in the United States because of their sexual orientation, according to the Southern Poverty Law Center, an Alabama group that tracks violence against minorities. According to the Federal Bureau of Investigation, sexual orientation was a factor in 11.6 percent of the 8,759 hate crimes recorded in 1996.

But Christian conservatives warn that gay leaders want to use today's death to expand hate-crime laws and curtail freedom of speech.

"Hate-crimes laws have nothing to do with perpetrators of violent crime and everything to do with silencing political opposition," said Steven A. Schwalm, an analyst with the Family Research Council, a Washington group dedicated to defending "faith, family and freedom."

"It would criminalize pro-family beliefs," Mr. Schwalm said. "This basically sends a message that you can't disagree with the political message of homosexual activists."

Agreement came from John Paulk, who was featured this summer in advertisements about how he and his wife, Anne, "overcame" homosexuality through religion.

"We have every right to speak out against an agenda that is contrary to Biblical norms," said Mr. Paulk, who describes himself as a homosexuality specialist for Focus on the Family, a Christian group in Colorado Springs. "Because we are standing up and opposing the homosexual agenda, we are being looked upon as advocating violence against homosexuals, when we categorically reject violence against homosexuals."

Last Thursday, the Family Research Council unveiled a series of television advertisements that preach the "healing" of homosexuality through religious conversion. Gay leaders charge that these advertisements help create a hostile climate for homosexuals, a climate that can lead to violence.

Hate-crime laws on the books in 40 states have not impinged on freedom of speech, said Brian Levin, a criminal justice professor who directs the Center on Hate and Extremism at Stockton College, in Pomona, N.J.

"We want to deter the broken windows and simple assaults before they escalate," he said.

Mr. Levin said that his research indicated that homosexuals suffered higher rates of violent crime than the population at large. He said that roughly half of the people who attack homosexuals are male, age 22 or under.

"With other crimes, violence is a means to an end; with hate crimes, the violence becomes an unstoppable goal," Mr. Levin said.

Mr. Shepard suffered a dozen cuts to his head, face and neck, as well as a massive, and ultimately fatal, blow to the back of his skull.

While some gay leaders saw crucifiction imagery in Mr. Shepard's death, others saw a different symbolism: the Old West practice of nailing a dead coyote to a ranch fence as a warning to future intruders.

"This University of Wyoming student was beaten and left to die, tied to a fence like an animal because he was honest and open about being gay," Beatrice Dohrn, legal director of the Lambda Legal Defense and Education Fund, said today. "Matthew Shepard's horrible suffering and death cannot be dismissed simply as the fault of deranged, isolated individuals," Ms. Dohrn said. "His attackers are among millions of Americans who constantly hear the message that gay people are not worthy of the most basic equal treatment."

30 Years After Stonewall, Diversity Is Shown in Gay Pride Parade

By AMY WALDMAN

Firefighter Tom Ryan walked soberly down Fifth Avenue yesterday, the Fire Commissioner at his side, the Mayor a few feet ahead, and a gyrating, feather-bedecked moving carnival of gay Brazilians behind.

For the first time in the 30-year history of the Gay and Lesbian Pride March, an active-duty firefighter in blue dress uniform was marching in the parade, and the Fire Department, known for its heavily male, tradition-bound culture, was recognizing Fireflag, a gay firefighters' group, as an official "line organization" in the parade.

The image of a uniformed firefighter amid thousands of gay men, lesbians, bisexuals, transvestites and transsexuals, some clad in shorts and T-shirts, others in heels and leather thong underwear, spoke volumes about the diversity of the gay rights movement 30 years after a police raid sparked an uprising at the Stonewall Inn in Greenwich Village and made the Stonewall a powerful symbol of resistance.

It also illuminated the uneasy bond that the movement and the establishment, once completely at odds, have formed. Twenty-nine years ago, there was a demonstration at City Hall against allowing homosexuals in the Fire Department — an incident that contrasts sharply with "the Fire Commissioner and the Mayor of the city proudly marching down the avenue," Firefighter Ryan said.

But Mayor Rudolph W. Giuliani was repeatedly heckled along the parade route, particularly by a contingent of minority marchers who were angry that he was marching close to them. The police said three people were arrested, two on charges of disorderly conduct and one on charges of petty larceny.

"You should be able to march as the Mayor of New York City anyplace you want," Mr. Giuliani said after he made his planned exit from the parade route, "and if people can't deal with their own anger over that, that's really something emerging from them, from inside them."

Jimmy Riordan, a spokesman for Heritage of Pride, which organizes the parade, was unapologetic. "Nobody is barred from being in the parade," he said. "It's completely open to all people. He's just not popular."

There were other tensions. Members of a group called SexPanic! said that near the end of the parade route, at Seventh Avenue South and Christopher Street, the police told them to pull the group's car, an old police car holding the self-styled "Rudy's sex police," out of the parade or face arrest because it was "inappropriate."

The police said the marchers' attire, or lack thereof, was the problem. "They were asked to leave the route because they were naked, from the waist down," said Lieut. Cory Cuneo, a police spokesman. "It didn't have anything to do with the police car or anything else."

And soon after the parade began, a clutch of protesters, kept safely behind a barricade, shouted at the marchers. Randall Terry, the founder of Operation Rescue, an antiabortion group, and of an antigay group called the Resistance, said, "We cannot pretend this is a normal life style. It is an abhorrent abomination." He called Stonewall an "anniversary of disgrace" and said, "Our goal is to mobilize resistance to these people at every level. They cannot prevail because there is a God in heaven."

But by the thousands — 700,000, according to parade organizers, or 100,000, according to the police — participants marched joyously. Among them were about 50 police officers who are members of the Gay Officers Action League.

Officer Anna Marie Buckley marched next to her longtime partner, Detective Marianne Murawski, and pushed a double stroller with their two daughters. Each woman had one child by artificial insemination from the same anonymous donor, Officer Buckley said.

The contingent of police officers in the Pride March grows each year, Officer Buckley said. "More and more people are realizing that the best place to be is out of the closet," she said. "People criticize you less, they ridicule you less."

Officer Buckley said the attitude of the Police Department toward gay men and lesbians had improved considerably since she joined the department eight years ago.

And Thomas Von Essen, the Fire Commissioner, said he was determined to bring his department along the same route.

"Our department is a very male-dominated group of people, and it's important for them to be rough and tough," he said. That makes them brave, he said, but not always accepting of those who are different.

"It's 1999," he continued. "These firefighters have proven they are just as competent, just as determined to do as good a job, and they deserve the respect of everyone else."

Firefighter Ryan, the only firefighter among 8,800 in New York City who has publicly declared that he is gay, said he had a "very, very" difficult time after he came out a year ago, and some friends in the department turned their backs on him. But he is undeterred.

"I'm hoping to show young people struggling in their sexuality that they can grow up to be a fireman or a cop," Firefighter Ryan said, "that they can have the same hopes and dreams as any other little kid."

The parade was a tapestry of stories and a tableau of images. Members of one leather-clad group stopped periodically along the route for demonstrations of sadism and masochism, whipping one another. The police officers lining the route watched them stoically, as they did the women who marched topless.

The sounds of the parade — a variety of music, including salsa and reggae — told another story, that of the growing number of immigrants for whom coming out is an American rite of passage. Among them was Bassam Kassab, 30, a graduate student in Boston who is from Lebanon.

When his mother, Aida, arrived for a visit from Lebanon two weeks ago, she did not know that he was gay, he said. But on Friday, as he drove to New York, he narrowly avoided a serious accident. He pulled into a rest stop and called his mother, who was still in Boston.

" 'I almost died,' " he said he told her, " 'and there's something I haven't told you for 15 years: I'm gay.' "

Her response, he said, was immediate: " 'You should have told me a long time ago, because that's how you are born, and I would have supported you, and you wouldn't have lived in misery for 15 years.' "

Yesterday, members of Karama, the New England Lavender Arab Society, pulled her along the parade route in a cart on which had been pasted a hand-lettered sign: "Proud Lebanese Gay's Mom."

Elaine Benov, 67, was another proud mother marching, if a bereft one. Two of her four sons were gay; both died in 1990 of complications from AIDS. "We have to be here for them, for their memories," she said.

On Stonewall's 30th anniversary, she contemplated life before Stonewall, when gay men could be arrested based on how they walked or dressed or sought companionship.

"How grateful I am that my sons didn't have to go through that," she said.

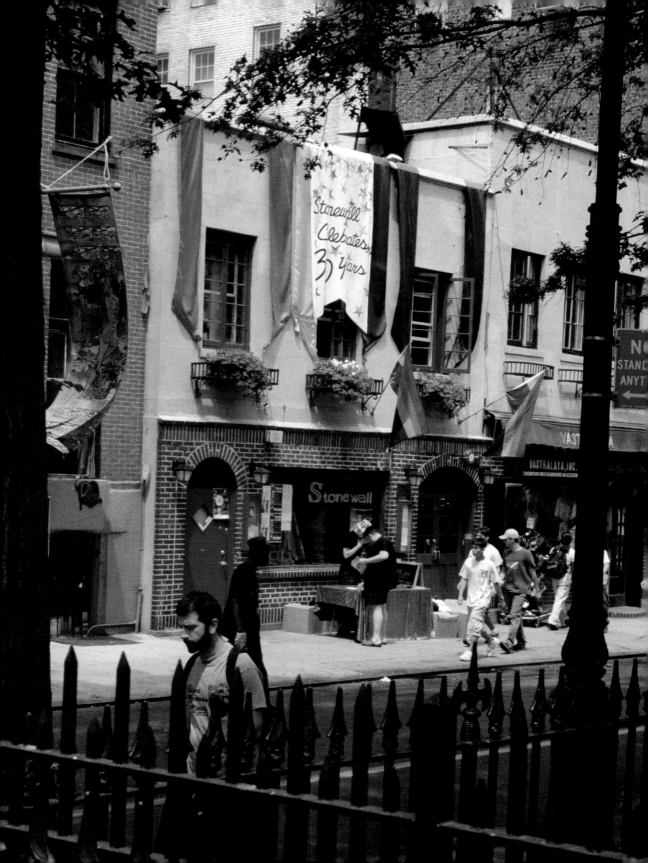

For Gays, Tolerance Is a Prime-Time Fantasy

With Pride and Corsages, Gay Proms Reach Suburbs

Social change has yet to bring legal equality for gays.

Gay Marchers Will Flex Political Muscle in Capital

Vermont Senate Votes For Gay Civil Unions

AIDS Groups Revive A Fight, and Themselves

Exchanging of Vows By Gays in Vermont

In Vermont, Gay Couples Head for the Almost-Altar

For Gay Men, Health Care Concerns Move Beyond the Threat of AIDS

Vermont Residents Split Over Civil Unions Law

Senate Panel Backs Hate-Crime Coverage for Gays

A Parade Underscores Candidates' Unity on Gay Issues

More Respect, but Too Few Rights

Passenger on Jet: Gay Hero or Hero Who Was Gay?

Gay History Is Still in the Closet

Gay Army Linguists Say They Were Ousted

Battle on Gay Pride Shirts Leads to Suit Against School

Old Dream and New Issues 40 Years After Rights March

JUSTICES, 6-3, LEGALIZE GAY SEXUAL CONDUCT IN SWEEPING REVERSAL OF COURT'S '86 RULING

Conservatives Furious Over Court's Direction

Gays Celebrate, and Plan Campaign for Broader Rights

AIDS After 'Angels': Not Gone, Not Forgotten

Small-Town

Teenage Girl Fatally Stabbed At a Bus Stop In Newark

Double Lives On The Down Low

Gay America

Fighting for Gay Rights in Full Cry

Caution in Court for Gay Rights Groups

Fearing Backlash, Legal Challenges Will Focus on Civil Unions

Gay Couples Pop Big Question, But the States' Reply Is the Same

The Two Sides of Stonewall

Boy Scouts Under Fire Ban on Gays Is at Issue

As gay couples marry in San Francisco, political battles heat up everywhere.

Backers of Gay Marriage Ban Use Social Security as Cudgel

Raise Glasses on Common Ground

Dozens of Gay Couples Marry in San Francisco Ceremonies

The Road to Gay Marriage

At Long Last Love: The Joy of Gay Marriage

Before politicians knew it, the queer eye was everywhere in straight culture.

Gay Rights Battlefields Spread to Public Schools

State Action Is Pursued On Same-Sex Marriage

New York Plans To Make Gender Personal Choice

A Quest for a Restroom That's Neither Men's Room Nor Women's Room

Aging and Gay, and Facing Prejudice in Twilight

House Backs Broad Protections for Gay Worker

Two Gay Cowboys Hit a Home Run

Claiming Constant Harassment, Gay Police Officer in City Files Suit

Judge in California Voids Ban on Same-Sex Marriage

Homophobia Is Alive in Men's Locker Rooms

Gay Band to March in Inauguration Parade

For Some Black Pastors, Accepting Gay Members Means Losing Others

A New Push to Roll Back 'Don't Ask, Don't Tell'

'Don't Ask, Don't Tell' Hits Women Much More

Some Tormented by Homosexuality Look to a Controversial Therapy

Psychologists Reject Gay 'Therapy'

BANS IN 3 STATES ON GAY MARRIAGE

Religious Right Exults — California Change

Marriage Ban Inspires New Wave of Gay Rights Activists

Gay Vows, Obama Invites Gay Rights Advocates to White House

Repeated REJECTING VETO, From State VERMONT BACKS To State GAY MARRIAGE

The Pressure to Cover

Political Shifts on Gay Rights Lag Behind Culture

Gay Groups Use Donations To Become a Force in Elections

A Setback for Same-Sex Marriage

House, 281-146, Votes to Define Antigay Attacks as Hate Crimes

A RAZOR-THIN MARGIN

Coming Out in Middle School

40 Years Later, Still Second-Class Americans

2000s

Recovery and rebirth are perhaps the best ways to describe LGBTQ culture in the first decade of the second millennium. More than twenty years into the AIDS crisis, infection rates began to stabilize—and then tumble—as more effective medications shifted the disease from a near-certain death sentence to a manageable condition. Gay men worldwide began to free themselves from the stigma of the disease and embrace a future few could ever have anticipated just a decade before.

Despite this progress, discrimination persisted. In 2000, the Supreme Court ruled in favor of the Boy Scouts of America, supporting its decision to exclude members due to sexual orientation.

As HIV began to recede from the forefront of the LGBTQ community, a vibrant decade of culture, politics, and social justice began to emerge. The legal battle for marriage equality truly came into its own—kicking off in 2000 when Vermont became the first state to legalize same-sex civil unions. By 2008, Massachusetts, Oregon, California, and New Jersey would follow Vermont's lead to offer LGBTQ couples the cultural and legal recognition so long denied to them. The Supreme Court also struck down national sodomy laws in 2003, ruling these anti-gay statutes "unconstitutional" and paving the way for true personal and sexual freedom.

This "normalization" extended far beyond the marriage registry. In 2000, for instance, *Queer as Folk* began its five-year television run as a sexually charged drama set in Pittsburgh focusing on a wide range of LGBTQ archetypes. Three years later came *Queer Eye for the Straight Guy*, which brought a camp-filled, out-and-proud, innuendo-rich sensibility straight to America's living rooms (it also foreshadowed the important impact LGBTQ people would have on the reality television explosion in the decade ahead). And in 2005, there was *Noah's Ark*, another gay teledrama, only with an all African-American cast. Four years later, *Glee* and *Modern Family*, popular shows that included gay main characters, arrived.

This was also the decade that saw *Will & Grace* become a hit, a funny, often poignant look at Manhattan life through the lens of its gay protagonists. Both *Will & Grace* and *Queer Eye* made such an impact that they returned to television—updated and rebooted—a decade after they went off the air. Lesbians were also making a cultural impact. Rosie O'Donnell came out in 2002 on *The View*, the daytime talk show she cohosted. A year later, Ellen DeGeneres returned from small-screen exile to launch her now daily program—which fifteen years later is the definition of "mainstream" television (and a winner of more than thirty Emmy Awards). Then, in 2004, *The L Word* premiered on Showtime, showcasing the lives of a close-knit, multicultural, successful, stylish, and sexy lesbian friendship circle.

The era's most pivotal cultural moment, however, took place mid-decade in 2005, when the film *Brokeback Mountain*—which told the story of two closeted Wyoming cowboys—won three Academy Awards, the first gay-themed movie to achieve widespread critical, box office, and Oscar acclaim.

Despite such achievements, this decade also brought important—and unexpected—setbacks. In 2008, at the same time that America elected its first African-American president, voters in California, Arizona, and Florida passed measures to ban marriage equality. Same-sex marriages immediately ceased in California—where 18,000 ceremonies had been performed since it was made legal by local courts six months earlier. Although the next six months welcomed marriage equality to Iowa, Maine, Vermont, and New Hampshire, nationwide equality had not yet been achieved by the close of the decade.

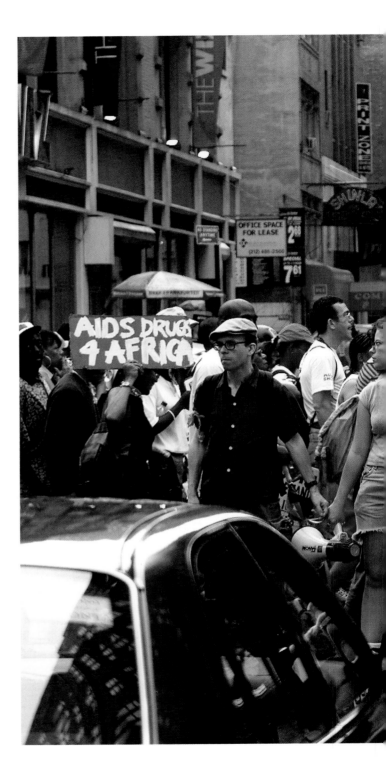

New York, June 24, 2001

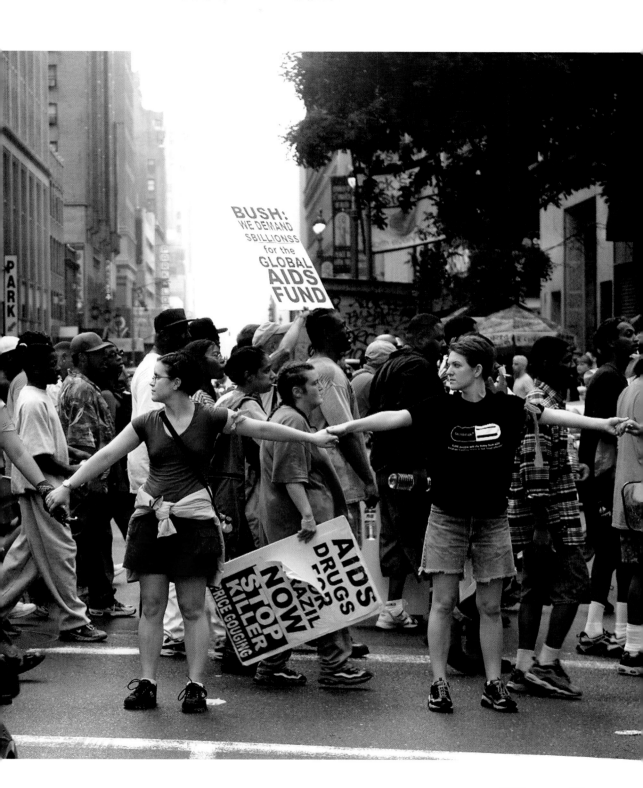

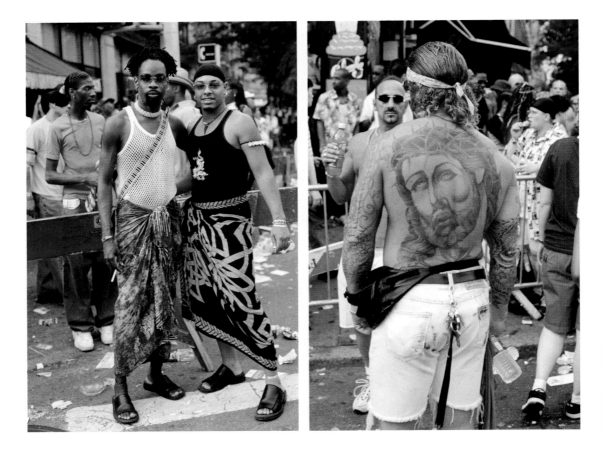

ABOVE & OPPOSITE
New York, June 24, 2001

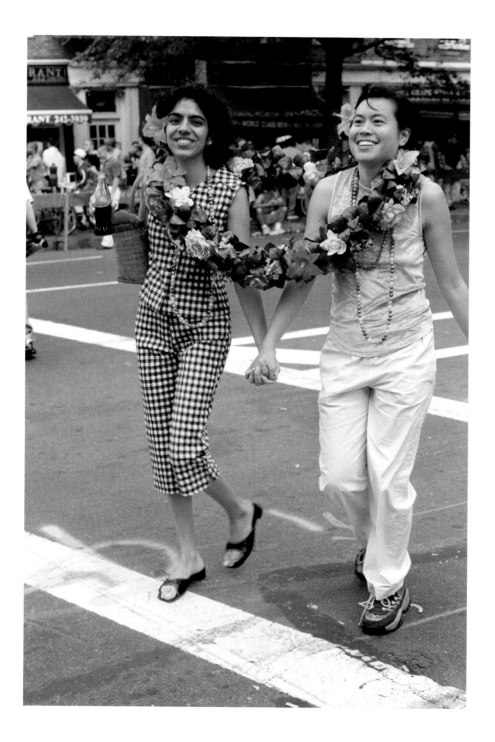

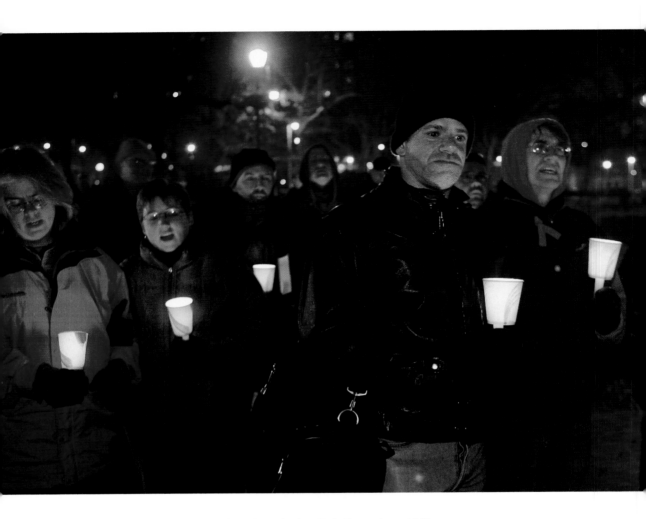

Marchers observe World AIDS Day in New York, December 1, 2002.

JUSTICES, 6-3, LEGALIZE GAY SEXUAL CONDUCT IN SWEEPING REVERSAL OF COURT'S '86 RULING

By LINDA GREENHOUSE

WASHINGTON, June 26 — The Supreme Court issued a sweeping declaration of constitutional liberty for gay men and lesbians today, overruling a Texas sodomy law in the broadest possible terms and effectively apologizing for a contrary 1986 decision that the majority said "demeans the lives of homosexual persons." The vote was 6 to 3.

Gays are "entitled to respect for their private lives," Justice Anthony M. Kennedy said for the court. "The state cannot demean their existence or control their destiny by making their private sexual conduct a crime."

Justice Kennedy said further that "adults may choose to enter upon this relationship in the confines of their homes and their own private lives and still retain their dignity as free persons." [Excerpts, Pages A18-19.]

While the result had been widely anticipated since the court agreed in December to hear an appeal brought by two Houston men who were prosecuted for having sex in their home, few people on either side of the case expected a decision of such scope from a court that only 17 years ago, in Bowers v. Hardwick, had dismissed the same constitutional argument as "facetious." The court overturned that precedent today.

In a scathing dissent, Justice Antonin Scalia accused the court of having "taken sides in the culture war" and having "largely signed on to the so-called homosexual agenda." He said that the decision "effectively decrees the end of all morals legislation" and made same-sex marriage, which the majority opinion did not discuss, a logical if not inevitable next step. Chief Justice William H. Rehnquist and Justice Clarence Thomas signed Justice Scalia's dissent.

While some gay rights lawyers said that there were still abundant legal obstacles to establishing a right either to gay marriage or to military service by gay soldiers, there was no doubt that the decision had profound legal and political implications. A conservative Supreme Court has now identified the gay rights cause as a basic civil rights issue.

Ruth Harlow, legal director of the Lambda Legal Defense and Education Fund and the lead counsel for the two men, John G. Lawrence and Tyron Garner, called the decision "historic and transformative." Suzanne Goldberg, a professor at Rutgers Law School who represented the men in the Texas courts, said that the decision would affect "every kind of case" involving gay people, including employment, child custody and visitation, and adoption.

"It removes the reflexive assumption of gay people's inferiority," Professor Goldberg said. "Bowers took away the humanity of gay people, and this decision gives it back."

The vote to overturn Bowers v. Hardwick was 6 to 4, with Justice Kennedy joined by Justices John Paul Stevens, David H. Souter, Ruth Bader Ginsburg and Stephen G. Breyer.

"Bowers was not correct when it was decided, and it is not correct today," Justice Kennedy said. "Its continuance as precedent demeans the lives of homosexual persons."

Justice Sandra Day O'Connor, who was part of the 5-to-4 majority in Bowers v. Hardwick, did not join Justice Kennedy in overruling it. But she provided the sixth vote for overturning the Texas sodomy law in a forcefully written separate opinion that attacked the law on equal protection grounds because it made "deviate sexual intercourse" — oral or anal sex — a crime only between same-sex couples and not for heterosexuals.

"A law branding one class of persons as criminal solely based on the state's moral disapproval of that class and the conduct association with that class runs contrary to the values of the Constitution and the Equal Protection Clause," Justice O'Connor said.

Texas was one of only four states — Kansas, Oklahoma and Missouri are the others — to apply a criminal sodomy law exclusively to same-sex partners. An additional nine states — Alabama, Florida, Idaho, Louisiana, Mississippi, North Carolina, South Carolina, Utah and Virginia — have criminal sodomy laws on their books that in theory, if not in practice, apply to opposite-sex couples as well. As a result of the majority's broad declaration today that the government cannot make this kind of private sexual choice a crime, all those laws are now invalid.

Twenty-five states had such laws at the time the court decided Bowers v. Hardwick. The Georgia sodomy law the court upheld in that case was overturned by a state court ruling in 1998. Some of the other state laws have been repealed and others invalidated by state courts.

In the Texas case, Mr. Lawrence and Mr. Garner were discovered by the Houston police while having sex in Mr. Lawrence's apartment. The police entered through an unlocked door after receiving a report from a neighbor of a "weapons disturbance" in the apartment. The neighbor was later convicted of filing a false report.

The men were held in jail overnight. They later pleaded no contest, preserving their right to appeal, and were each fined $200. The Texas state courts rejected their constitutional challenge to the law.

Asked today for the Bush administration's reaction to the ruling, Ari Fleischer, the White House press secretary, noted that the administration had not filed a brief in the case. "And now this is a state matter," he said. In fact, the decision today, Lawrence v. Texas, No. 02-102, took what had been a state-by-state matter and pronounced a binding national constitutional principle.

The delicacy of the moment for the White House was apparent. Groups representing the socially conservative side of the Republican Party reacted to the decision with alarm and fury. On the other hand, important libertarian groups had supported the challenge to the Texas law. Justice Thomas, who is often in sympathy with libertarian arguments, wrote a brief separate dissenting opinion today with a nod in that direction.

He said he would vote to repeal the law if he were a member of the Texas Legislature. "Punishing someone for expressing his sexual preference through noncommercial consensual conduct with another adult does not appear to be a worthy way to expend valuable law enforcement resources," Justice Thomas said, but added that he could not overturn the law as a judge because he did not see a constitutional basis for doing so.

Charles Francis, co-chairman of the Republican Unity Coalition, a group of gay and heterosexual Republicans seeking to defuse the issue within the party, said today, "I hope the giant middle of our party can look at this decision not as a threat but as a breakthrough for human understanding." The group includes prominent Republicans like former President Gerald R. Ford, David Rockefeller and Alan K. Simpson, the former senator from Wyoming, who is its honorary chairman. No member of the Bush administration has joined the group, Mr. Francis said.

As the court concluded its term today, the absence of any sign of a retirement meant that the issue was not likely to surface in judicial politics anytime soon. There was a tense and ultimately humorous moment in the courtroom this morning when, after the announcements of decisions, Chief Justice Rehnquist brought the term to a close with his customary words of thanks to the court staff.

A broad ruling that invalidates laws in 13 states that make sodomy a crime.

"The court today notes the retirement," he then said drily as those in the audience caught their breath, "of librarian Shelley Dowling." A collective sigh and audible chuckles followed as the marshal, Pamela Talkin, banged her gavel and the nine justices left the bench, all of them evidently planning to return when the court meets on Sept. 8 for arguments in the campaign finance case.

Earlier, as Justice Kennedy was reading excerpts from his decision, the mood in the courtroom went from enormous tension and then — on the part of the numerous gay and lesbian lawyers seated in the bar section — to visible relief. By the time he referred to the dignity and respect to which he said gays were entitled, several were weeping, silently but openly.

The majority opinion was notable in many respects: its critical dissection of a recent precedent; its use of a decision by the European Court of Human Rights, supporting gay rights, to show that the court under Bowers v. Hardwick was out of step with other Western countries; and its many citations to the court's privacy precedents, including the abortion rights cases.

The citations to Roe v. Wade and Planned Parenthood v. Casey appeared particularly to inflame Justice Scalia. If Bowers v. Hardwick merited overruling, he said, so too did Roe v. Wade. He also said that laws against bigamy, adultery, prostitution, bestiality and obscenity were now susceptible to challenges.

The majority opinion did not precisely respond to that prediction, noting instead that the right claimed by Mr. Lawrence and Mr. Garner did not involve prostitution, public behavior, coercion or minors.

The fundamental debate on the court was over the meaning of the Constitution's due process guarantee, which Justice Kennedy said was sufficiently expansive so that "persons in every generation can invoke its principles in their own search for greater freedom."

Wedding-license applicants wait their turn in Cambridge City Hall after Massachusetts became the first state to legalize gay marriage, May 17, 2004.

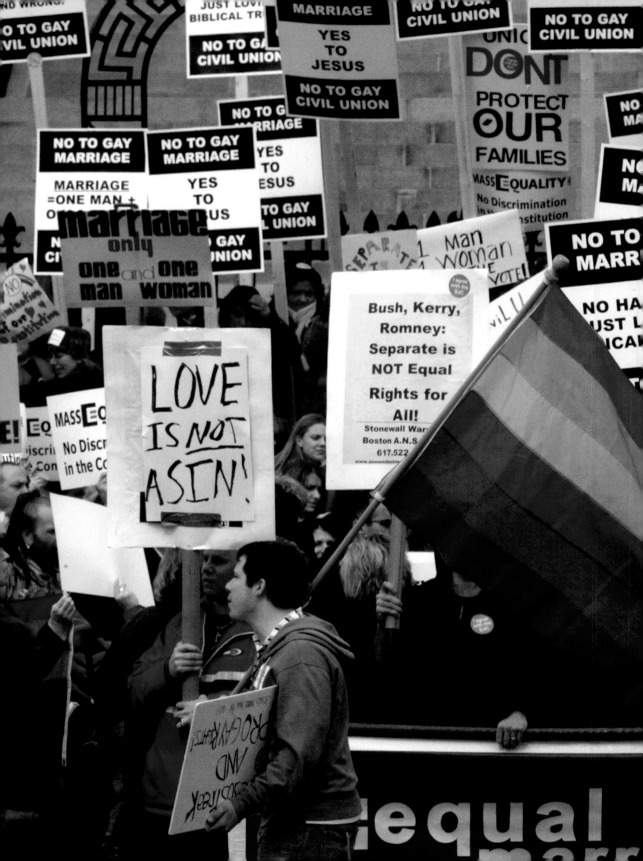

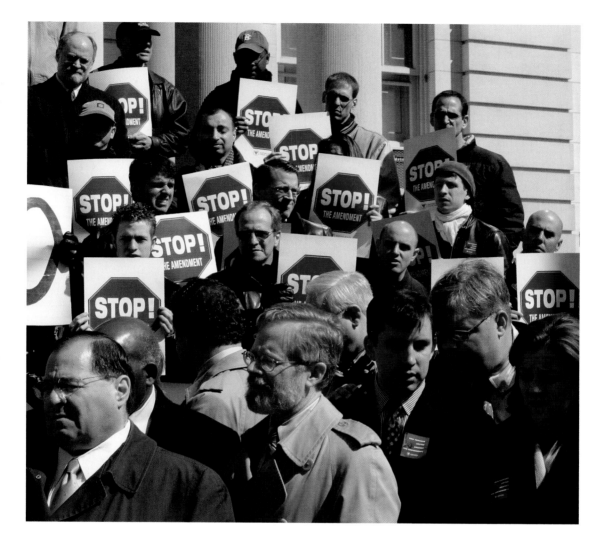

OPPOSITE
Groups for and against same-sex marriage demonstrate outside of the State House in Boston on March 11, 2004.

ABOVE
Congressman Jerrold Nadler, left, City Council Speaker Gifford Miller, and State Senator Thomas Duane attend a rally on the steps of City Hall to protest the proposed constitutional amendment that would ban gay marriage, New York, March 12, 2004.

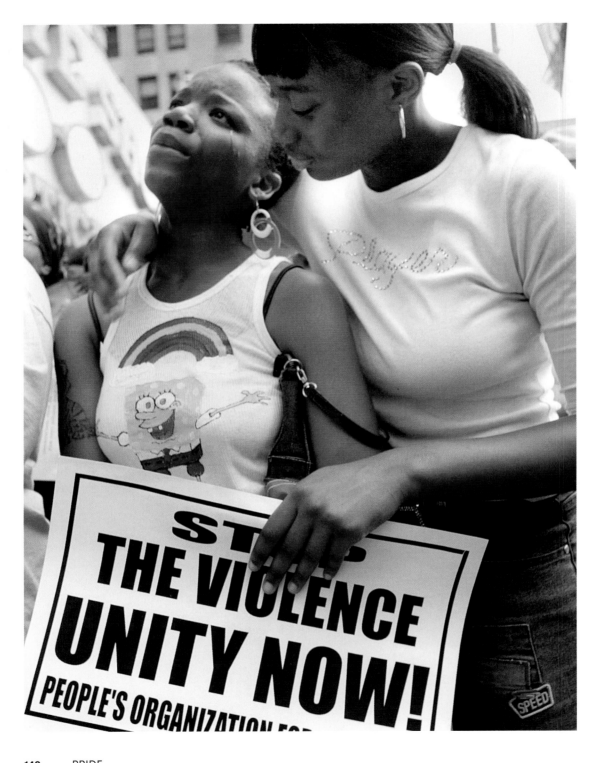

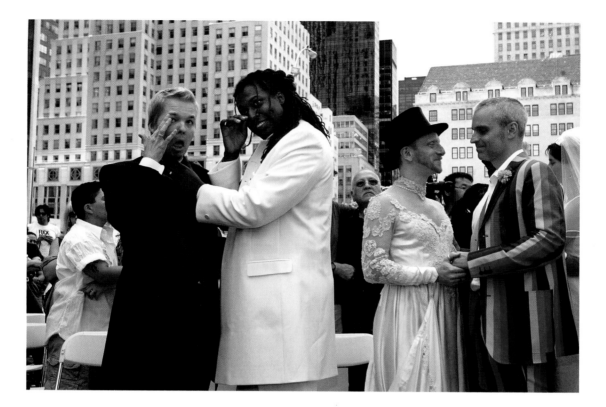

OPPOSITE
Two young women attend a vigil in Newark, New Jersey, for their friend Sakia Gunn as officials declare May 11, 2004, "no name-calling day." The gathering was held at the intersection of Market and Broad Streets, where Gunn was killed one year prior.

ABOVE
Two couples exchange wedding vows during the fourth annual mass wedding ceremony. New York, June 27, 2004

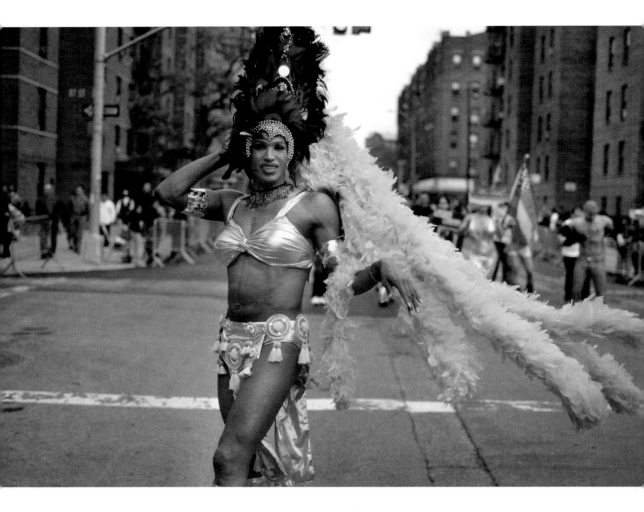

ABOVE & OPPOSITE
New York, June 6, 2004

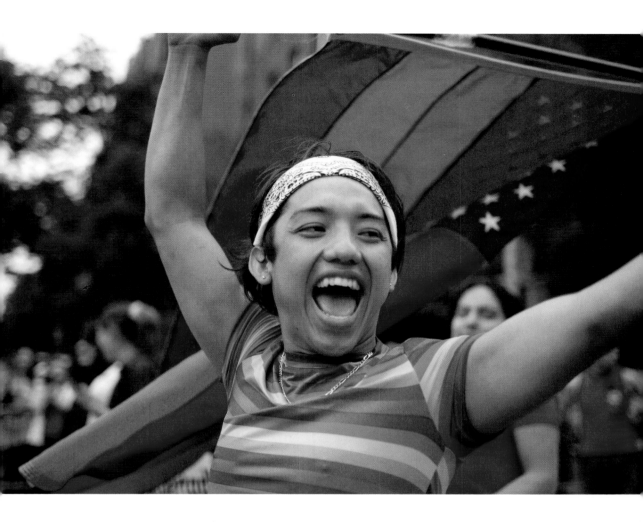

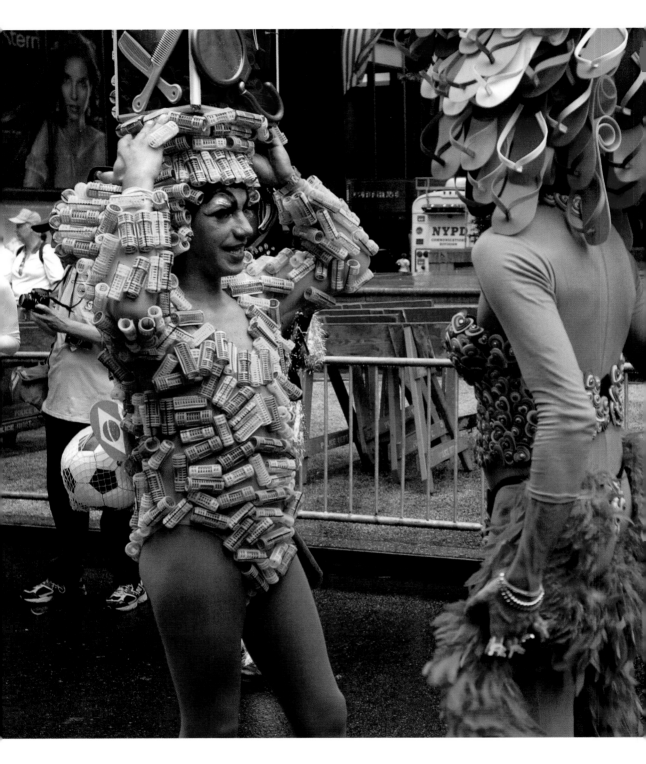

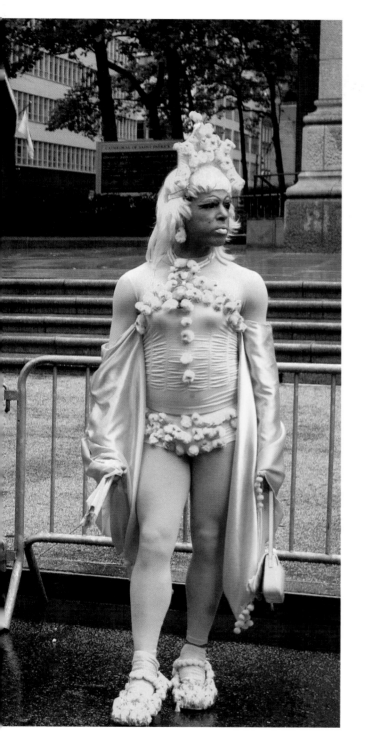

Marcy, Ilia Papeao, and Agatha on the corner
of 5th Avenue and 51st Street in New York,
June 25, 2006

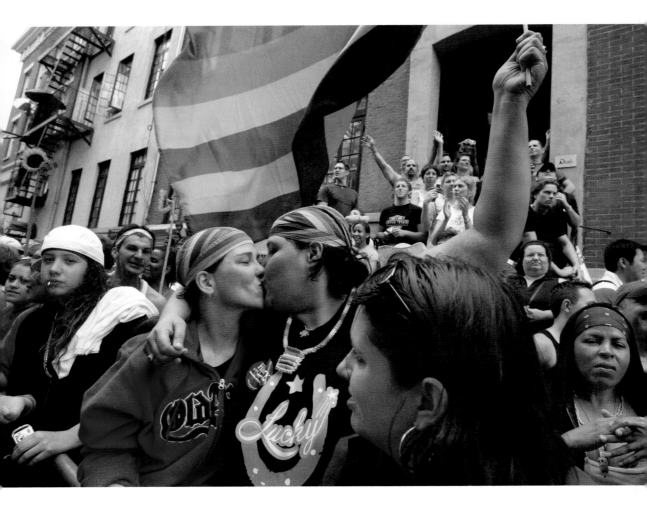

ABOVE & OPPOSITE
New York, June 25, 2006

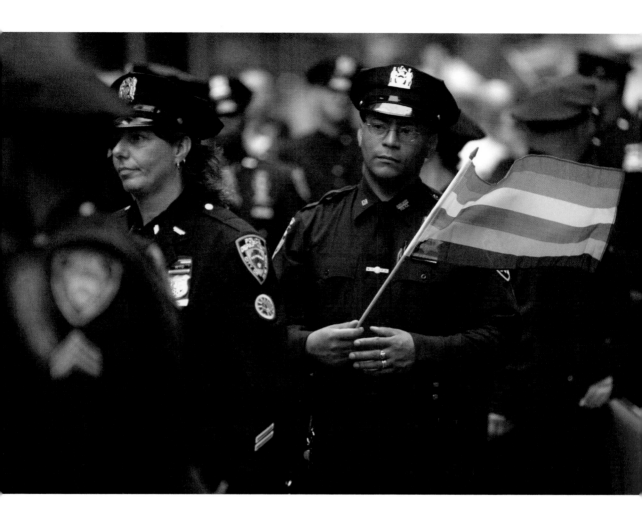

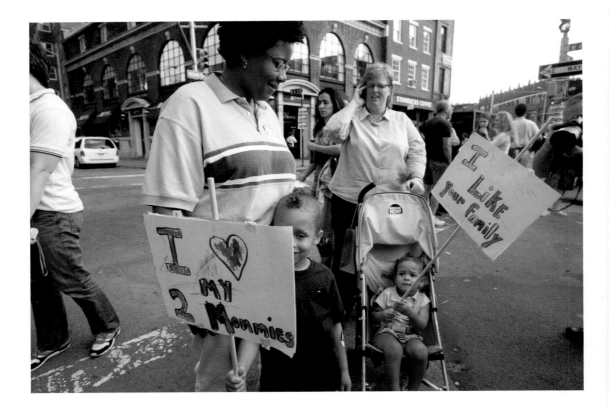

ABOVE & OPPOSITE
A rally held in support of same-sex marriage after the New York State
Supreme Court ruled against it, July 6, 2006

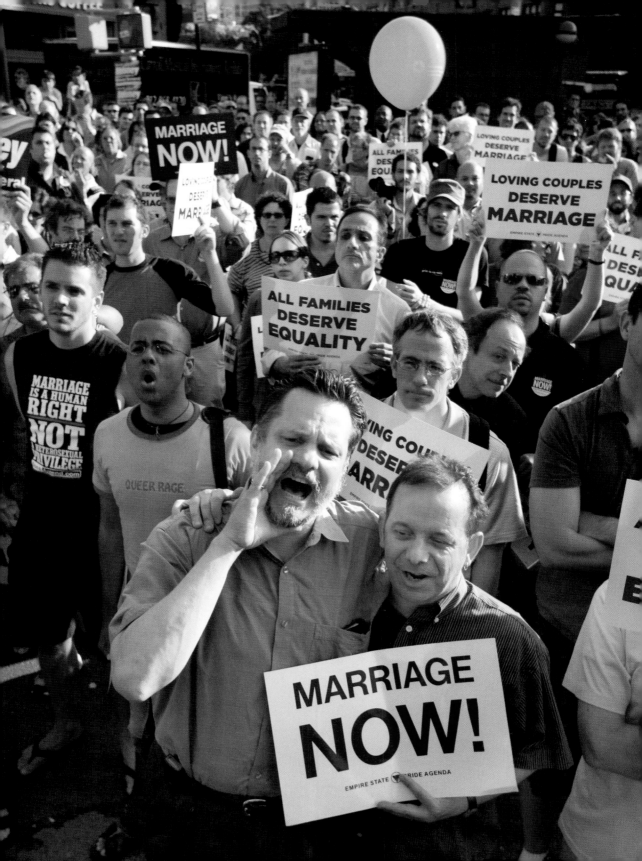

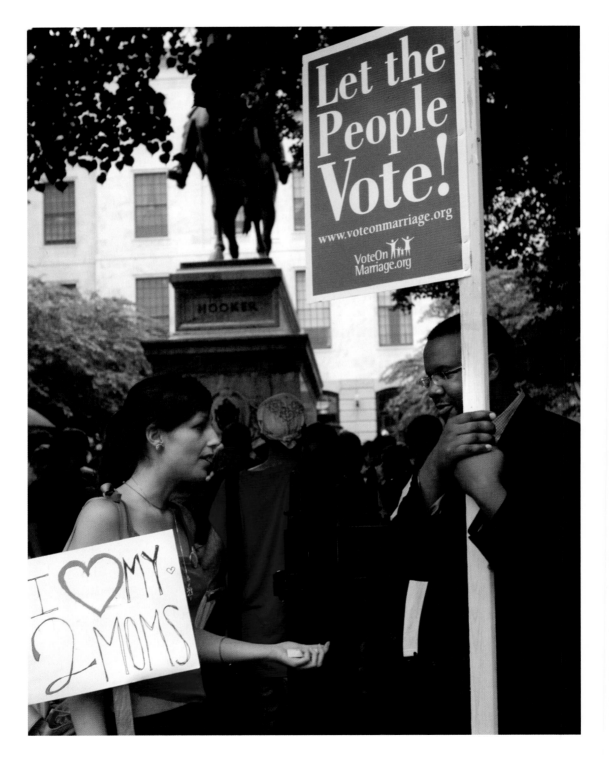

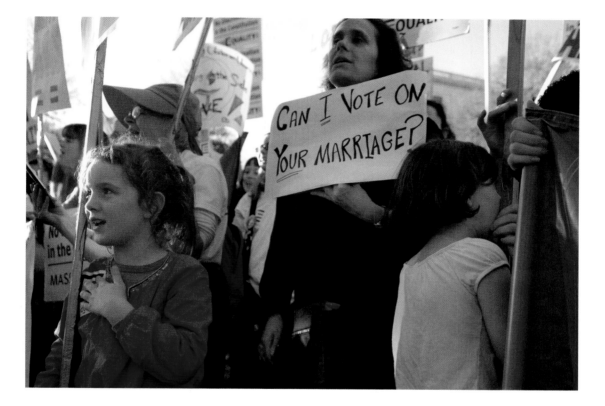

OPPOSITE
Debating the right to same-sex marriage outside the Massachusetts State House in Boston, July 12, 2006.

ABOVE
Supporters of same-sex marriage sing "This Land Is Your Land" as they rally outside the State House in Boston, where the Massachusetts Legislature convened a constitutional convention to vote on an amendment that would ban same-sex marriage, November 9, 2006.

FOLLOWING, TOP
Supporters of same-sex marriage celebrate outside the Massachusetts State House after legislators voted against a measure that would have put it on the ballot, June 14, 2007.

FOLLOWING, BOTTOM
An opponent of same-sex marriage is arrested at the Massachusetts State House after slapping a supporter, June 14, 2007.

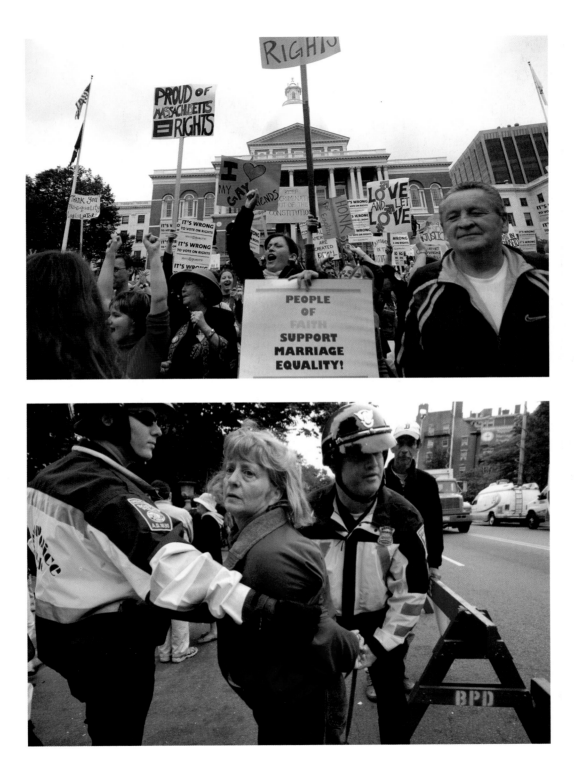

BANS IN 3 STATES ON GAY MARRIAGE

Religious Right Exults — California Change

By JESSE McKINLEY and LAURIE GOODSTEIN

SAN FRANCISCO — A giant rainbow-colored flag in the gay-friendly Castro neighborhood of San Francisco was flying at half-staff on Wednesday as social and religious conservatives celebrated the passage of measures that ban same-sex marriage in California, Florida and Arizona.

In California, where same-sex marriage had been performed since June, the ban had more than 52 percent of the vote, according to figures by the secretary of state, and was projected to win by several California news media outlets. Opponents of same-sex marriage won by even bigger margins in Arizona and Florida. Just two years ago, Arizona rejected a similar ban.

The across-the-board sweep, coupled with passage of a measure in Arkansas intended to bar gay men and lesbians from adopting children, was a stunning victory for religious conservatives, who had little else to celebrate on an Election Day that saw Senator John McCain lose and other ballot measures, like efforts to restrict abortion in South Dakota, California and Colorado, rejected.

"It was a great victory," said the Rev. James Garlow, senior pastor of Skyline Church in San Diego County and a leader of the campaign to pass the California measure, Proposition 8. "We saw the people just rise up."

The losses devastated supporters of same-sex marriage and ignited a debate about whether the movement to expand the rights of same-sex couples had hit a cultural brick wall, even at a time of another civil rights success, the election of a black president.

Thirty states have now passed bans on same-sex marriage.

Supporters of same-sex marriage in California, where the fight on Tuesday was fiercest, appeared to have been outflanked by the measure's highly organized backers and, exit polls indicated, hurt by the large turnout among black and Hispanic voters drawn to Senator Barack Obama's candidacy. Mr. Obama opposes same-sex marriage.

California will still allow same-sex civil unions, but that is not an option in Arizona and Florida. Exit polls in California found that 70 percent of black voters backed the ban. Slightly more than half of Latino voters, who made up almost 20 percent of voters, favored the ban, while 53 percent of whites opposed it.

Julius Turman, a chairman of the Alice B. Toklas L.G.B.T. Democratic Club, a gay political group here, said he called his mother in tears when Mr. Obama won the presidency, only to be crying over the same-sex marriage vote in a different way not much later.

"It is the definition of bittersweet," Mr. Turman said. "As an African-American, I rejoiced in the symbolism of yesterday. As a gay man, I thought, 'How can this be happening?'"

Proposition 8's passage left only Massachusetts and Connecticut as states where same-sex marriages are legal, though both Rhode Island and New York will continue to recognize such ceremonies performed elsewhere. Civil unions or domestic partnerships, which carry many of the same rights as marriage, are allowed in a handful of states. More than 40 states now have constitutional bans or laws against same-sex marriages.

On Wednesday, five months of same-sex marriages in California — declared legal by the State Supreme Court in May — appeared to have come to a halt. "This city is no longer marrying people" of the same sex, Gavin Newsom, the mayor of San Francisco, announced at a grim news conference at City Hall, where hundreds of same-sex couples had rushed to marry in the days and hours leading up to Tuesday's vote.

The status of those marriages, among 17,000 same-sex unions performed in the state, was left in doubt by the vote. The state's attorney general, Jerry Brown, reiterated Wednesday that he believed that those marriages would remain valid, but legal skirmishes were expected.

The cities of Los Angeles and San Francisco, and Santa Clara County, as well as several civil rights and gay rights groups, said on Wednesday that they would sue to block the ban.

Some opponents of the proposition were also still holding out slim hopes that a batch of perhaps as many as four million provisional and vote-by-mail ballots would somehow turn the tide.

The victory of the social and religious conservatives came on a core issue that has defined their engagement in politics over the past decade.

The Rev. Joel Hunter, an evangelical pastor in Florida, said many religious conservatives felt more urgency about stopping same-sex marriage than about abortion, another hotly contested issue long locked in a stalemate.

"There is enough of the population that is alarmed at the general breakdown of the family, that has been so inundated with images of homosexual relationships in all of the media," said Mr. Hunter, who gave the benediction at the Democratic National Convention this year, yet supported the same-sex marriage ban in his state. "It's almost like it's obligatory these days to have a homosexual couple in every TV show or every movie."

Supporters of the bans in California, Arizona and Florida benefited from the donations and volunteers mobilized by a broad array of churches and religious groups from across the ethnic spectrum.

The Rev. Samuel Rodriguez, a pastor in Sacramento and president of the National Hispanic Christian Leadership Conference, said the campaign to pass Proposition 8 had begun with white evangelical churches but had spread to more than 1,130 Hispanic churches whose pastors convinced their members that same-sex marriage threatened the traditional family.

"Without the Latino vote," Mr. Rodriguez said, "Proposition 8 would never have succeeded."

Frank Schubert, the campaign manager for Protect Marriage, the leading group behind Proposition 8, agreed that minority votes had put the measure over the top, saying that a strategy of working with conservative black pastors and community leaders had paid off.

"It's a big reason why we won, no doubt about it," he said.

Proposition 8 was one of the most expensive ballot measures ever waged, with combined spending of more than $75 million. Focus on the Family and other religious conservative groups contributed money to help pass the same-sex marriage measures in all three states.

Forces on both sides viewed California as a critical test of the nation's acceptance of gay people, who have made remarkable strides in the decades since the 1969 riots in New York at the Stonewall Inn, considered the beginning of the gay rights movement.

Scholars were divided on how large a setback Tuesday's votes would be for that movement. Andrew Koppelman, a professor of law at Northwestern University and the author of "Same Sex, Different States," a study of same-sex marriage, said the outcome had a silver lining, namely that it was closer than in previous statewide measures.

A 2000 ballot measure establishing a California state law against same-sex marriage passed with 61 percent of the vote. That law was overturned in May by the State Supreme Court.

In Arizona, where same-sex marriage was already against the law, the victory for Proposition 102, which amends the State Constitution, was met with a shrug by some.

"I think the country was like, 'Look, you get Obama, call it a day and go home,'" said Kyrsten Sinema, a Democratic state representative who led opponents against Proposition 102. "And frankly, I'll take it."

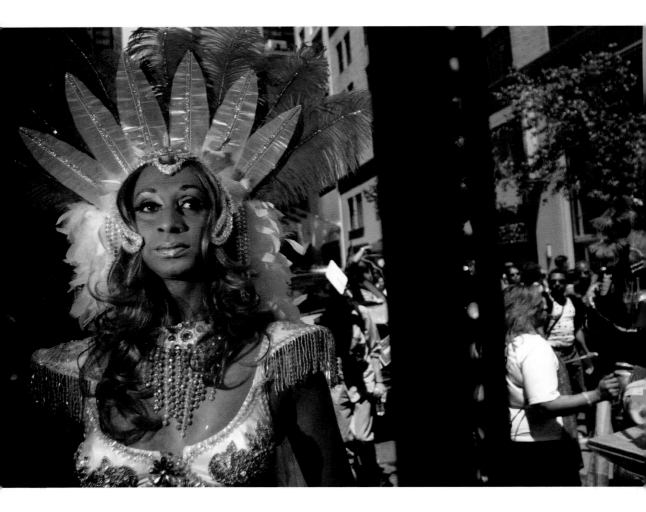

ABOVE & OPPOSITE
New York, June 24, 2007

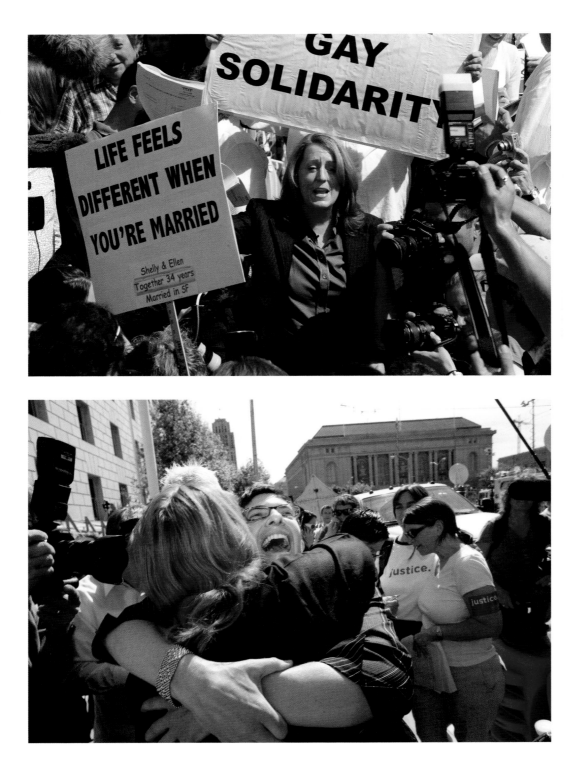

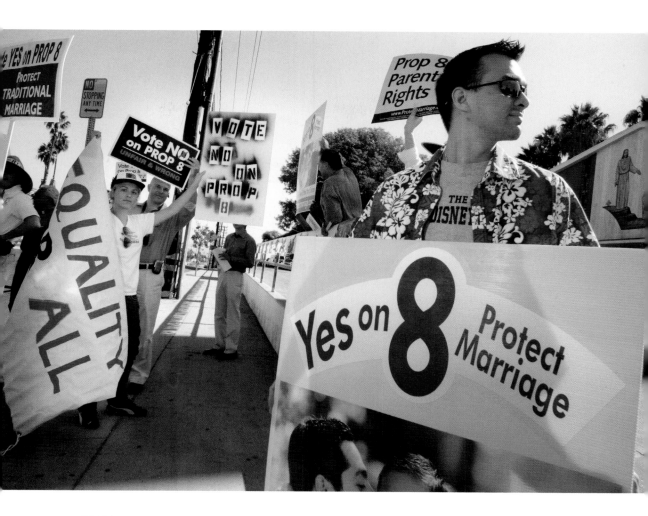

OPPOSITE
Kate Kendall declares, "We won" as the crowd celebrates the California State Supreme
Court ruling in favor of same sex unions, May 15, 2008.

ABOVE
Opponents and supporters of Proposition 8, which would ban same-sex marriage in
California, gather outside St. Frances Cabrini Church in Los Angeles on October 24, 2008.

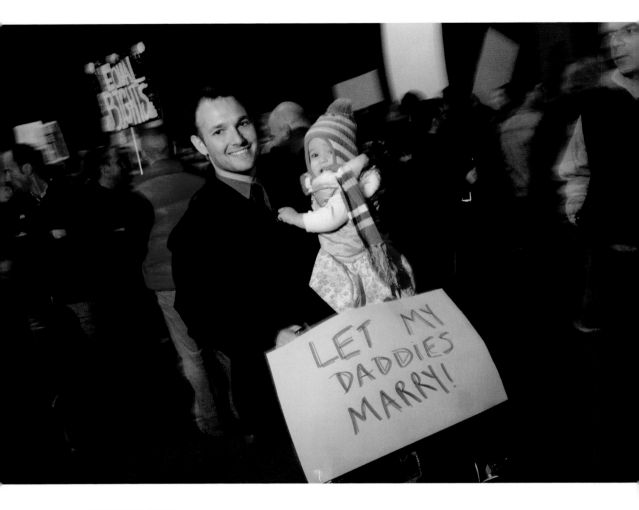

OPPOSITE & ABOVE
Thousands of marchers gather in front of the Mormon church in New York on November 12, 2008, to protest the vote in California on Prop 8. The Church of Jesus Christ of Latter Day Saints heavily financed the measure.

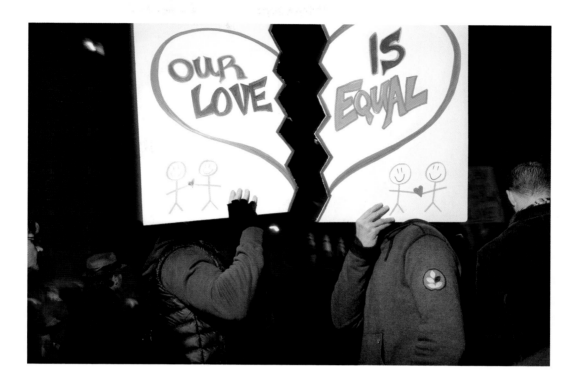

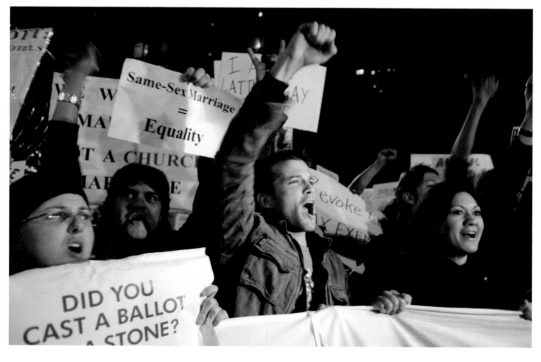

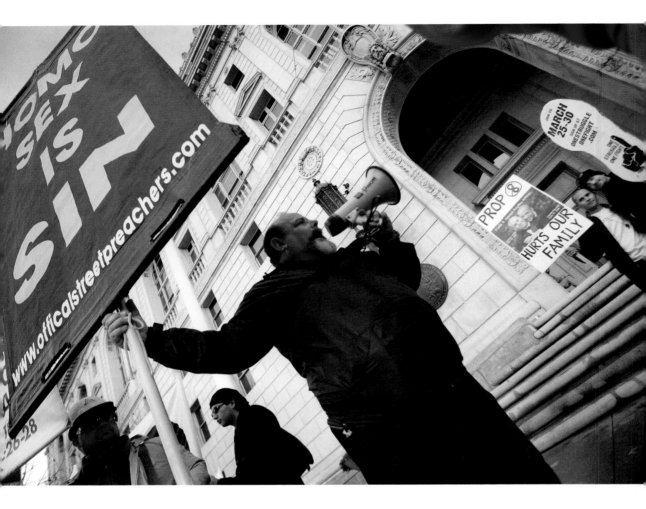

Supporters and opponents of Prop 8 gathered on the steps of the California State Supreme Court, where justices were to hear challenges to the law in San Francisco on March 5, 2009. Ruben Israel, a preacher from L.A., stood in front of the courthouse with a banner declaring homosexuality a sin while a gay couple, Joseph and Frank Capley-Alfano, who were married in 2008, held signs denouncing Prop 8.

House, 281-146, Votes to Define Antigay Attacks as Hate Crimes

By CARL HULSE

WASHINGTON — The House voted Thursday to expand the definition of violent federal hate crimes to those committed because of a victim's sexual orientation, a step that would extend new protection to lesbian, gay and transgender people.

Democrats hailed the vote of 281 to 146, which brought the measure to the brink of becoming law, as the culmination of a long push to curb violent expressions of bias like the 1998 murder of Matthew Shepard, a gay Wyoming college student.

"Left unchecked, crimes of this kind threaten to ruin the very fabric of America," said Representative Susan A. Davis, Democrat of California, a leading supporter of the legislation.

Under current federal law, hate crimes that fall under federal jurisdiction are defined as those motivated by the victim's race, color, religion or national origin.

The new measure would broaden the definition to include those committed because of gender, sexual orientation, gender identity or disability. It was approved by the House right before a weekend when gay rights will be a focus in Washington, with a march to the Capitol and a speech by President Obama to the Human Rights Campaign.

Republicans criticized the legislation, saying violent attacks were already illegal regardless of motive. They said the measure was an effort to create a class of "thought crimes" whose prosecution would require ascribing motivation to the attacker.

Representative John A. Boehner of Ohio, the House Republican leader, called the legislation radical social policy.

"The idea that we're going to pass a law that's going to add further charges to someone based on what they may have been thinking, I think is wrong," Mr. Boehner said.

Republicans were also furious that the measure was attached to an essential $681 billion military policy bill, and accused Democrats of legislative blackmail.

Even some Republican members of the usually collegial House Armed Services Committee who helped write the broader legislation, which authorizes military pay, weapons programs and other necessities for the armed forces, opposed the bill in the end, solely because of the hate crimes provision.

"We believe this is a poison pill, poisonous enough that we refuse to be blackmailed into voting for a piece of social agenda that has no place in this bill," said Representative Todd Akin of Missouri, a senior Republican member of the committee.

On the final vote, 237 Democrats were joined by 44 Republicans in support of the bill; 131 Republicans and 15 Democrats opposed it. The Democratic opponents were a mix of conservatives who were against the hate crimes provision and liberals opposed to Pentagon provisions.

The military bill has yet to be approved by the Senate. But the hate crimes provision has solid support there, and Senator John McCain of Arizona, the senior Republican on the Senate Armed Services Committee, said the overall bill outweighed his own objections to including the hate crimes measure.

Mr. Obama supports the hate crimes provision, though the White House has raised objections to elements of the bill related to military acquisitions. If signed into law, the hate crimes legislation would reflect the ability of Democrats to enact difficult measures with their increased majorities in Congress and a Democrat in the White House.

"Elections have consequences," Mr. McCain said.

Similar hate crime provisions have passed the House and the Senate in previous years but have never been able to clear their final hurdles. Speaker Nancy Pelosi said Thursday that it was fitting that Congress was acting now, since next Monday is the 11th anniversary of Matthew Shepard's killing. The hate crimes part of the bill is named for Mr. Shepard and James Byrd Jr., a black man killed in a race-based attack in Texas the same year.

The hate crimes legislation would give the federal government authority to prosecute violent crimes of antigay bias when local authorities failed to act. It would also allocate $5 million a year to the Justice Department to provide assistance to local communities in investigating hate crimes, a process that can sometimes strain police resources. And it would allow the department to assist in the inquiry and local prosecution if requested.

"The problem of crimes motivated by bias," the measure says, "is sufficiently serious, widespread and interstate in nature as to warrant federal assistance to states, local jurisdictions and Indian tribes."

Senator Carl Levin, the Michigan Democrat who heads the Armed Services Committee, said that the Federal Bureau of Investigation recorded reports of more than 77,000 hate crimes from 1998 through 2007 and that crimes based on sexual orientation were on an upward trend.

"The hate crimes act will hopefully deter people from being targeted for violent attacks because of the color of their skin or their religion, their disability, their gender or their sexual orientation, regardless of where the crime takes place," he said.

But Representative Mike Pence of Indiana, the No. 3 House Republican, said the measure could inhibit freedom of speech and deter religious leaders from discussing their views on homosexuality for fear that those publicly expressed views might be linked to later assaults.

"It is just simply wrong," Mr. Pence said, "to use a bill designed to support our troops to reverse the very freedoms for which they fight."

Democrats, however, noted that the bill would specifically bar prosecution based on an individual's expression of "racial, religious, political or other beliefs." It also states that nothing in the measure should be "construed to diminish any rights under the First Amendment to the Constitution."

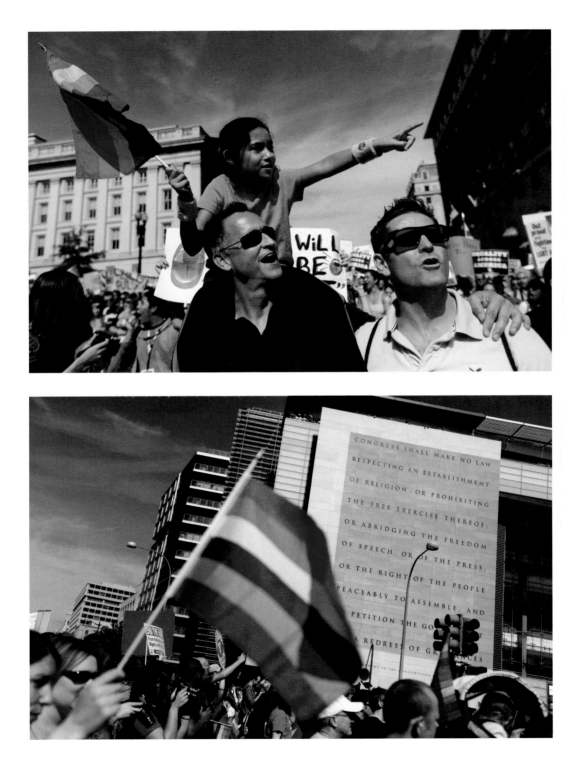

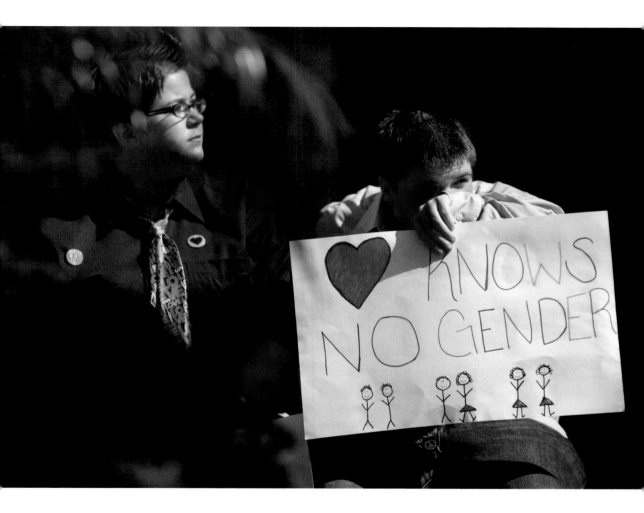

OPPOSITE, ABOVE, & FOLLOWING
National Equality March in Washington, D.C., October 12, 2009

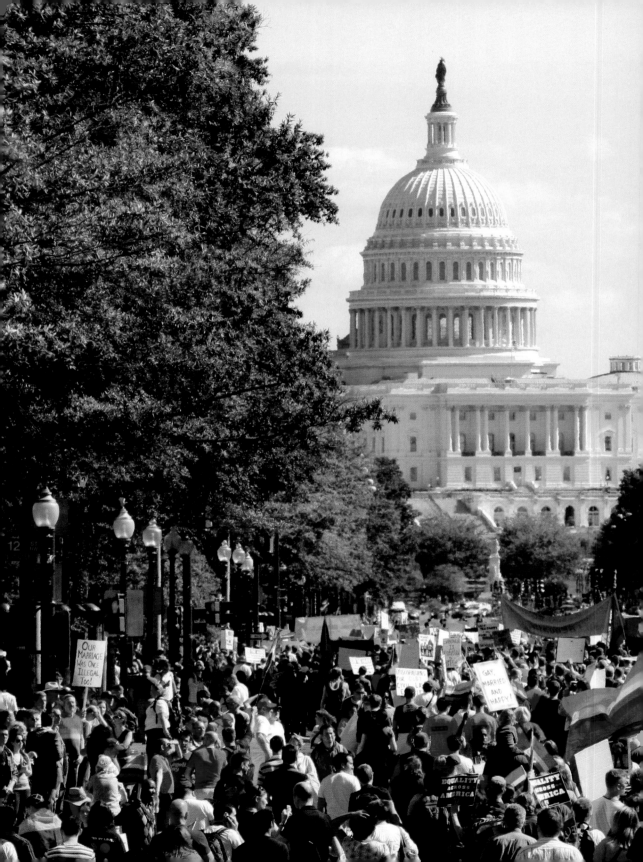

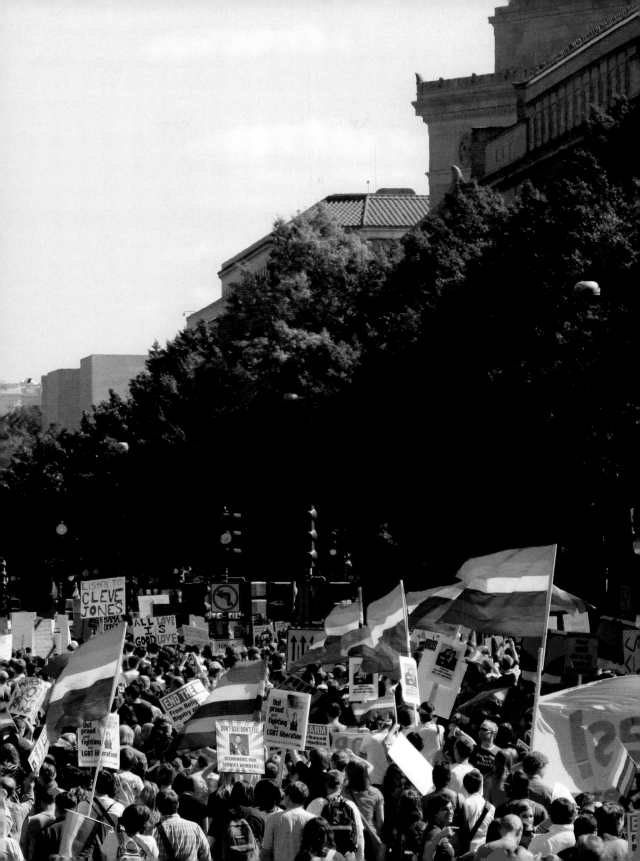

Several Recent Suicides Put Light on Pressures Facing Gay Teenagers

LOVE IN THE TIME OF STONEWALL
The real lovers behind a Village sculpture.

Antigay Attacks Reported At Stonewall and in Chelsea

'It Gets Better' Starting Now for Gay Youth

Obama Ends 'Don't Ask, Don't Tell' Policy

California To Require Gay History In Schools

IN TURNABOUT, U.S. SAYS MARRIAGE ACT BLOCKS GAY RIGHTS

WITH WAIT OVER, GAY COUPLES WED

California Ban On Gay Unions Is Struck Down

Faith Groups Campaign To Block Gay Marriage

Gay Identity Refracted In Multiple Voices

ACROSS NEW YORK

Homosexual straight out of the womb? It's unclear. And immaterial.

Proposition 8 Violated Rights, Judges Rule

OBAMA CAMPAIGN PUSHES THE ISSUE OF GAY MARRIAGE

As Victories Pile Up, Gay Rights Advocates Cheer 'Milestone Year'

Crowd Led by Priests Storms Gay Rights March in Georgia

A Tipping Point for Gay Marriage?

Openly Gay in the Bronx, but Constantly on Guard

Same-Sex Marriage Support Shows Pace of Social Change Accelerating

Gay Marriage Victory Still Shadowed by AIDS

A Sea Change in Less Than 50 Years As Gay Rights Gained Momentum

Effects of Ruling on Same-Sex Marriage Start Rippling Out Through Government

Obama Calls For 'Repairing'

N.F.L. Is Pressured on Issues of Gay Rights

Celebrating Pride and Progress at Parade

Of Gays to End

In Shadow of the Stonewall Inn, a Gay Man Is Killed

Rainbow-Hued Housing for Gays in Golden Years

Court Follows Lead of a Nation That Rapidly Changed Course

A response spurred b a transgender youth's online suicide note.

A Decade of Progress on AIDS

Bill Clinton's Decision, and Regret, Over Signing the Defense of Marriage Ac

Young Opponents of Gay Marriage Undaunted by Battle Ahead

Rights Bill Sought for Lesbian, Gay, Bisexual and Transgender Americans

For Gay Community, Finding Acceptance Is Even More Difficult on the Streets

JUSTICES EXTEND BENEFITS TO GAY COUPLES; ALLOW SAME-SEX MARRIAGES IN CALIFORNIA

Boy Scouts End Ban on Gay Leader Over Protests by Mormon Church

Collins, First Openly Gay N.B.A. Player, Signs With Nets and Appears in Game

Celebrating the nation's rapid shift on same-sex marriage.

'EQUAL DIGNITY'

The Long Road to Marriage Equalit

5-4 Ruling Makes Same-Sex Marriage a Right Nationwid

Next Fight for Gay Rights: Bias in Jobs and Housing

An Ecstatic Toast to Equal Rights in New York and San Francisco

N.F.L. Prospect Proudly Says What Teammates Knew: He's Gay

50 Killed at Gay Nightclub in the Worst Shooting on U.S. Soil

'We Will Not Give In to Fear,' Obama Says as Florida Aches

At Stonewall Inn, a Gay Rights Landmark, a Vigil in Pride and Ange

Last Call, and Then The Shots Rang Out

Pride Marches On, With Jubilation and Solemn Tributes to Victims of Massacre

Brown, Black, Queer and Invisibl

Bathroom Case Puts Transgender Student on National Stage

ABCs of L.G.B.T.Q.I.A.

If You're Asking, 'Am I Gay? Lesbian? Bi? Trans? Queer?' Here's a Start

Stonewall Inn Named National Monument, a First for the Gay Rights Movement

In Narrow Decision, Suprem Court Sides With Baker Wh Turned Away Gay Couple

A Jury May Have Sentenced a Man to Death Because He's Gay. And the Justices Don't Care.

Trump Surprises Military With Announcement of Transgender Ban

New York Passes a Ban on 'Conversion Therapy' After Years-Long Efforts

Prominent Lawyer in Fight for Gay Rights Dies After Setting Himself on Fire in Prospect Par

In 'Rainbow Wave,' L.G.B.T. Candidates Elected in Record Numbers

2010s

Evolution as much as revolution best describes the past decade of the LGBTQ rights movement. Both began almost immediately after Barack Obama's arrival in the White House. Despite cries that his gay rights agenda wasn't robust enough, Obama quickly ended the ban on HIV-positive visitors to the United States, repealed the military's Don't Ask/Don't Tell policy, signed the Matthew Shepard Hate Crimes Act, and ultimately shifted his views on marriage equality during his presidency.

A potent example of the legal discrimination people still face is the "same-sex wedding cake" case. In 2012, a bakery in Colorado refused, on religious grounds, to create a cake for a same-sex wedding. The couple sued the bakery—a case that reached the United States Supreme Court in 2018. The court ruled in favor of the baker, overturning the findings of the lower court that his religious beliefs were used to justify discrimination.

Following a series of decisions by the Supreme Court, marriage equality became a right nationwide in 2013. Edie Windsor, a software developer from New York, became the unlikely face of the movement after successfully petitioning the Supreme Court for equal inheritance rights following the death of her partner of forty years. Today, according to the Pew Research Center, 62 percent of Americans are in favor of marriage equality.

The most visible change over the last ten years is the newfound attention paid to gender identity rather than sexual orientation. Far beyond mere L., G., and B., genderqueers, the transgendered, and people who conform to no set gender are solidifying their rights to safety and equality in a nation where they still face outsized obstacles.

Transgender celebrities such as Caitlyn Jenner, and politicians like Christine Hallquist, have achieved a level of cultural significance unimaginable at the dawn of the decade. At the same time, successful shows like *RuPaul's Drag Race* and *Pose* have proven powerful platforms for transgender and gender nonconforming narratives. Fashion lines, makeup brands, and social-media influencers are also creating content and products aimed at people across the entire gender spectrum.

Still, transgender people are at the center of cultural wars that seek to strip them of their legality and humanity. In 2016, for instance, North Carolina initiated a bill that required people to use public bathrooms in schools and other government buildings matching the sex they were assigned at birth. It was eventually overturned, highlighting why many in the transgender community fear for their existence. Furthermore, the Trump administration seeks to expel transgender soldiers from the military and redefine gender along strict biological lines.

Fifty years after the Stonewall riots ignited this battle for equality, same-sex marriage is a right, LGBTQ parenthood is a reality, and community visibility has never been stronger. HIV is also now mostly manageable, if not preventable.

However, this decade was not without its struggles. Gay people still lack workplace protections on a national level, while an increasingly conservative Supreme Court could roll back key political gains. Despite decreasing numbers, HIV remains near epidemic proportions among black gay men, while suicide remains a risk for vulnerable youth. And violent crimes perpetrated against the gay community remain an ongoing threat, as evidenced by the horrific Pulse nightclub shooting in Orlando.

By 2019, the movement had entered a phase of intersectionality—aligning its own liberation platform with similar progressive movements, including immigrant rights, #blacklivesmatter, and the fight to ensure female sexual and reproductive freedoms. The revolution is not yet complete.

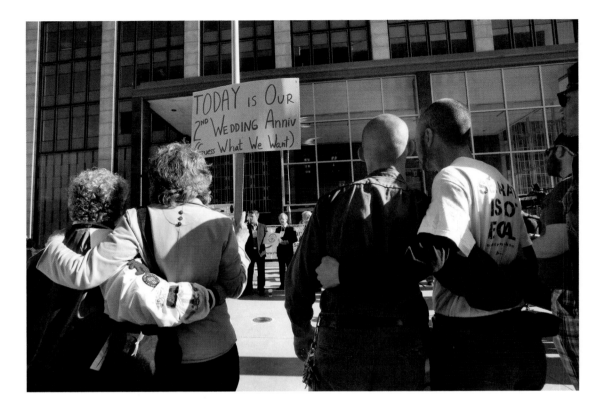

ABOVE
Opponents of Prop 8 gather at the Phillip J. Burton Federal Courthouse in San Francisco on June 16, 2010. Closing arguments in the case were presented before Judge Vaughn Walker, who would rule on the matter. The two couples pictured were both wed in June 2008, when same-sex marriage was allowed under state law.

OPPOSITE
New York, June 27, 2010

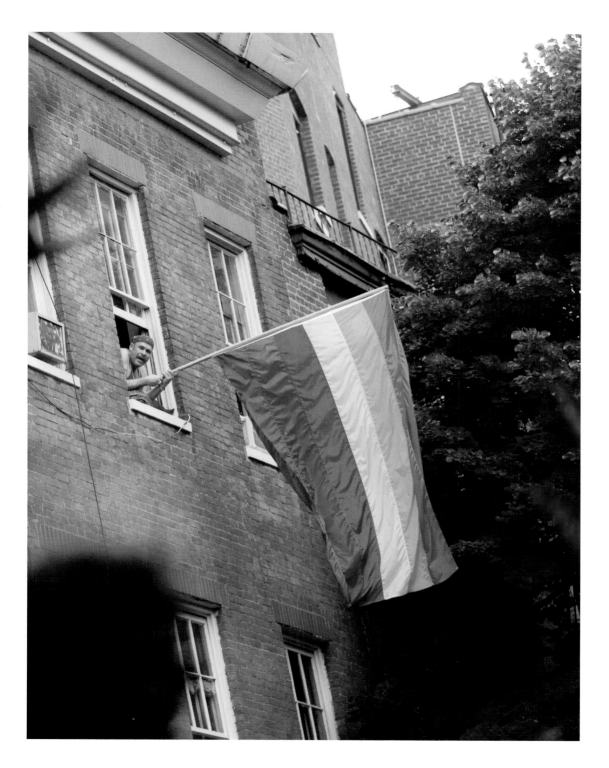

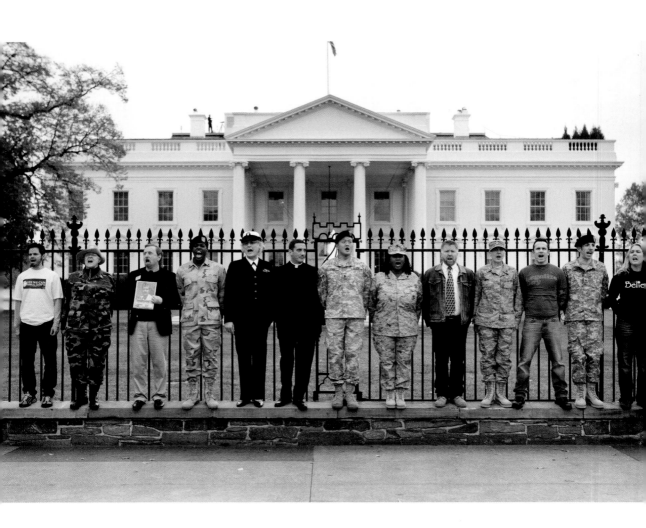

ABOVE & OPPOSITE
Former members of the U.S. military and LGBTQ rights activists handcuff themselves to a fence in front of the White House to protest President Barack Obama's handling of the country's "Don't Ask, Don't Tell" policy, November 15, 2010.

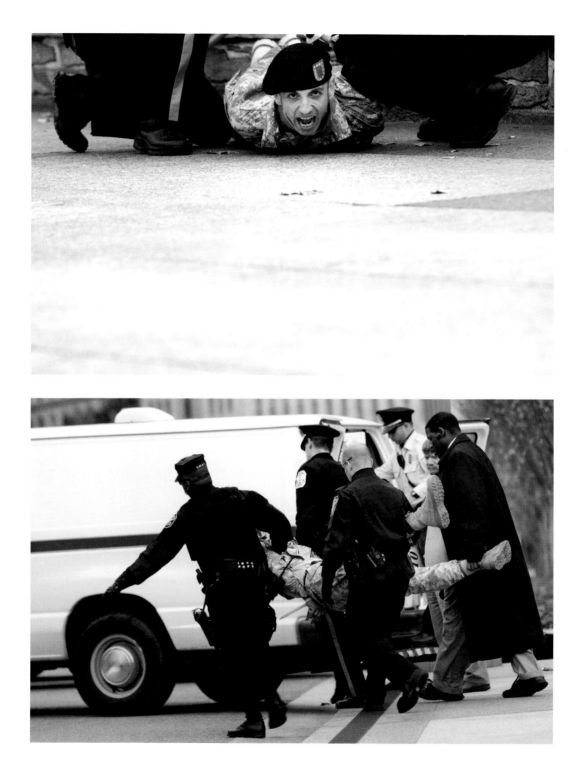

House Votes to Repeal 'Don't Ask, Don't Tell'

By JENNIFER STEINHAUER

WASHINGTON — The House on Wednesday handily approved a repeal of a ban on gay men and lesbians serving openly in the military, ratcheting up the pressure on Senate Republicans who have resisted holding a vote on procedural grounds.

The measure that the House approved, 250 to 175, had originally been part of a broader military policy bill. Last week, the Senate failed to break a Republican filibuster of that measure, with only one Republican, Senator Susan Collins of Maine, voting to advance the bill.

As a last-shot effort, Democrats decided to take the repeal provision out of the larger military measure, in an effort to address the complaints of Senate Republicans that they had not been given enough time to debate the Pentagon bill. A stand-alone measure was introduced by Representative Steny H. Hoyer, Democrat of Maryland, and Representative Patrick J. Murphy, a Pennsylvania Democrat and Iraq war veteran — at the behest of Ms. Collins and Senator Joseph I. Lieberman, an independent from Connecticut.

Also removed from the broader bill was a provision that would have allowed privately financed abortions at military hospitals and bases.

Saying the Clinton-era "don't ask, don't tell" policy "contra-

> *A stand-alone vote on a measure from a broader military bill.*

venes our American values," Speaker Nancy Pelosi of California urged her colleagues to support the stand-alone measure on Wednesday. Mr. Hoyer, who has been the biggest champion in the House for repeal, a priority of President Obama, said, "It is never too late to do the right thing."

The House bill now goes back to the Senate as a privileged bill, meaning that the majority leader, Harry Reid of Nevada, can call it up immediately. Among Republicans, Senators Scott P. Brown of Massachusetts, Lisa Murkowski of Alaska, Olympia J. Snowe of Maine and Richard G. Lugar of Indiana have indicated they could be open to voting for a repeal.

Groups that advocate repeal remained hopeful. "Today the U.S. House of Representatives said, for the second time, what military leaders, the majority of our troops and 80 percent of the American public have been saying all along," said Joe Solmonese, the president of Human Rights Campaign, in a news release. "The only thing that matters on the battlefield is the ability to do the job. Momentum is

solidly on the side of ending 'don't ask, don't tell.' Now it is up to the Senate to consign this failed and discriminatory law to the dustbin of history."

Defense Secretary Robert M. Gates and Adm. Mike Mullen, the chairman of the Joint Chiefs of Staff, have called repeatedly for repeal of the policy so gay men, lesbians and bisexual people could serve openly.

The Pentagon press secretary, Geoff Morrell, said in a statement that Mr. Gates was pleased by the House vote, adding, "He encourages the Senate to pass the legislation this session, enabling the Department of Defense to carefully and responsibly manage a change in this policy instead of risking an abrupt change resulting from a decision in the courts."

Excising the repeal provision had almost immediate impact on the stalled National Defense Authorization Act, the formal name of the larger bill that provides pay increases and enhanced benefits for members of the armed forces.

Just after the House vote, Senator Carl Levin, Democrat of Michigan and chairman of the Senate Armed Services Committee, and Senator John McCain of Arizona, the ranking Republican member of the committee and a steadfast opponent of repealing "don't ask don't tell," said in a joint statement that they would now move to bring the larger bill to the floor for passage.

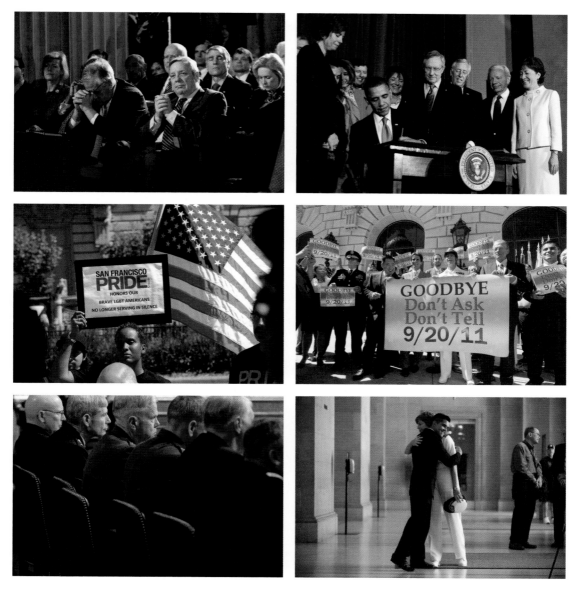

On December 22, 2010, the repeal of "Don't Ask, Don't Tell" was signed into law
by President Obama at the Department of the Interior in Washington, D.C.

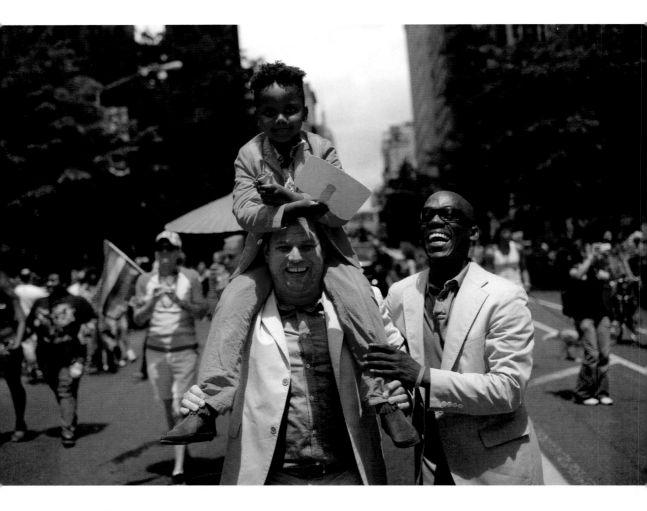

ABOVE
New York, June 26, 2011

OPPOSITE
Couples apply for marriage licenses and exchange wedding vows in July 2011,
after the New York State Marriage Equality Act goes into effect.

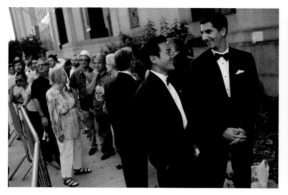
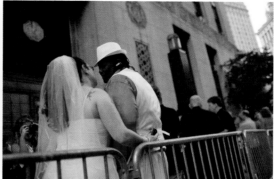

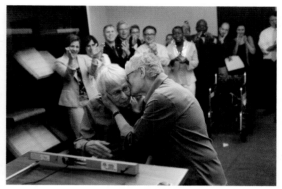

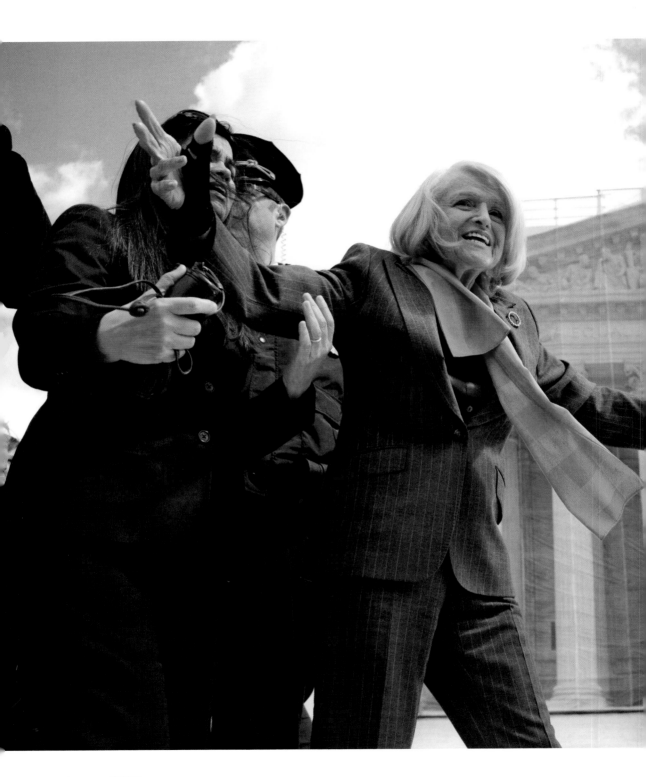

The U.S. Supreme Court heard arguments pertaining to the constitutionality of the Defense of Marriage Act on March 27, 2013. Edith Windsor, the plaintiff of the case, greets hundreds of protestors outside the court building.

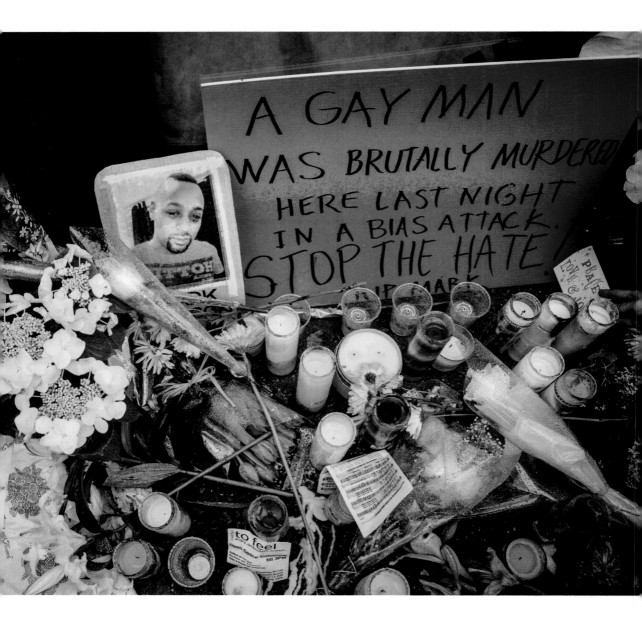

A makeshift memorial in Greenwich Village in honor of Mark Carson, a gay man who was fatally shot in New York on May 19, 2013

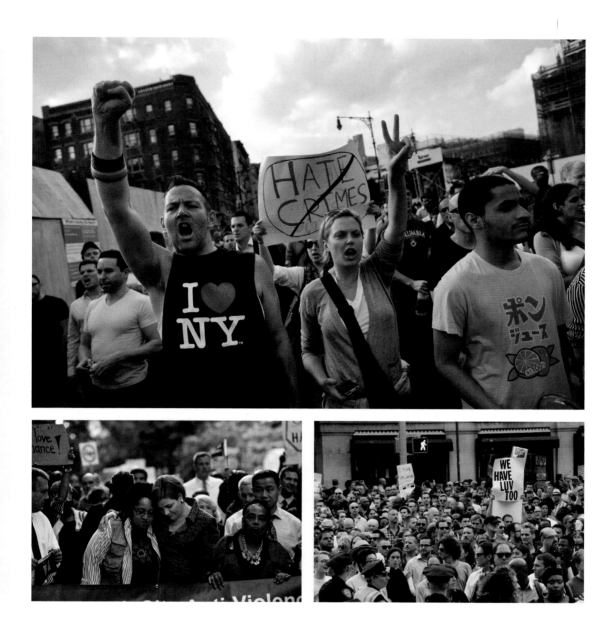

Reactions and protest in the wake of Mark Carson's death, New York, May 20, 2013

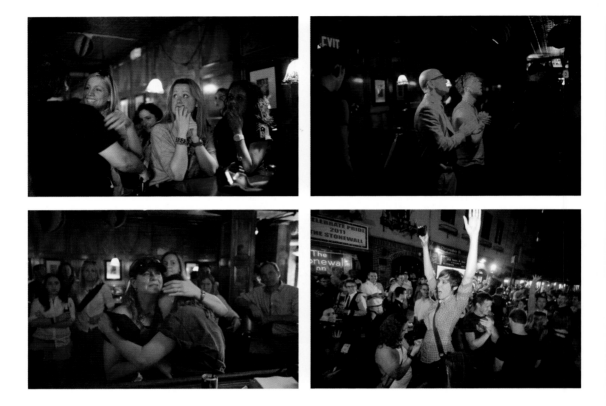

ABOVE
New Yorkers gather at the Stonewall Inn during and after the decision from the U.S. Supreme Court on the Defense of Marriage Act (DOMA), June 26, 2013. The court issued a pair of rulings expanding LGBTQ rights, ruling unconstitutional the 1996 law that denied federal benefits to legally married same-sex couples, and clearing the way for California to legalize same-sex marriage.

OPPOSITE, TOP
A couple from Washington, D.C., who had been previously married in Toronto, reacts to the news that DOMA was struck down, June 26, 2013.

OPPOSITE, BOTTOM
The Gay Men's Chorus of Washington, D.C., sings the national anthem on June 26, 2013.

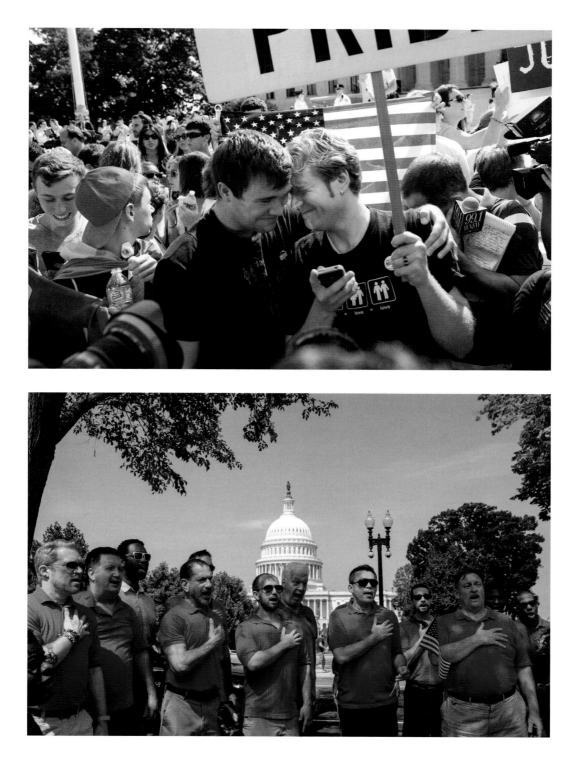

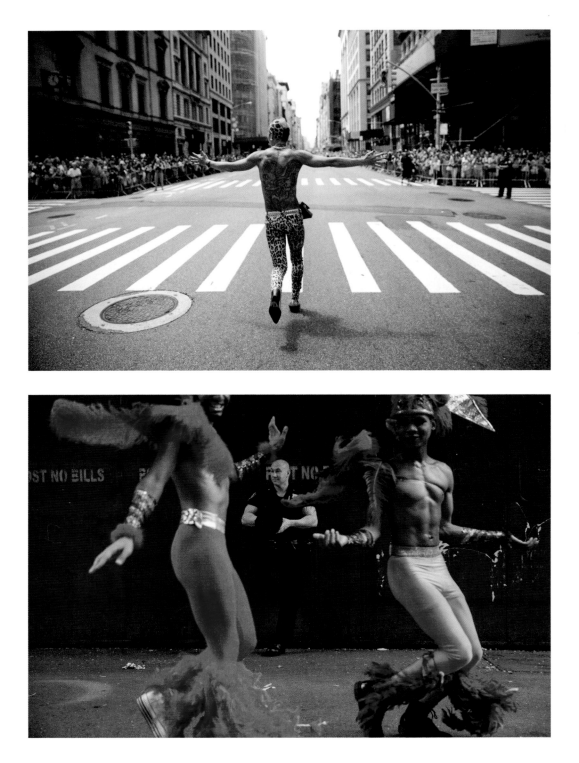

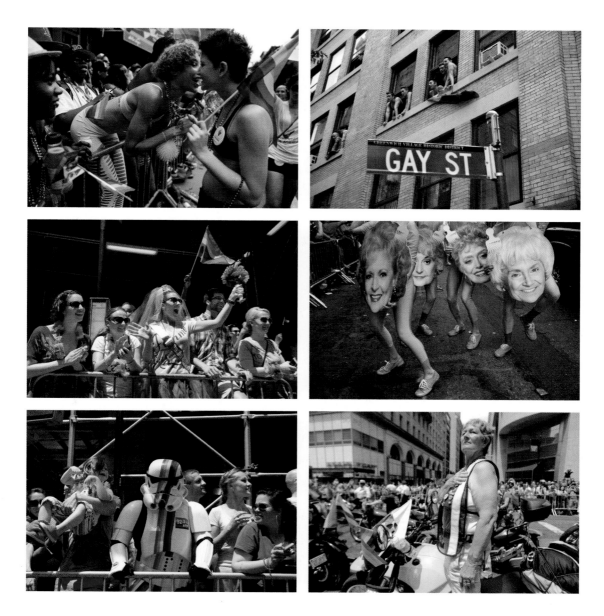

OPPOSITE & ABOVE
New York, June 30, 2013

The New York Times

Late Edition
Today, mostly cloudy, afternoon rain, windy, cooler, high 71. Tonight, heavy rain, thunder, flooding, low 64. Tomorrow, a thunderstorm, high 78. Weather map, Page C8.

VOL. CLXIV ... No. 56,910 © 2015 The New York Times NEW YORK, SATURDAY, JUNE 27, 2015 $2.50

'EQUAL DIGNITY'

5-4 Ruling Makes Same-Sex Marriage a Right Nationwide

Michael Crow and Robert Woodcock

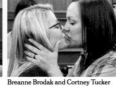

Breanne Brodak and Cortney Tucker

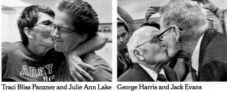

Traci Bliss Panzner and Julie Ann Lake George Harris and Jack Evans

Natalie, Christina and Alice Leslie

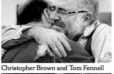

Christopher Brown and Tom Fennell

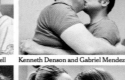

Kenneth Denson and Gabriel Mendez Crystal Zimmer and Lena Williams

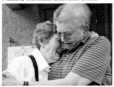

Marge Eide and Ann Sorrell

Barbara Schwartz and Julia Troxler

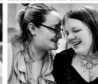

Lori Hazelton and Stephanie Ward

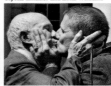

Terrence McNally and Thomas Kirdahy

Forceful Dissents From the Court And Nation

By ADAM LIPTAK

WASHINGTON — In a long-sought victory for the gay rights movement, the Supreme Court ruled by a 5-to-4 vote on Friday that the Constitution guarantees a right to same-sex marriage.

"No longer may this liberty be denied," Justice Anthony M. Kennedy wrote for the majority in the historic decision. "No union is more profound than marriage, for it embodies the highest ideals of love, fidelity, devotion, sacrifice and family. In forming a marital union, two people become something greater than once they were."

Marriage is a "keystone of our social order," Justice Kennedy said, adding that the plaintiffs in the case were seeking "equal dignity in the eyes of the law."

The decision, which was the culmination of decades of litigation and activism, set off jubilation and tearful embraces across the country, the first same-sex marriages in several states, and resistance — or at least stalling — in others. It came against the backdrop of fast-moving changes in public opinion, with polls indicating that most Americans now approve of the unions.

The court's four more liberal justices joined Justice Kennedy's majority opinion. Each member of the court's conservative wing filed a separate dissent, in tones ranging from resigned dismay to bitter scorn.

In dissent, Chief Justice John G. Roberts Jr. said the Constitution had nothing to say on the subject of same-sex marriage.

"If you are among the many Americans — of whatever sexual orientation — who favor expanding same-sex marriage, by all means celebrate today's decision," Chief Justice Roberts wrote. "Celebrate the achievement of a desired goal. Celebrate the opportunity for a new expression of commitment to a partner. Celebrate the availability of new benefits. But do not celebrate the Constitution. It had nothing to do with it."

In a second dissent, Justice An-
Continued on Page A11

"It would misunderstand these men and women to say they disrespect the idea of marriage. Their plea is that they do respect it, respect it so deeply that they seek to find its fulfillment for themselves."

JUSTICE ANTHONY M. KENNEDY, from the majority opinion

Historic Day for Gay Rights, but a Twinge of Loss for Gay Culture

By JODI KANTOR

From Capitol Hill in Seattle to Dupont Circle in Washington, gay bars and nightclubs have turned into vitamin stores, frozen yogurt shops and memories. Some of those that remain are filled increasingly with straight patrons, while many former customers say their social lives now revolve around preschools and playgrounds.

Rainbow-hued "Just Be You"

messages have been flashing across Chase A.T.M. screens in honor of Pride month, conveying acceptance but also corporate blandness. Directors, filmmakers and artists are talking about moving past themes of sexual orientation, which they say no longer generate as much dramatic energy.

The Supreme Court on Friday expanded same-sex marriage rights across the country, a crowning achievement but also a confounding challenge to a group

that has often prided itself on being different. The more victories that accumulate for gay rights, the faster some gay institutions, rituals and markers are fading out. And so just as the gay marriage movement peaks, so does a debate about whether gay identity is dimming, overtaken by its own success.

"What do gay men have in common when they don't have oppression?" asked Andrew Sullivan, one of the intellectual architects of the marriage move-

ment. "I don't know the answer to that yet."

John Waters, the film director and patron saint of the American marginal, warned graduates to heed the shift in a recent commencement speech at the Rhode Island School of Design. "Refuse to isolate yourself. Separatism is for losers," he said, adding, "Gay is not enough anymore."

No one is arguing that prejudice has come close to disappearing, especially outside major

Continued on Page A12

THE OPPOSITION Many conservatives hope that stronger legal protections for religious beliefs and other exemptions will allow them to avoid any involvement in same-sex marriages. PAGE A14

THE REACTION It was a day of celebration for some, denunciation for others and delays and confusion in some of the country's most conservative pockets. PAGE A13

THE CHIEF JUSTICE Even though he wound up in the minority, the views of Chief Justice John G. Roberts Jr. came across as consistent and principled. PAGE A13

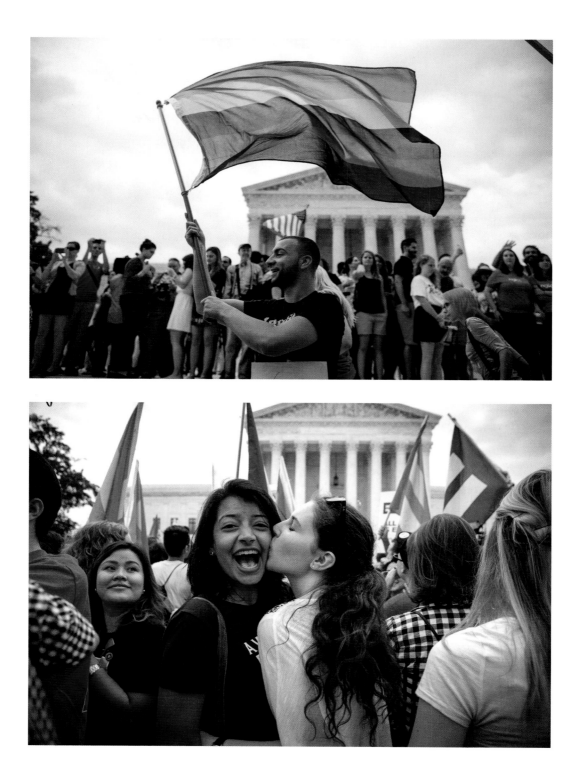

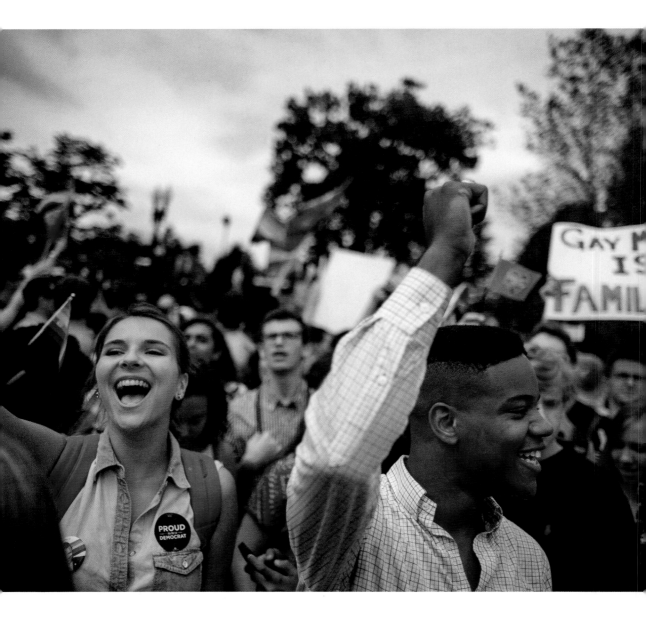

PREVIOUS & ABOVE
Celebrations commence in Washington, D.C., after the U.S. Supreme Court's
historic ruling in favor of same-sex marriage, June 26, 2015.

OPPOSITE
People gather at the Stonewall Inn to celebrate, New York, June 26, 2015.

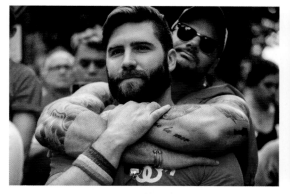

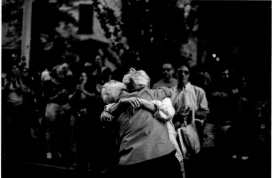

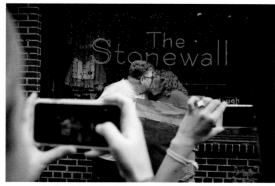

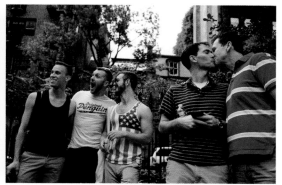

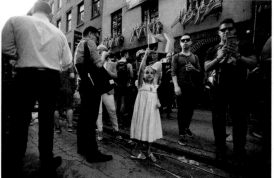

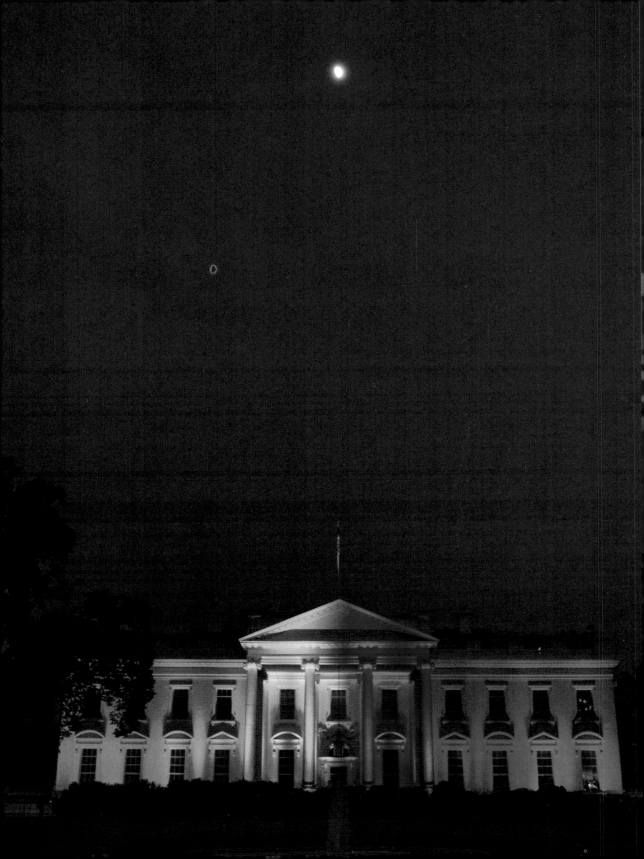

OPPOSITE
Rainbow-colored lights illuminated the White House on June 26, 2015.

ABOVE
A child holds a Pride flag outside of the Stonewall Inn in New York after the announcement of the legalization of same-sex marriage, June 26, 2015.

FOLLOWING
New York, June 28, 2015

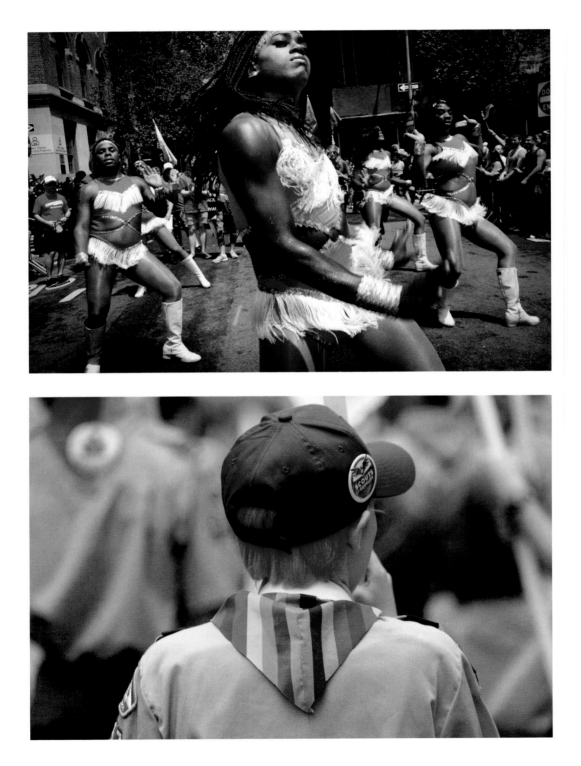

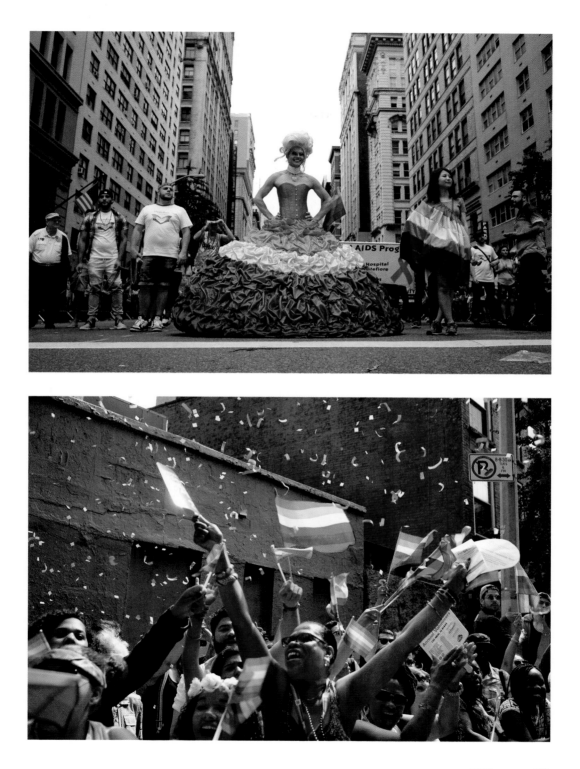

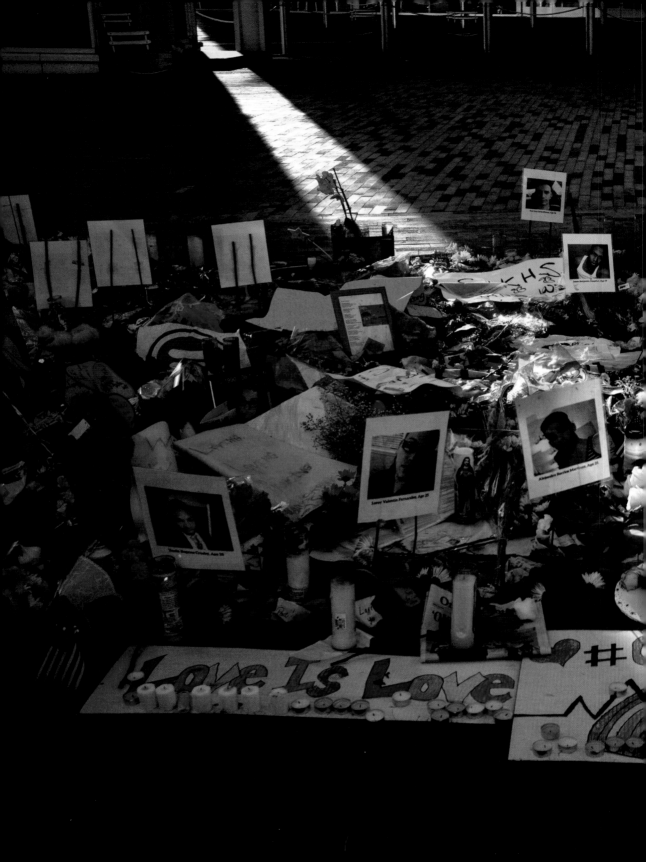

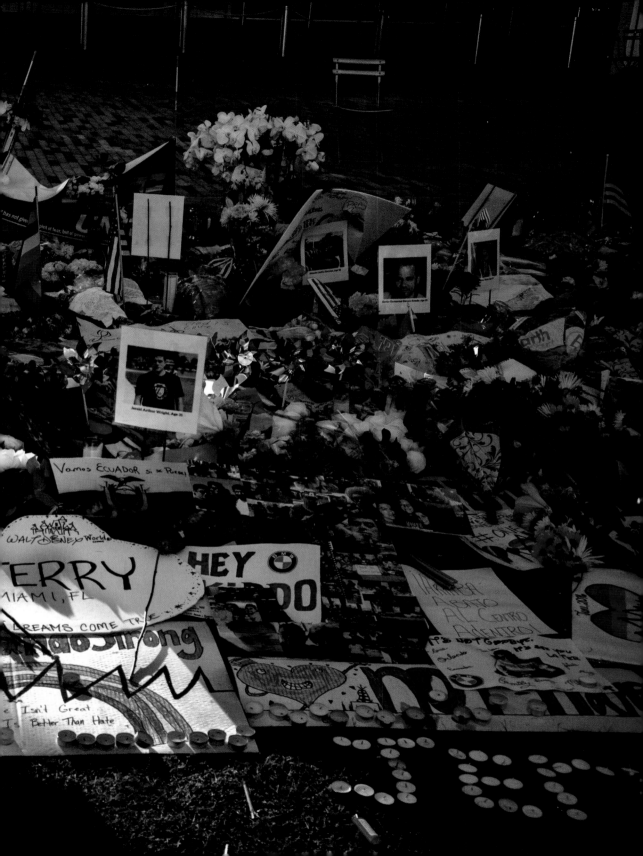

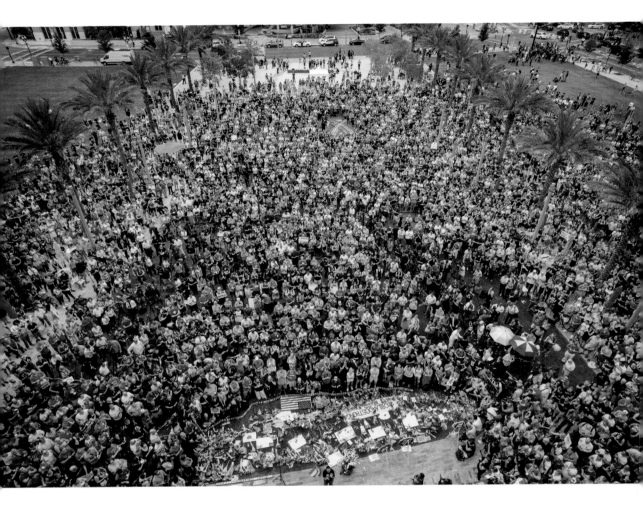

PREVIOUS & ABOVE
On June 12, 2016, a shooter opened fire in the crowded Pulse nightclub in Orlando, Florida, killing forty-nine people and wounding fifty-three others. At the time, the attack was the single deadliest mass shooting in U.S. history. In the following days, a makeshift memorial was created in honor of the victims at the Dr. Phillips Center for the Performing Arts.

OPPOSITE
Stonewall Inn, New York, June 13, 2016

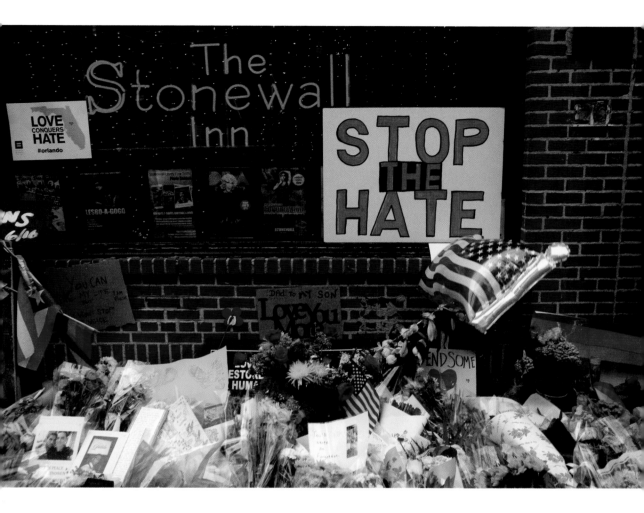

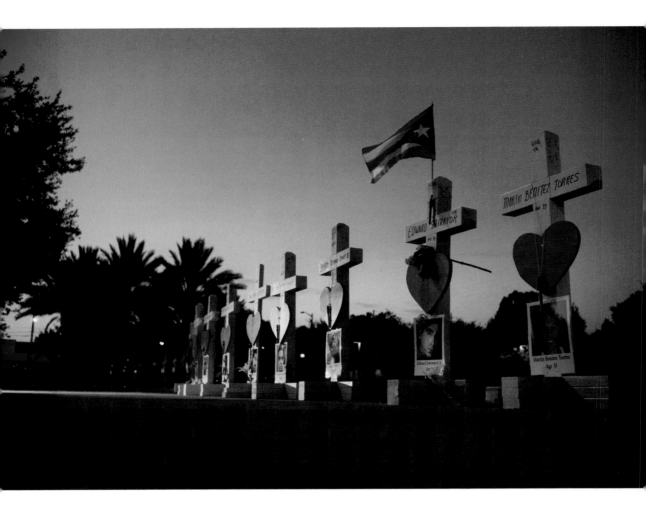

ABOVE
The sun rises behind forty-nine crosses—one in honor of each person who was killed—at a small lake near Pulse nightclub, June 17, 2016.

OPPOSITE, TOP
During a vigil, the names of all forty-nine deceased were read. A moment of silence followed, with one second for every person either injured or killed, June 16, 2016.

OPPOSITE, BOTTOM
Eric Rollings, left, hugs David Velez at a fundraiser for the Pulse victims on June 17, 2016.

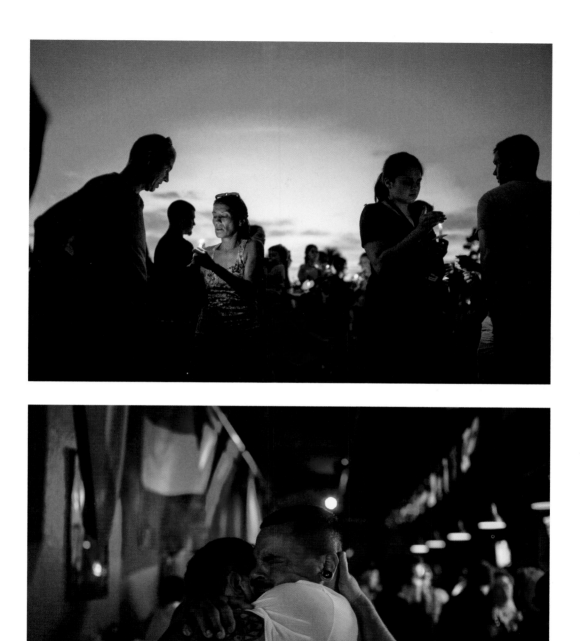

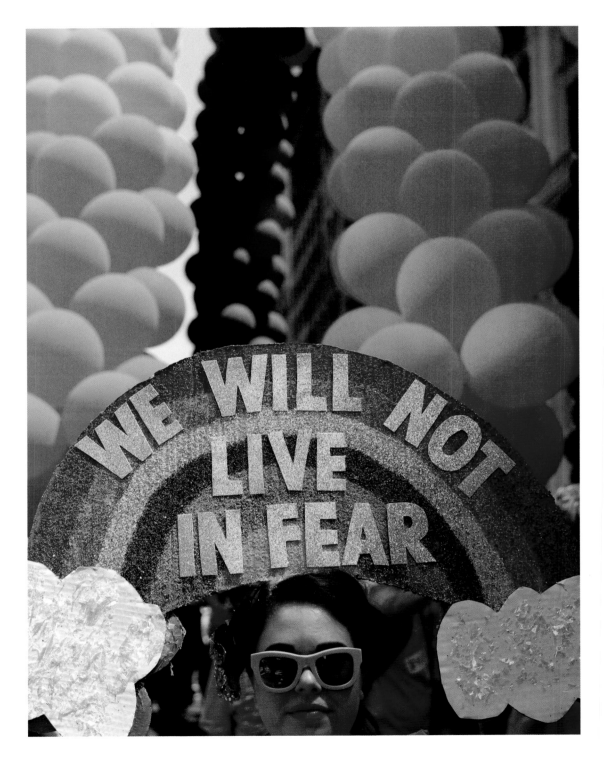

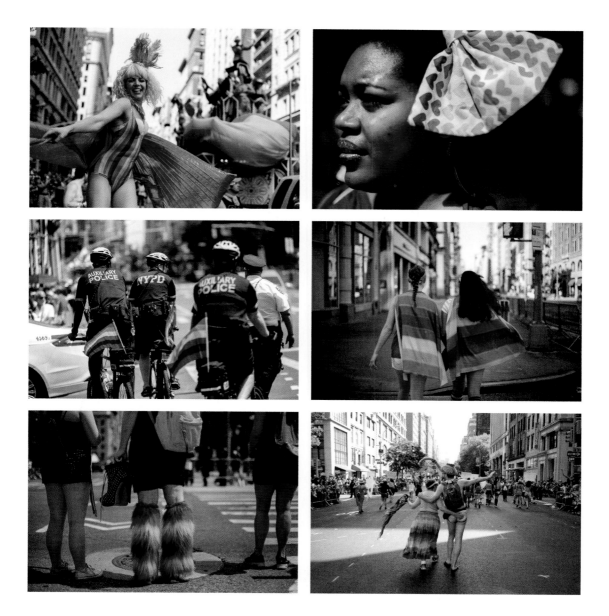

OPPOSITE & ABOVE
New York, June 26, 2016

FOLLOWING
Hundreds of activists gather in front of the Stonewall Inn on February 23, 2017, in protest of the Trump administration's announcement that reverses an Obama-era order allowing transgender students to use the bathrooms that match their gender identities.

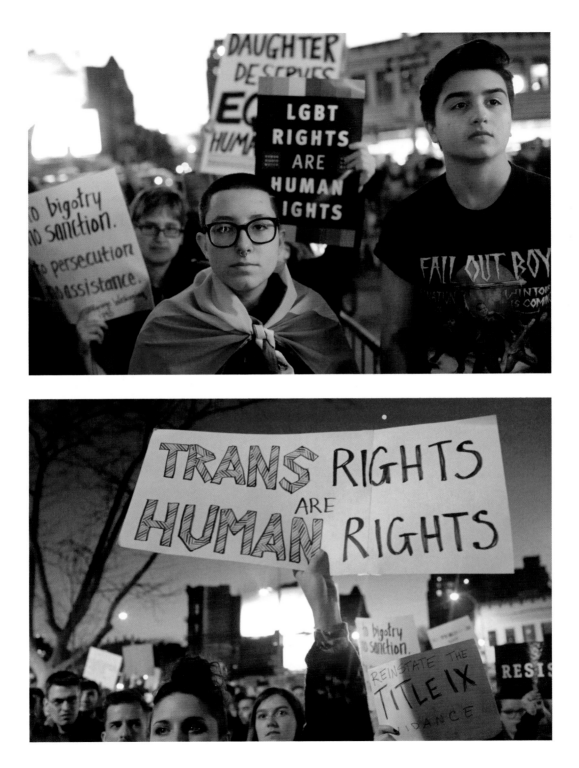

Trump Surprises Military With a Transgender Ban

By JULIE HIRSCHFELD DAVIS and HELENE COOPER

WASHINGTON — President Trump abruptly announced a ban on transgender people serving in the military on Wednesday, blindsiding his defense secretary and Republican congressional leaders with a snap decision that reversed a year-old policy reviled by social conservatives.

Mr. Trump made the declaration on Twitter, saying that American forces could not afford the "tremendous medical costs and disruption" of transgender service members. He said he had consulted generals and military experts, but Jim Mattis, the defense secretary, was given only a day's notice about the decision.

Mr. Trump elected to announce the ban in order to resolve a quietly brewing fight on Capitol Hill over whether taxpayer money should pay for gender transition and hormone therapy for transgender service members. The dispute had threatened to kill a $790 billion defense and security spending package scheduled for a vote this week.

But rather than addressing that narrow issue, Mr. Trump opted to upend the entire policy on transgender service members.

His decision was announced with such haste that the White House could not answer basic inquiries about how it would be carried out, including what would happen to openly transgender people on active duty. Of eight defense officials interviewed, none could say.

"That's something that the Department of Defense and the White House will have to work together as implementation takes place and is done so lawfully," Sarah Huckabee Sanders, the White House press secretary, said.

Still, the announcement pleased elements of Mr. Trump's base who have been dismayed to see the president break so bitterly in recent days with Attorney General Jeff Sessions, a hard-line conservative.

Civil rights and transgender advocacy groups denounced the policy, with some vowing to challenge it in court. Pentagon officials expressed dismay that the president's tweets could open them to lawsuits.

The ban would reverse the gradual transformation of the military under President Barack Obama, whose administration announced last year that transgender people could serve openly in the military. Mr. Obama's defense secretary, Ashton B. Carter, also opened all combat roles to women and appointed the first openly gay Army secretary.

And it represented a stark turnabout for Mr. Trump, who billed himself during the campaign as an ally of gay, lesbian, bisexual and transgender people.

The president, Ms. Sanders said, had concluded that allowing transgender people to serve openly "erodes military readiness and unit cohesion, and made the decision based on that."

Mr. Mattis, who was on vacation, was silent on the new policy. People close to the defense secretary said he was appalled that Mr. Trump chose to unveil his decision in tweets, in part because of the message they sent to transgender active-duty service members, including those deployed overseas, that they were suddenly no longer welcome.

The policy would affect only a small portion of the approximately 1.3 million active-duty members of the military. Some 2,000 to 11,000 active-duty troops are transgender, according to a 2016 RAND Corporation study commissioned by the Pentagon, though estimates of the number of transgender service members have varied widely, and are sometimes as high as 15,000.

The study found that allowing transgender people to serve openly in the military would "have minimal impact on readiness and health care costs" for the Pentagon. It estimated that health care costs would rise $2.4 million to $8.4 million a year, representing an infinitesimal 0.04 to 0.13 percent increase in spending. Citing research into other countries that allow transgender people to serve, the study projected "little or no impact on unit cohesion, operational effectiveness or readiness" in the United States.

Lt. Commander Blake Dremann, a Navy supply corps officer who is transgender, said he found out his job was in danger when he turned on CNN on Wednesday morning. Commander Dremann came out as transgender to his commanders in 2015, and said they had been supportive of him.

He refused to criticize Mr. Trump — "we don't criticize our commander in chief," he said — but said the policy shift "is singling out a specific population in the military, who had been assured we were doing everything appropriate to continue our honorable service."

He added: "And I will continue to do so, until the military tells me to hang up my boots."

The announcement came amid the debate on Capitol Hill over the Obama-era practice of requiring the Pentagon to pay for medical treatment related to gender transition. Representative Vicky Hartzler, Republican of Missouri, has proposed an amendment to the spending bill that would bar the Pentagon from spending money on transition surgery or related hormone therapy, and other Republicans have pressed for similar provisions.

Mr. Trump and Republican lawmakers had come under pressure from Tony Perkins, the president of the Family Research Council, a leading Christian conservative group, and an ally of Mr. Trump's. Mr. Perkins opposed the bill over spending on transgender medical costs and lobbied lawmakers to do the same.

Opponents of allowing openly transgender service members had raised a number of concerns, including what they said was the questionable psychological fitness of those troops. They said the military was being used for social experimentation at the expense of national security.

"This was Ash Carter on his way out the door pulling the pin on a cultural grenade," Mr. Perkins said on Wednesday. "Our military leaders are saying this doesn't help make us a better fighting force; it's a distraction; it's taking up limited resources."

Mr. Carter objected to the decision, for its effect on the military and on those considering joining.

"To choose service members on other grounds than military qualifications is social policy and has no place in our military," he said in a statement. "There are already transgender individuals who are serving capably and honorably. This action would also send the wrong signal to a younger generation thinking about military service."

While some conservative lawmakers, including Ms. Hartzler, praised Mr. Trump, the president drew bipartisan condemnation on Capitol Hill and outrage from civil rights and transgender advocacy groups.

"There is no reason to force service members who are able to fight, train and deploy to leave the military — regardless of their gender identity," said Senator John McCain, Republican of Arizona and the chairman of the Senate Armed Services Committee.

He called Mr. Trump's move "yet another example of why major policy announcements should not be made via Twitter."

Senator Jack Reed, Democrat of Rhode Island and the ranking member of the Armed Services Committee, noted the irony of Mr. Trump's announcing the ban on the anniversary of President Harry Truman's order to desegregate the military. "President Trump is choosing to retreat in the march toward equality," he said.

In June, the administration delayed by six months a decision on whether to allow transgender recruits to join the military. At the time, Mr. Mattis said the delay would give military leaders a chance to review the shift's potential impact. Mr. Mattis's decision was seen as a pause to "finesse" the issue, one official said, not a prelude to an outright ban.

Mr. Trump's abrupt decision is likely to end up in court; OutServe-SLDN, a nonprofit group that represents gay, lesbian, bisexual and transgender people in the military, immediately vowed to sue.

"We have transgender individuals who serve in elite SEAL teams, who are working in a time of war to defend our country, and now you're going to kick them out?" Matthew F. Thorn, executive director of OutServe, said in an interview.

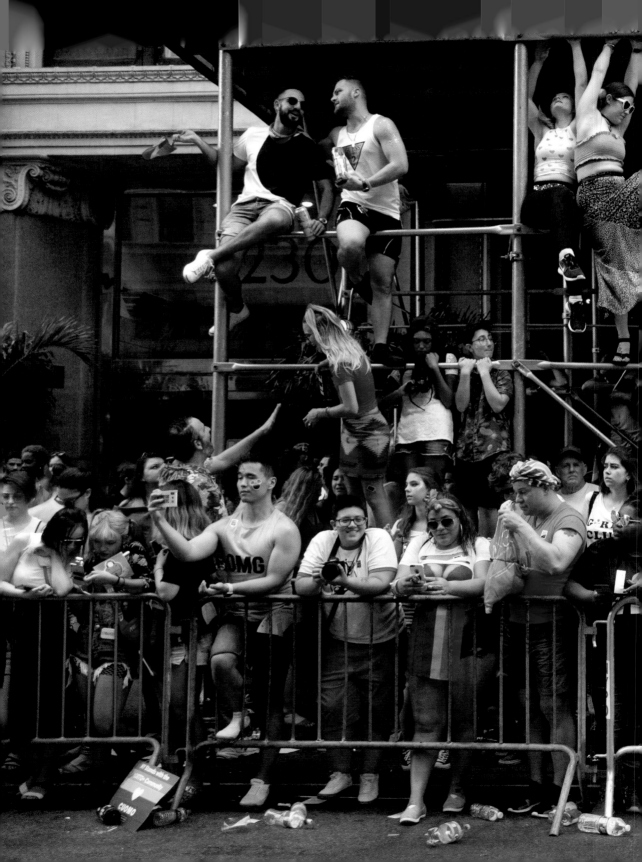

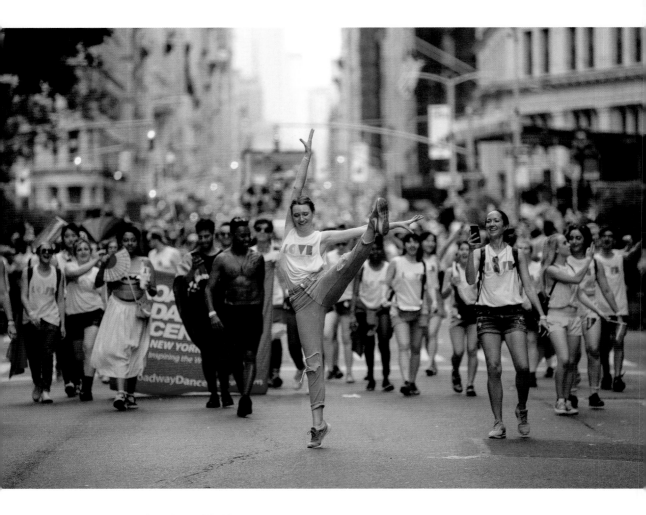

PREVIOUS, ABOVE, & OPPOSITE
New York, June 24, 2018

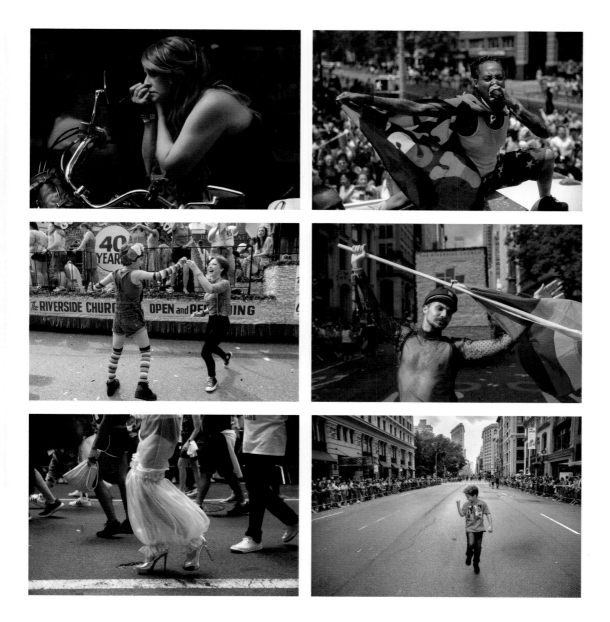

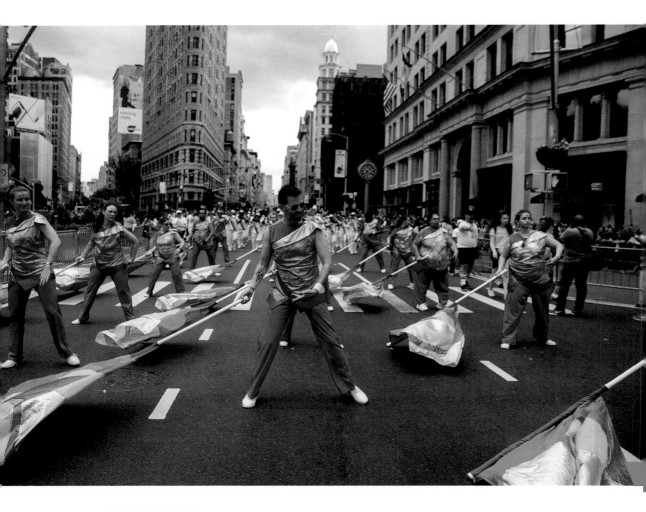

ABOVE & OPPOSITE
New York, June 24, 2018

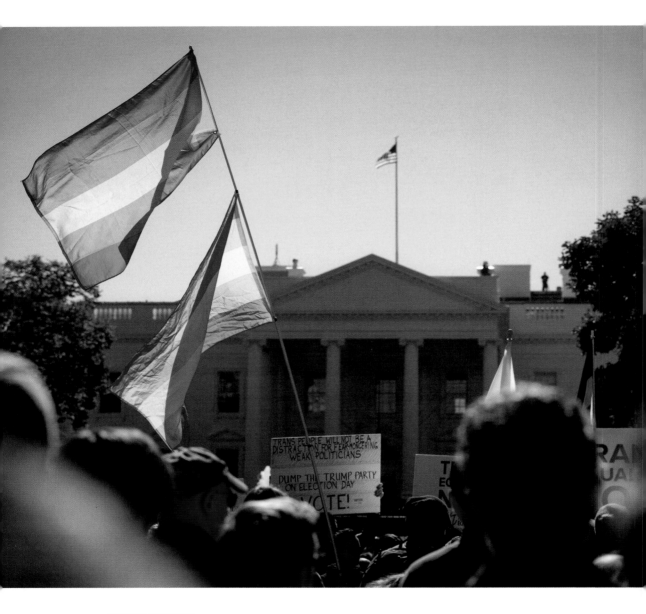

ABOVE & OPPOSITE
LGBTQ activists and supporters rally at the White House on October 22, 2018, in response to news that the Trump administration was considering redefining gender as a "biological, immutable condition determined by genitalia at birth," which activists believed would subject transgender and gender nonconforming people to discrimination, harassment, and violence.

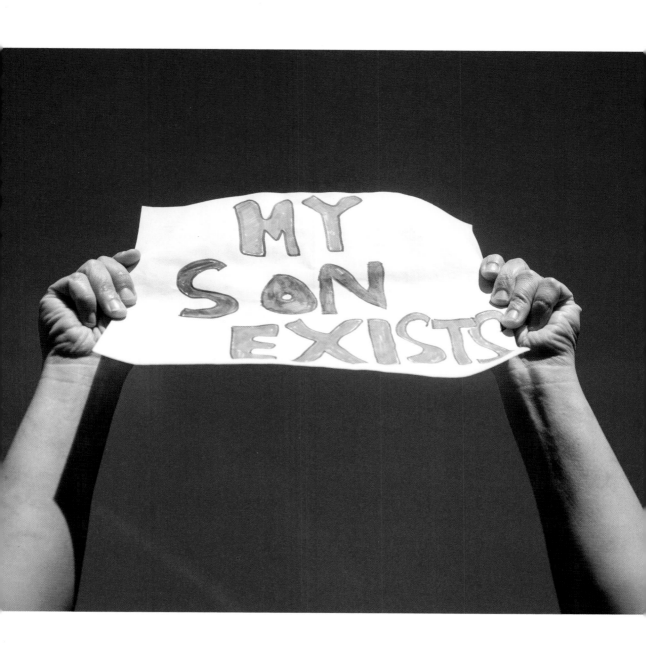

ABOVE
During Sunday night mass at St. John the Evangelist Catholic Church in San Diego, California, a Day of the Dead altar sits in the entryway to memorialize LGBTQ youth who committed suicide. October 28, 2018

OPPOSITE
A demonstrator from Westboro Baptist Church protests at a football game between Western Illinois University (WIU) and Indiana State in Macomb, Illinois, due to Indiana State's openly gay cornerback, Jake Bain. WIU students and faculty hosted a counter-protest called Rally for Love in response. November 17, 2018

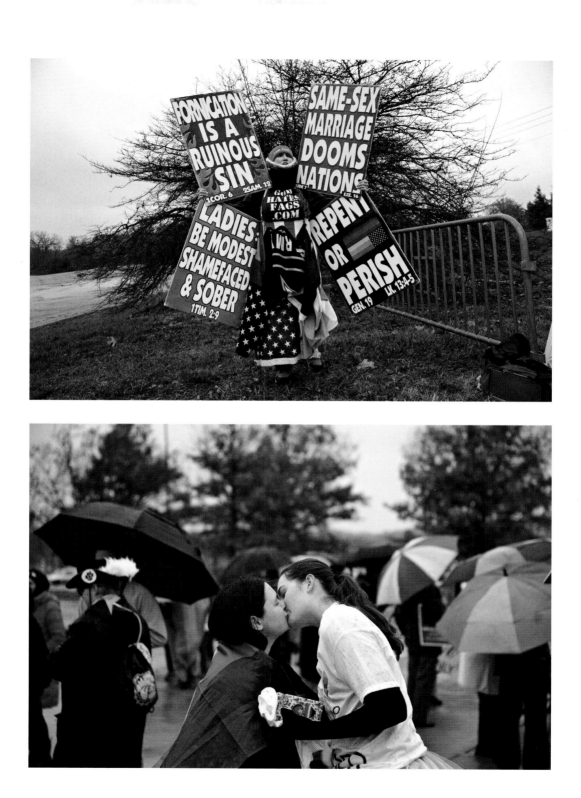

In 'Rainbow Wave,' L.G.B.T. Candidates Are Elected in Record Numbers

By CHRISTINA CARON

More openly lesbian, gay, bisexual and transgender people were elected Tuesday night than in any previous election, signaling a shift in cultural attitudes even as the Trump administration has chipped away at L.G.B.T. rights.

The results are still rolling in, but at least 153 have won so far, said Elliot Imse, a spokesman for the Victory Fund, a nonpartisan political action committee devoted to electing L.G.B.T. candidates. The group endorsed 225 candidates in this election cycle, nearly all of whom were Democrats.

L.G.B.T. candidates ran for office in record numbers this year. "Success breeds success," said Annise Parker, the president and chief executive of the Victory Fund and former mayor of Houston.

"We're not going out and pleading with people to run," she added. "These are people who say, 'I want to go out and do this and bring my whole self to the campaign.'"

The candidates not only won open seats but also made a strong showing as incumbents and challengers on Tuesday in what became a day of firsts for groups that have traditionally been underrepresented in political office.

And in Massachusetts, voters chose to uphold a two-year-old state law protecting transgender people from discrimination in public places like bathrooms, locker rooms and hotels. The law, which was signed in 2016, was challenged by conservative activists who collected enough signatures to put a repeal measure on the ballot.

The referendum was the first time a law prohibiting gender discrimination was put to a statewide vote, according to the American Civil Liberties Union.

AARON ONTIVEROZ/THE DENVER POST, VIA ASSOCIATED PRESS

Jared Polis, with Dianne Primavera, his running mate, is the first openly gay man to be a governor.

In Kansas, Sharice Davids won a seat in the House of Representatives, becoming the first lesbian congresswoman from the state and one of the first two Native American women elected to Congress. In addition, Brandon Woodard, who identifies as gay, and Susan Ruiz, a lesbian, were elected state representatives.

Until now, Kansas was one of seven states that had never elected an openly L.G.B.T. state legislator, according to the Victory Fund.

"Kansas is going to change," Ms. Parker said, noting that the state had also elected a Democratic governor. "It's astounding."

In Colorado, Jared Polis defeated a Republican opponent to become the first openly gay man elected governor in any state.

L.G.B.T. people of color won several seats in state legislatures. They included Sonya Jaquez Lewis of Colorado, who is Latina; Shevrin Jones of Florida, who is black; and Malcolm Kenyatta, who is black and the first openly L.G.B.T. person of color elected to the Pennsylvania state legislature.

Ms. Parker said she was particularly focused on victories like these because laws passed on the state level can have long-lasting ramifications for L.G.B.T. people.

"If you look at where most of the anti-L.G.B.T. legislation originates across the country, it originates in our state legislatures," Ms. Parker said, citing the approximately 300 bills proposed over the last legislative cycle that would have hurt the L.G.B.T. community.

At least 399 L.G.B.T. candidates at all levels of government — including 22 for Congress and four for governor — appeared on the ballot, the highest number recorded in the Victory Fund's 27-year history. Most were Democrats, though there were 18 Republicans and seven independents. The full list of winners is being tallied online.

Among the notable incumbents who were re-elected were Gov. Kate Brown of Oregon, who is bisexual, and Senator Tammy Baldwin of Wisconsin, a lesbian who was the first openly L.G.B.T. person elected to the United States Senate.

But the path to Election Day was not without difficulties. Many candidates faced threats and bias.

Gina Ortiz Jones, a Democratic candidate in the 23rd Congressional District in Texas, was asked onstage by an opponent to tell voters that she was a lesbian so it would not be "revealed later." Her race has not been called yet.

And in Kansas, a Republican official called Ms. Davids a "radical socialist kickboxing lesbian Indian" who should be "sent back packing to the reservation."

The vitriol could be especially toxic for transgender candidates.

Christine Hallquist, the Democratic nominee for governor of Vermont and the first transgender person nominated for governor by a major party, received death threats. She stayed in the race but stopped publicizing her campaign schedule and eventually lost to the incumbent, Phil Scott, a Republican.

Amelia Marquez, who could become the first openly transgender state legislator in Montana, was referred to as "he" by her Republican opponent, who also called her by her birth name. Her race has not been called yet.

Despite the difficulties, transgender candidates are making inroads. Danica Roem was elected to the Virginia House of Delegates last year, while this year Gerri Cannon and Lisa Bunker won seats in the New Hampshire House of Representatives.

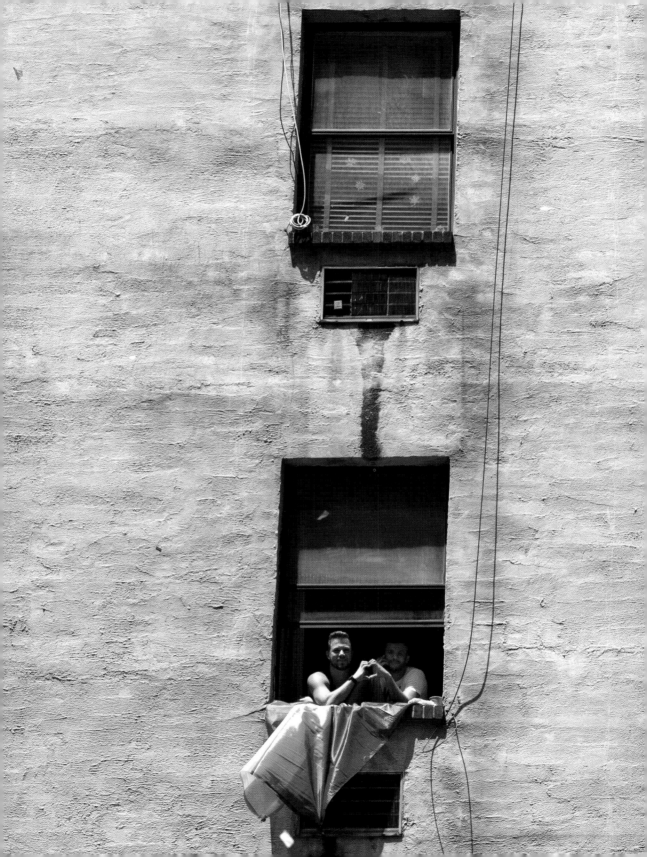

ACKNOWLEDGMENTS

We are indebted to a number of people who provided valuable assistance and advice in assembling this book. At *The New York Times* they are Alex Ward, Cecilia Bohan, Jeff Roth, Sara Krulwich, David W. Dunlap, Jane Bornemeier, Jill Agostino, William P. O'Donnell, Patricia Wall, Alessandra Montalto, and Sonny Figueroa; and at Abrams they are Samantha Weiner, Devin Grosz, Elizabeth Broussard, Lisa Silverman, and Mary O'Mara.

CONTRIBUTORS

ADAM NAGOURNEY is the Los Angeles bureau chief of *The New York Times* and coauthor, with Dudley Clendinen, of *Out for Good: The Struggle to Build a Gay Rights Movement in America*.

DAVID KAUFMAN is a former *New York Times* and *New York Post* editor who has written about cultural, political, and economic topics for *The Times*, *Esquire*, *The Financial Times*, and *The Wall Street Journal*.

PHOTO CREDITS

FRONT COVER: Sam Hodgson; **TITLE PAGE:** Monica Almeida; **INTRODUCTION:** Larry C. Morris: p. 7; Luke Sharrett: p. 8; **BACK COVER**, clockwise from top left: Jim Wilson, Michael Evans, Luke Sharrett, and Chester Higgins Jr.

1970s

Michael Evans: pp. 14, 15, 16, 17; Tyrone Dukes: pp. 18, 20–21, 32 (top and bottom), 36; Patrick A. Burns, p. 19; John Sotomayor: pp. 23, 24, 37; Librado Romero: pp. 25, 26–27, 28, 30, 31; John Muravcki, pp. 33, 35; Frank C. Dougherty: p. 34; Paul Hosefros: pp. 38, 39, 40, 43, 44–45; Eddie Hausner: p. 41; Fred R. Conrad: pp. 42, 47; D. Gorton: p. 46; *The New York Times*: p. 48; Neal Boenzi: p. 50; Vic DeLucia: p. 51; Mark Reinstein/Corbis, via Getty Images: pp. 52–53

1980s

Dith Pran: pp. 56–57, 60, 61, 63, 84–85; Chester Higgins Jr.: pp. 59, 62, 72, 73 (top and bottom), 74, 75, 76, 77, 88–89; Jim Wilson: pp. 64, 65, 68; John Sotomayor: pp. 66, 78, 79; Neal Boenzi: pp. 69, 70; William E. Sauro: p. 71; Sara Krulwich: pp. 80, 86, 87, 90, 91, 92, 93, 94–95; Jose R. Lopez: pp. 81, 82

1990s

Sara Krulwich: pp. 98–99, 106–107, 108, 109, 110–111; Barton Silverman: pp. 100, 101; G. Paul Burnett: p. 102; Michelle V. Agins: pp. 103, 118–119, 132; James Estrin: pp. 104–105, 113, 114, 122, 123, 124, 125, 128, 129, 130 (top left, top right, bottom left, bottom right), 131; John Sotomayor: p. 112; Nancy Seisel: pp. 116–117; Jim Wilson: p. 120; Bill Cunningham: p. 127; Ruby Washington: p. 135

2000s

Andrea Mohin: pp. 138–139; Bill Cunningham: pp. 140 (left and right), 141; Ozier Muhammad: p. 142; Ruth Fremson: pp. 144–145; Robert Spencer: p. 146; John Marshall Mantel: p. 147; Monika Graff: p. 148; James Estrin: pp. 149, 157; Tyler Hicks: pp. 150, 151; Patrick Andrade: pp. 152–153; Michelle V. Agins: pp. 154, 156; Erik Jacobs: p. 155; Jodi Hilton: pp. 158, 159, 160 (top and bottom); Kitra Cahana: pp. 162, 163; Jim Wilson: pp. 164 (top and bottom), 168; J. Emilio Flores: p. 165; Rob Bennett: pp. 166, 167 (top and bottom); Luke Sharrett: pp. 170 (top and bottom), 171, 172–173

2010s

Jim Wilson: pp. 176, 181 (middle left, middle right, bottom right); Piotr Redlinski: p. 177; Brendan Smialowski: pp. 178, 179 (top and bottom); Drew Angerer: pp. 181 (top left and top right), 189 (top and bottom); Stephen Crowley: p. 181 (bottom left); Marcus Yam: p. 182; Michael Appleton: p. 183 (top left, top right, middle right); Stewart Cairns: p. 183 (middle left, bottom right); Nathaniel Brooks: p. 183 (bottom left); Christopher Gregory: pp. 184–185; Robert Stolarik: p. 186; Victor J. Blue: p. 187 (top and bottom left); Chester Higgins Jr.: p. 187 (bottom right); Ozier Muhammad: p. 188 (top left, top right, bottom left); C.S. Muncy: p. 188 (bottom right); Damon Winter: pp. 190 (top and bottom), 191 (top left, top right, middle left, middle right, bottom left), 206, 207 (bottom right); James Estrin: pp. 191 (bottom right), 198 (bottom); Zach Gibson: pp. 193 (top), 194, 196; Doug Mills; p. 193 (bottom); Sam Hodgson: pp. 195 (top left, top right), 197, 207 (top left, top right, middle left, middle right, bottom left), 218; Todd Heisler: pp. 195 (middle left, middle right, bottom left), 199 (top and bottom), 200–201, 204, 205 (top and bottom); Nicole Bengiveno: p. 195 (bottom right); Deirdre Schoo: p. 198 (top); Ángel Franco: p. 202; George Etheredge: p. 203; Yana Paskova: p. 208 (top and bottom); Emma Howells: pp. 210-211, 212, 213 (top left, top right, middle right, bottom left, bottom right), 214, 215; Michelle V. Agins: p. 213 (middle left); Sarah Silbiger: pp. 216, 217; Daniel Acker: p. 219 (top and bottom); Gabriella Angotti-Jones: p. 221

Editor: Samantha Weiner
Designer: Devin Grosz
Production Manager: Sarah Masterson Hally

Library of Congress Control Number: 2019930863

ISBN: 978-1-4197-3792-3
eISBN: 978-1-68335-587-8

Printed and bound in the United States
10 9 8 7 6 5 4 3 2 1

Abrams Image books are available at special discounts when purchased in quantity for premiums
and promotions as well as fundraising or educational use. Special editions can also be created to
specification. For details, contact specialsales@abramsbooks.com or the address below.

Abrams Image® is a registered trademark of Harry N. Abrams, Inc.

ABRAMS The Art of Books
195 Broadway, New York, NY 10007
abramsbooks.com